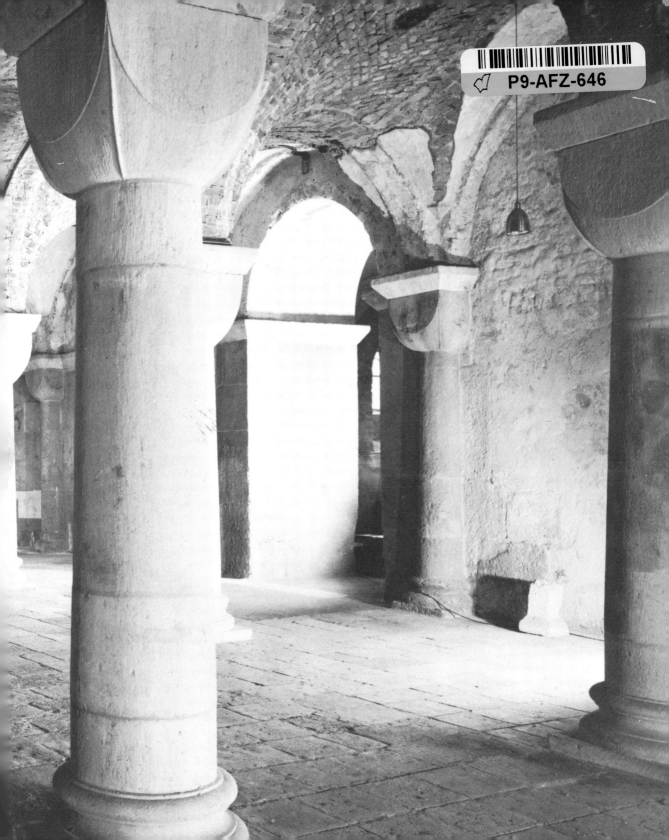

PANORAMA OF WORLD ART

———

ART OF THE DARK AGES

ART OF THE

DARK AGES

Text by MAGNUS BACKES
and REGINE DÖLLING

HARRY N. ABRAMS, INC. Publishers NEW YORK

The sections on the art of the periods of the Migrations, the Merovingians, and the Carolingians are by Regine Dölling and those on the art of the tenth and eleventh centuries are by Magnus Backes

Front end papers:
Crypt of the former abbey church of Saint Maria im Kapitol, Cologne. Begun 1015; altar consecrated 1049; final consecration 1065

Back end papers:
Aachen Antependium, so-called *Pala d'Oro* (total view). c. 1020. Gold. Aachen Cathedral

Translated from the German by Francisca Garvie

Standard Book Number: 8109–8023–1
Library of Congress Catalogue Card Number: 70–90886

Contents

Introduction

FROM THE FALL OF ROME TO CHARLEMAGNE

Modern Europe has grown out of centuries of confusion, beginning with the fall of the Roman Empire, during which time the cultural heritage that had slowly evolved in Antiquity was transformed. The Late Roman Empire, with its vast social distinctions, crippled by weakness and disorder, could not for long withstand the onslaught of the young Germanic tribes. Its decline was precipitated by its division into "Eastern" and "Western" Rome. About A.D. 400, the Visigoths, who had been settled in the Danube region from the third century, moved into Italy under Alaric. Roman garrisons were hastily summoned to the defense, but this left the Rhineland inadequately protected, so that the Franks and Burgundians, Alamanni and Vandals found it relatively easy to fall upon Gaul. On the death of Alaric, the Visigoths moved on through Provence to Spain. Efforts to unite the Catholic peoples of the Roman Empire and the Arian Goths broke down owing to theological differences.

The Ostrogoths, who had freed themselves from the Huns in 454 and in Noricum had been accepted by the Byzantine Empire, had a somewhat similar history. Under Theodoric the Amal, who was both Imperial general-in-chief and consul, they set out for Italy in 488 at the wish of the Emperor. Even if the original intention had been to re-establish control over the Western Empire, and even if accordingly Theodoric had felt himself initially to be only a viceroy (see the picture on page 14), religious differences led to a breach after A.D. 560 with the Rome of the East—though later to the overthrow in Italy of the Ostrogothic kingdom itself in the time of the Emperor Justinian. Once again the attempt of Germanic forces to take over the Roman state failed. King Theodoric, who later entered legend as Dietrich von Bern, took a great personal interest in the restoration of ancient buildings. For Ravenna he also commissioned new buildings after contemporary Byzantine models. The Goths, however, had an importance greater than this: they were responsible for the transmission of south Russian goldwork techniques—in particular gold cloisonné work (see page 16)—and for the reuse of Late Roman art forms (see pages 14, 15), and the Visigoths were important for their connections with Byzantium (see pages 22, 23), which made them one of the most important links in a cultural chain reaching deep into western Europe.

Soon after the death of Justinian in 565, the Lombards came into an Italy already prostrate after the ravages of the Ostrogoths. Although their leaders (dukes) did not manage to prevent the remnants of Byzantine authority from asserting itself in the southern coastal towns, the Lombard incursion was a permanent one. The few new works of architecture they created either used ancient materials or were copies of earlier models (see page 21). The conversion of the Lombards to Catholicism, in which Queen Theodolinda and Pope Gregory the Great played a major part, brought certain changes. As a sign of their new faith, baptized Christians wore small gold crosses (see page 17), in which the fusion of Germanic forms with the art of the Mediterranean, and the cautious representation of the human form, can be traced. Small works, often serving as ornaments, combine the Germanic animal style with classical interlaced bands, and we also find simplified Late Roman decorative forms which survived until the Middle Ages. Since architecture only later developed a style of its own, these small works of silver and gold act as a kind of seismograph of contemporary spiritual and religious developments.

Outside Italy, the Franks, composed of several tribes who had settled on the west bank of the Rhine, advanced toward Gaul in the fourth century. In a period of violent upheaval, graphically described in the chronicles of Gregory of Tours, old and new met face to face. In Frankish culture, very meager at first, the

important themes were the struggle with nature and works of charity—considered holy, hence why they are an important feature in the lives of the saints.

In retrospect, the year 496 was historically one of fundamental importance, for in that year, after his victory over several small kingdoms, Clovis, the Merovingian king of the Franks (481–511), was converted to Catholicism. Geographically his boundaries coincided with the French heartland between Paris, Reims, and Soissons, which was again to become an important French center of power in later days. A union with the Arian Ostrogoths did not come to pass, but the connection with the Roman Catholic Church gave him access to the Roman cultural traditions which the Catholic Church had to such a great extent adopted. This alliance with the Church, which seems to have been effected without much difficulty, also gave something of a crusading impetus to the Frankish settlement of the Rhineland and the Germanic territories farther east. The borders between the Merovingian kingdom of the Franks which gradually fell apart into small states, and the Saxons and Frisians, are still apparent in Germany today. An increasing number of Franks also entered parts of what is now Belgium. So, even more than northern Italy, the area between the Rhine and the Loire became the nucleus of modern Europe. Here Greco-Roman and Christian, Latin and Germanic elements merged to form the specifically European character which the Middle Ages and later times showed. It also makes the cultural allegiances of the numerous small states of later times intelligible.

We owe most of our knowledge of these movements to archaeological finds. Architectural or written records are extremely rare and generally relate to Latin populations (see pages 35–37). Excavations have allowed us to retrace how the Christian transcendental concept of man of Late Roman times gradually merged with the Germanic view of the unity of the earthly and the supernatural. They also tell us of the process of fusion between the Germanic and the Latin peoples.

The custom of burying the dead with rich grave goods and surrounding them with articles of personal use (see pages 24–29) is an early example of mutual influence. Originally the Germanic tribes burned their dead, but inhumation gradually took over in the Roman border areas. Whether this custom was related to concepts of the afterlife of the deceased, or whether it was simply a distinction conferred on the dead, is not always certain. The extent and the siting of the cemeteries give us information on the degree of settlement and on the social structure of an area. The Franks adopted many of the techniques of the still partially surviving Roman workshops, such as chip carving and cloisonné enamel. In the cloisonné technique, narrow partitions are attached to a background and the resulting cells are filled with patterns of multicolored precious stones or with molten glass.

Much of the importance and influence of the Germanic kings was based on their treasures, as is made clear in the legend of Wayland the Smith and the Life of Saint Eloi (d. 659), the patron saint of goldsmiths. The ornaments developed from Late Roman decoration gradually assumed the typically Germanic motif of animal interlace, often in the form of abstract compositions with intricate convolutions interspersed with mythical beings. This technique with its rich formal repertoire even entered religious art (see pages 30–33).

At the end of the fourth century, the Angles and Saxons moved into the British Isles, hence the name "Anglo-Saxons," and settled there on a wide scale from the mid-fifth century on. They had evolved sophisticated ornamental techniques, and also, in Scandinavia, granulation and filigree (patterns of fine wire or little balls of gold and silver attached to a ground), as well as inlaid metalwork of the most varied kinds, and they had an extreme mastery over their material. Again our information comes chiefly from large burials, such as the ship burials at Sutton Hoo, Nydam Moor, and Vendel (see pages 45–47, 54–57).

Irish monastic life, which flourished soon after the final withdrawal of the Romans, and particularly, after 520 under Saint Columba, proved an extremely important artistic stimulus. Ireland was very poor economically, and its architectural forms remained correspondingly very simple and unadorned (see page 38).

But the spirit of the land expressed itself in outstanding miniatures and illuminations which adopted and continued the Celtic heritage with its characteristic spiral and trumpet patterns (see pages 40 and 48–52). Even the human figure was gradually reintroduced; a very rare example of this on the continent is the famous equestrian relief of Hornhausen (see page 34). Irish book illumination was directly inspired by the renewed contacts with Mediterranean works, and it in turn affected the continent wherever Irish, Scottish, and Anglo-Saxon monks traveled and founded monasteries.

The artistic productions of the kingdom of the Franks, and of the North, showed distinct tendencies to mingle indigenous and Mediterranean styles. But Italy, thanks to the continued influence of Byzantine art and the political presence of the Eastern Empire, adhered more closely to the classical tradition, particularly in architecture and painting (see pages 58–63). This remained so even when the Popes seceded from Constantinople in the early days of iconoclasm. The Christianized Lombards evolved rather more individual styles (see pages 64–68).

The strong sense of independence of the Frankish nobles prevented the formation of a centralized Merovingian state, and one dynasty, the Carolingians, finally overthrew the Merovingians. In 732, in a furious battle somewhere between Poitiers and Tours, Charles Martel ("Mayor of the Palace" 716–41) finally averted the danger threatening from outside in the form of Islam. His successor, Pepin the Short, was anointed King of the Franks in 751. When Pope Stephen II fled to his side, the position of the king as the spiritual protector of Christendom was once again affirmed. Pepin's son Charlemagne, sole ruler from 771, had to wage war for much of his life in order to secure the boundaries of the kingdom. One after another, Saxons, Lombards, Arabs, and Avars had to be fought off in bitter battles, until the establishment of the Spanish March in 796 and the bloody conquest of the Saxons in 804 led to a period of relative peace. But in 843 the Empire was divided up among his successors by the Treaty of Verdun.

The great achievement of a united Europe, of which the borders almost coincide with those of the European Economic Community, is inconceivable without the person of Charlemagne, whom Frederick Barbarossa even had canonized at Aachen in 1165. His life illustrates the transition from Germanic princeling to emperor in the Roman sense, for whom the *renovatio* of the old *imperium* was the chief concern. Charlemagne made several journeys to Italy; from his last stay there he brought back the crown of the Caesars with which Leo III had crowned him on December 25, 800, in gratitude for the help he had rendered him against the Romans.

Italy, with its predominantly Byzantine style of art, was the main incentive for the Emperor's concentrated efforts. It was in Italy that Alcuin, the great English scholar and future organizer of Charlemagne's cultural program, joined him as did Paul the Deacon and others. In that land were the books which were the models for his own people's efforts, and it was there that he gave the monk Godescalc the first commission of its kind. *The Godescalc Gospels* were followed by a series of large, splendid manuscripts which make up the so-called Court School of Charlemagne (see pages 96–103). The illuminators revived the traditions of Late Roman painting, although their actual models are unknown. When the Emperor and his advisers officially rejected the decrees of the Byzantine iconoclast emperors on the worship of images in 791—as recorded in the *Libri Carolini* compiled by Theodulf—the way was paved for the rich pictorial imagery of the West (see page 88).

Charlemagne collected books and documents and embarked upon the almost impossible task of administering his heterogeneous state as a unity. He left to the different tribes their own laws (he even commissioned a collection of heroic epics and old songs) and reformed handwriting.

Only comparatively late did Charlemagne's court, which during the first half of the reign was constantly on the move, become settled, and it is amazing what energy he brought to the building of his palace at Aachen, a town which his contemporaries saw as a second Rome. He deliberately fostered this view by bringing there especially prized columns, to which he added the equestrian statue of Theodoric, the first great Germanic

prince on Italian soil. Only the upper administrative and military posts remained reserved to the Franks; otherwise the Emperor summoned scholars, artists, and craftsmen from every part of his far-flung empire.

Thus, in a unique fashion and at a historic moment in time, he managed to synthesize the most varied cultural traditions, subordinating them all to his striving for Latinity. From this sprang what is called the "Carolingian Renaissance" (see pages 99–109). The life and activity of Charlemagne's court, which continually fascinated the minds of medieval scholars, was in fact the work of an extremely small number of highly cultivated men who became the beacons of the new culture. After a short time in the immediate vicinity of the Emperor, they usually returned home, or were created bishops or abbots as a reward for their services. It is their work that inspired the formation and flowering of other artistic centers, such as Reims, Metz, Fulda, Saint Gall, and Salzburg.

The striving for authentic and accurate copies, particularly in the monasteries, of liturgical and scholarly texts, even the Bible itself, was the chief motive behind all the writing activity—to which illuminations were added by way of amplification. Ornamental initials, canonic tables showing concordances between the gospels, and, at a later date, full-page illustrations were executed with an increasing mastery. The renewed representation of the human form after ancient models and standards, was perhaps their greatest contribution to the art of evolving Europe; it has continued to influence the European visual arts until modern times.

The Christian way of life found its expression in large cycles of paintings (see pages 106–8, 112, 113), usually executed in flat color complemented by monochrome pen-and-ink drawings (see page 107). Unfortunately, few wall paintings have survived (see pages 85, 87, 93, and 95), so that generally we have to rely on smaller-scale works.

Many of the manuscripts had magnificent bindings. Those of carved ivory have survived best (see pages 96–98). They are the chief source for our impression of Carolingian sculpture, although written sources tell us of large-scale works in this form, and a few rare fragments have survived intact. These very early works, particularly those by the Court School, are based closely on Late Roman models.

Contemporaries considered works of gold perhaps the most important of all. In an almost archaic way, they associated higher powers and an inner meaning with this metal; indeed it counted as a symbol of Divine Light also embracing earthly majesty. Their reports are full of reverent admiration, and the sole surviving Carolingian gold altar (see page 130), the few liturgical implements (see pages 121–29), and book covers (see pages 114 and 120) justify such admiration even today. These works speak more clearly of the high level of handicrafts and the magnificent sense of form of the people of those times than any other expressions of their culture.

The wonderful variety in the visual arts is also reflected in Carolingian architecture though here the desire to experiment with different forms is even clearer. Carolingian buildings such as the palatine chapel at Aachen (page 73), Santa Cristina de Lena (page 89), Corvey (pages 80–81), and Mistail (page 94), all seem to speak a very varied formal language, and at first it is not easy to distinguish a common Carolingian style in the way we can with other styles such as Gothic or Baroque. The surviving churches are almost exclusively of stone. Secular buildings, which were usually made of wood, are only known to us from excavations; unfortunately, few have been discovered. Most of them were simple rectangular or trapezoid structures. Also we do not now know how surviving Roman buildings were used. However, our knowledge of the royal palatine chapels and monastic foundations is more complete, e.g., the plan of Saint Gall has proved to be a standard pattern.

Apart from the utilitarian form of the simple hall church (pages 90–92, 95), which showed regionally the most varied solutions to the problem of the shape of the choir, especially in the East, the Roman basilican form adopted at the reconstruction of the abbey church of Saint-Denis (from 754) was to become the predominant form for medieval architects (pages 78–83). A special type of *westwork* evolved through the

variety of its functions (pages 79–81). The growing cult of saints inspired the building of separate subterranean places of worship, i.e., crypts, whose forms could vary greatly (pages 84–87). Charlemagne's palatine chapel at Aachen was a deliberate copy of the central structure of San Vitale in Ravenna, although it is different in character, and it was frequently copied in Ottonian times (pages 180 and 199). Often we know only the ground plans of Carolingian churches, but these became the basis for the outlines of their successors.

Developments in England and Scandinavia are much more complex and difficult to follow. From the late eighth century on, the Vikings were migrating from Norway and Sweden, and even if the discovery of America was temporarily forgotten by history and relegated to the realm of legend for many centuries, they left definite traces on all the coasts of Europe. The gold treasures and Antique coins the Vikings found on their expeditions were elaborated at home into strikingly individual ornaments. Goldsmiths' work in England, which was occupied by the Danes from 836, shows traces of typically northern Germanic formal language (page 138), and this remained so even after the final union of the several Anglo-Saxon kingdoms under Alfred the Great (871–900; page 137). Noteworthy also is the adoption of the human figure in the convoluted animal compositions of Northern art, as found on the picture stones, the secret significance of which has still not been fully interpreted (pages 141–43).

OTTONIAN ART: THE TENTH AND EARLY ELEVENTH CENTURIES

The great flowering of Carolingian art was followed at first by a certain period of stagnation lasting some fifty years, but around the mid-tenth century a new, fruitful, and creative development appeared which continued well into the eleventh century and was the direct basis of the Romanesque art of the Early Middle Ages. The different tribes and peoples—the different "nationalities"—now began to assume distinct characteristics of their own. With the treaties of Verdun in 843 and Mersen in 870, the Carolingian Empire had been divided politically and then culturally into two parts, a western and an eastern Frankish kingdom. In 911, the Carolingians died out in the kingdom of the east, and in 987 in that of the west. The kingdom of the western Franks, in what is now France, was ruled by the Capetian dynasty from 987 to 1328. Starting out from their ducal domain of France, or Francia (which included the Paris basin and Orléans), the Capetians imposed Frankish rule on the feudal states—Burgundy, Normandy, Brittany, Aquitaine, etc.

Italy, by contrast, was not a political unit in the tenth and eleventh centuries: it was divided up into the States of the Church; Byzantine, Norman, and Saracen domains; and various principalities and duchies.

The name "regnum teutonicum" for the former Carolingian eastern kingdom of the Franks first appeared in documents about A.D. 920. For over a century, from 919 to 1024, the Saxon dukes held the crown of the German kingdom and (from 962) of the Holy Roman Empire. Three of the Saxon emperors bore the name Otto, and this is why we speak of "Ottonian art" in reference to their age. When Otto I, called the Great (936–73), was elected King of Germany, he took up the Carolingian idea of a central European empire, following Roman and Christian tradition, and gave it a new meaning. This is why he chose to receive the crown of Germany on the throne of Charlemagne at Aachen in 936. From then on, Aachen and its palatine chapel became the central symbol of the Ottonian Empire. The architectural copies of the Aachen chapel in the tenth and eleventh centuries are, therefore, not so much "artistic imitations" as "political documents," particularly since the builders usually had close personal links with the royal house (see pages 180, 181, 199).

In retrospect, it may seem curious that church buildings should be the symbols of political ideas and concepts of sovereignty. But the Early Middle Ages saw all aspects of religious and political life as a harmonious whole. The created world and all human activity had their source in God, and the earthly ruler was merely the appointed custodian of the Kingdom of God on earth. Kings, emperors, and princes received their charge

and their authority from the hand of Christ. Accordingly, Otto the Great could only receive the Imperial crown of the West in Rome, from the hand of the Pope, John XII. His coronation in 962 laid the foundations of the "Holy Roman Empire of the German Nation" (a late medieval definition), and expressed its ideal, its religious basis, and its Roman and Carolingian heritage.

The son of Otto the Great, Otto II (973–83; crowned joint Emperor in 967), and his grandson Otto III (983–1002; crowned Emperor in 996), carried on the great imperial idea in the face of much conflict and with occasional aberrations. Otto III even wanted to make Rome the capital of the Empire. The Ottonian dynasty died out in 1024 on the death of Henry II, who had held the royal crown since 1002 and the imperial crown since 1014.

The Ottonians embodied their sublime concept of the all-embracing lordship of Christ in many works of art and architecture. These were commissioned by the Emperor and executed with outstanding artistic taste and consummate craftsmanship; they are indeed the highest achievement of their age, both model and pattern for the great variety of contemporary artistic works.

The Imperial insignia (pages 148f.) symbolized the Ottonian Empire both artistically and as relics. The Imperial crown may have been made specially for the coronation of Otto the Great. Its eight sides symbolized perfection: the enamel portrait of King David was a sign of justice; the picture of King Solomon was a sign of wisdom; that of Ezekiel expressed the hope that the Emperor would live a long and beneficent life; finally, the portrait of Christ is inscribed: PER ME REGES REGNANT ("kings rule through me"). The precious stone in the crown became the theme of a poem written about 1200, in which the famous Meistersinger, Walther von der Vogelweide, wrote ambiguously: "...the stone is the lodestar of all princes."

The martyrs were witnesses to, and sacrifices for, the Kingdom of God on earth; the saints were its heralds and fighters; the Emperor and Empress its earthly custodians and protectors. Ultimately they all served the same purpose, and so they could all be ranked together in common picture cycles, as on the cover of the *Codex Aureus* of Echternach (page 175).

The Ottonians had halted the Hungarian and Slav invasions against the West and had begun to Christianize the eastern lands of the Empire by establishing new bishoprics (the archbishopric of Magdeburg 968; the bishoprics of Merseburg and Meissen 968; Gnesen 1000; Bamberg 1007). They conquered northern Italy and the states of the Church and fought the King of France. The manuscripts of the Ottonians fixed in visual form the ceremonies of homage the nations and provinces of Europe rendered to the Emperor and helped to create the image of a universal empire (see pages 161, 164–65).

The Saxon "tribal" lands enjoyed the special favor of the Ottonians. Henry I (919–36) chose the church of Saint Peter in Quedlinburg as his burial place; the crypt church of Saint Wipert there dates from his time. Magdeburg was Otto the Great's favorite place of residence. He began to build the cathedral there in 955, endowing it richly (see page 152), and chose it to be his burial place. Saint Cyriakus in Gernrode (pages 153–54) is the oldest Ottonian church to survive almost intact, and the burning and gutting of the church of Saint Michael in Hildesheim (pages 208–10) created an opportunity for the reconstruction of an Ottonian building in its original form.

Henry II gave his patronage to the bishopric and cathedral of Bamberg which he had founded. Thietmar of Merseburg reports that the Emperor "particularly loved Bamberg and cherished and cared for it above all other [places of worship in the Empire]." The cathedral, begun in 1004, was restored and altered in Romanesque and late Romanesque times after being damaged by fire. The Imperial ceremonial robes (pages 150–51) are still preserved in the cathedral treasury, while the famous *Book of Pericopes* and the so-called *Portable Altar of Henry II*, given to the cathedral by the Emperor and Empress, are now in Munich (pages 167–68, 178). The *Basel Antependium* (pages 170–71), which shows the Emperor and Empress kneeling at

the feet of Christ, was originally intended for Bamberg. Henry II also made gifts to the palatine chapel at Aachen, as evidence of his goodwill and reverence for this important place of worship (pages 187–91).

The life and times of Charlemagne were certainly the inspiration, and often the model, for the religious and political ideas and the artistic creations of the Ottonians. But there was also a lively exchange of ideas between the Ottonians and the contemporary Byzantine Empire, and periods of fruitful coexistence alternated with rivalry and conflicts of interest, as in the quarrel over northern Italy. Otto the Great married his son, the future Otto II, to the Byzantine princess Theophano in the hope that family ties would produce a political settlement; this marriage was at the same time a sign of very close cultural contacts. Byzantine metalwork, ivories, and illuminations, which were copied in the mother country or removed to the treasuries of Western cathedrals and monasteries, became the technical, formal, and iconographic models for many Ottonian works of art (see pages 163, 177, 219).

Late classical and early Christian traditions of Rome were a further source of artistic and religious inspiration to the Ottonian age. Since the Byzantine Empire was continuing to make use of ancient Roman traditions in a Christian guise, the conscious reaching back of the Ottonians to early Christian precedents, the "Ottonian Renaissance," was a political necessity to back up the claim of the Western Christian empire to precedence over the Eastern Christian one.

Late Roman, Carolingian, and Byzantine art gave ideas and inspiration, but this does not account for the individual style and originality of Ottonian art. This style was an independent and distinct phase of development in the art of the Middle Ages in the West. It drew on its own resources and took its own precedents from itself in fulfilling its spiritual and political functions. Originality is the main reason for the richness and force of Ottonian art, and led to the flowering of Romanesque art later in the eleventh and twelfth centuries.

Otto the Great and his successors had given temporal authority and rights to the bishops and abbots of their lands and often raised them to the rank of prince, not only to emphasize the priestly structure of the Empire, but also for reasons of economic or political expediency. Very often, the holders of religious or temporal power were relatives of the Imperial house, like Archbishop Bruno of Cologne (953–65; see page 192), the Abbesses Matilda, Theophano, and Sophia in the foundation at Essen (see page 201), and the Abbess Ida, granddaughter of Otto II, in the Cologne Chapter. Or high noblemen loyal to the Empire occupied bishops' sees—like Egbert, the former chancellor of Otto II (see page 174), and Poppo in Trier, Gero (see page 194), in Cologne, Willigis in Mainz, Meinwerk in Paderborn (see page 206), Bernward in Hildesheim (see pages 208–10), Werner in Strasbourg, and Bishop Richard in Fulda (see page 183).

All these important figures themselves supervised the construction of great churches and cathedrals and commissioned numerous precious works of art. Often it was they who determined the form and scheme of the works, or they were artists in their own right, as is said of Bishop Bernward of Hildesheim. Accordingly, the art forms of the Ottonian age, like the Carolingian age, were decidedly aristocratic and courtly.

The majority of the artists belonged to the clergy and were mostly monks. Artistic workshops were formed in certain monasteries, and probably also at cathedrals, to execute the wishes of their high patrons. Many an illumination or ivory affords us a glimpse into such a workshop (see pages 160, 162, 166, 187). This resulted in the rise of geographically defined art centers, the so-called "schools," with clearly distinguished styles, such as the School of Reichenau (pages 155–68), Regensburg (page 172), Echternach (page 175), Lorraine (pages 223–25), Trier (pages 173, 174, 176), Fulda (pages 178–79, and perhaps pages 170–71), Aachen (pages 185–86, 190–91), Cologne (pages 187, 192–98), Essen (pages 199–203), Mainz (page 184, and perhaps page 204), Paderborn (pages 206–7), and Hildesheim (pages 208–15). The particular richness of Ottonian art becomes especially clear in the wealth of variety of these schools.

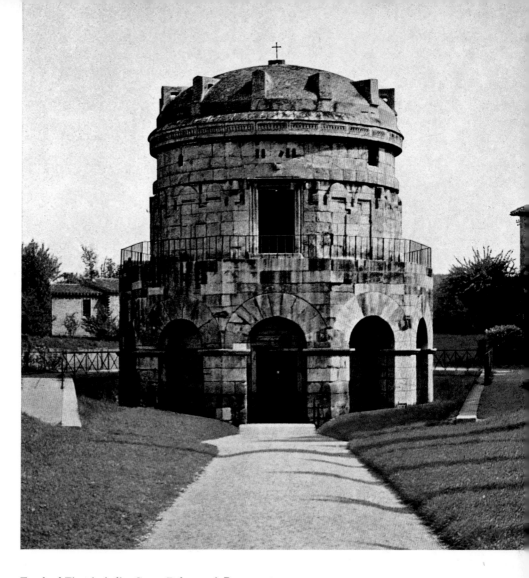

Tomb of Theodoric the Great. Before 526. Ravenna

One of the most impressive buildings commissioned by Theodoric, founder of the Ostrogothic kingdom and the most important Germanic king in Italy, was his mausoleum outside the walls of his capital, Ravenna. It asserts its own distinctive character and at the same time reaches far back into the past. A blind arcade of simple wide arches on broad piers at the angles of the ten-sided structure girds its lower story, within which there is a cruciform, barrel-vaulted *cella*. The gallery on the upper story shows traces of a colonnade. A giant dome-shaped cupola surmounts the tomb of this king who was later to become a part of legend. The exterior is reminiscent of the burial places of the Germanic princes, while at the same time the interior recalls the forms of Roman and Byzantine stone mausoleums. The sparse ornament reminds one of the work of Ostrogothic goldsmiths.

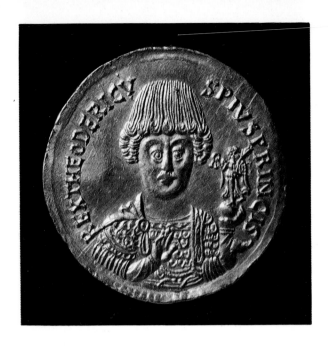

Theodoric the Great Coin portrait. Early sixth century. Gold. Museo Nazionale, Rome. Above: obverse. Below: reverse

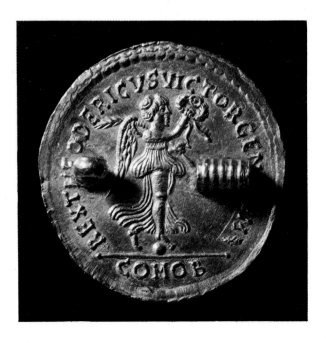

Long after the conquest of Italy, which he had begun in 488 on the orders of the Eastern Emperor Zeno, Theodoric continued to feel subject to Constantinople. This relationship came to an end only when the Byzantine court adopted an anti-Arian attitude. Theodoric took more pains than other Germanic kings to attempt the mixing of the Arian Goths and Catholic Italians culturally, but this policy failed under his successors, largely owing to religious differences. Just as Theodoric deliberately imitated Roman coins with their imperial iconography, so he made efforts to restore Roman monuments, as we know from the writings of the Senator Cassiodorus. The famous gold portrait medallion is not a portrait in the current sense of the term. The enlarged eyes and sculptured quality of the face are typical of late classical Byzantine figurative art; only the hairstyle is Gothic, while the robe points to Byzantine influence again. We find the same features in a number of portraits of an empress who has been identified as Theodoric's daughter and successor Amalasuntha. These portraits reflect the attempt to take up the Roman and Byzantine heritage and—as a kind of state policy—to continue it. Charlemagne, some three hundred years later, was also to see himself as the restorer of the Roman Empire and to transfer an equestrian statue of the Ostrogothic king to Aachen.

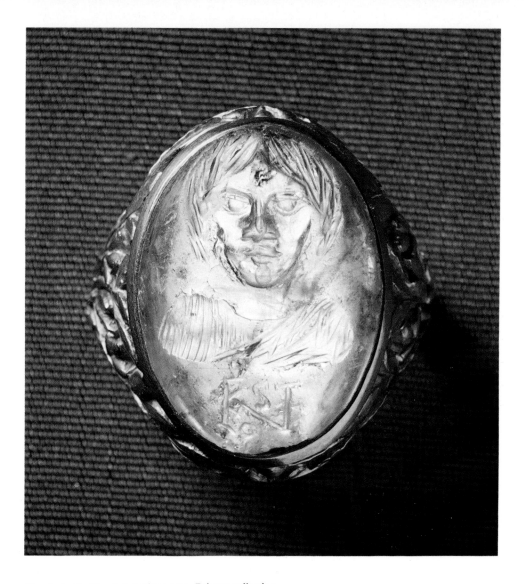

Theodoric the Great. Amethyst gem. Private collection

This is another contemporary portrait of Theodoric. The overall style is somewhat freer and more as though painted; the face bears only a remote resemblance to that of the portrait medallion. Striking indeed is the adoption of the form of the cut gem, an art form to which we owe many Ancient portraits of the emperors.

Although the architecture and the few surviving portraits from the time of the Ostrogoths clearly reflect Byzantine and early Christian concepts of form, the jewelry has a specifically Ostrogothic character. From the second half of the fourth century there had appeared in Germanic art a technique which probably originated in the East and was much used by the Scythians and the Sarmatians around the Black Sea. It was introduced by the Huns into the artistic repertory of the Germanic tribes, and the Ostrogoths, whom they drove before them, brought it to Italy. The Ostrogoths had a predilection for a particular form of this so-called *polychrome* style: they set precious stones close together in cellular form separated from each other and held in place by thin walls of gold; usually the flat polished stones (almandines, garnets, or lapis lazuli) were cut in geometric shapes, but when there was a scarcity of them, the cells were sometimes filled in part with enamel; this technique is called *cloisonné* enamel.

The *fibula* is perhaps the best-known Germanic ornament. It served as a brooch or clasp and was attached to the dress by a pin on the back. It boasts a rich history from La Tène times onward. Animal forms were particularly admired in the Early Middle Ages and the Goths esteemed the image of the eagle most of all. The entire surface of the fibula from the Cesena treasure, shown here, was covered with almandines, alternately angular, round, and rectangular in shape. The sparkling richness of this work can only be imagined today, since most of the stones are lost.

Eagle fibula. Late fifth century. Ostrogothic gold cloisonné, length 4³/₄″. From Cesena. Germanisches Nationalmuseum, Nuremberg

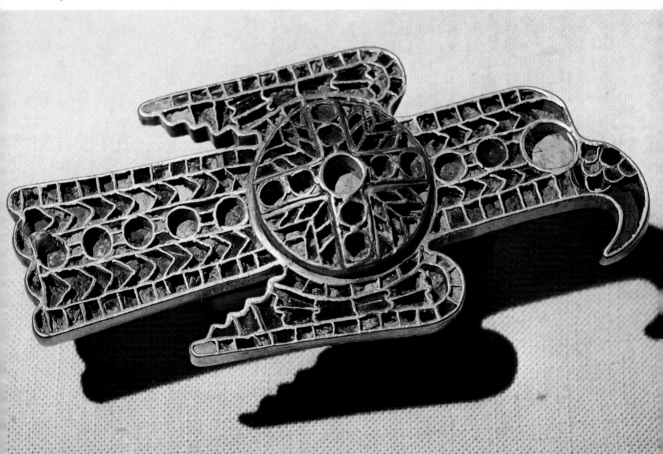

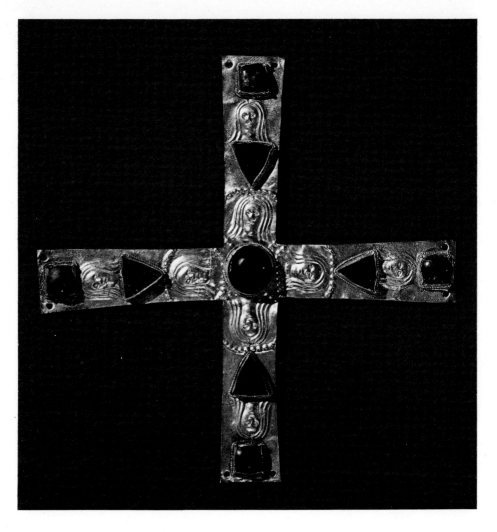

Cross of Duke Gisulf. Late seventh century. Gold and precious stones, height 4³/₈″. From Italy. Museo Archeologico, Cividale

As a sign of their Catholic faith in an Arian environment, the converted Lombards who migrated to northern Italy wore small gold crosses, usually cut from gold or silver plate. They were not regarded as ornaments until the eighth century. Some of them distinctly show assimilation of Mediterranean interlaced bands into the so-called Northern Animal Style II. One also finds figurative images on these crosses, sometimes in the form of coins, which show how the Byzantine theme of homage to the ruler entered the Christian artistic repertory. The arms of the Greek cross of Duke Gisulf are decorated with eight portraits, alternating with insets of lapis lazuli grouped around a central garnet. It may be that these heads, impressed into the gold plate, were portraits of Christ.

On the christening of her son
Adalobald in 603, Pope Gre-
gory the Great gave the Lom-
bard Queen Theodolinda a
precious gospel book, and
other works in gold, in grat-
itude for her aid in converting
the Lombards to Catholicism.
Both front and back covers
have a cross, of which the
arms are inlaid with regular
patterns of precious stones.
The edges are emphasized by
delicate red cloisonné frames,
and a cameo from classical
times is set on each of the free
surfaces outside the cross. After
the adoption of Catholicism,
Late Roman goldwork began
to influence the art of the
Lombards.

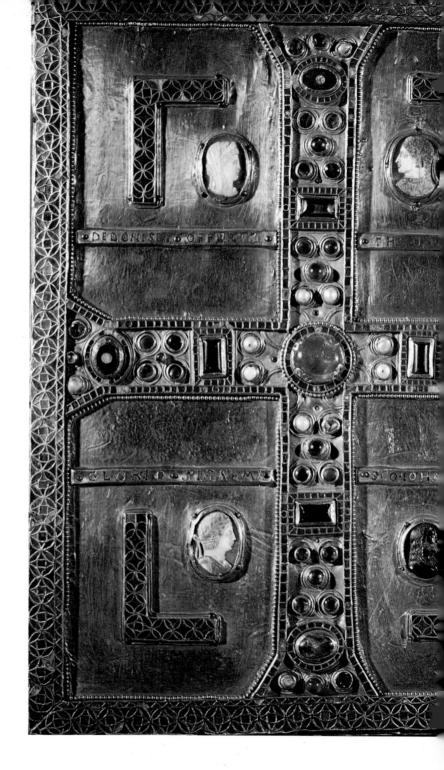

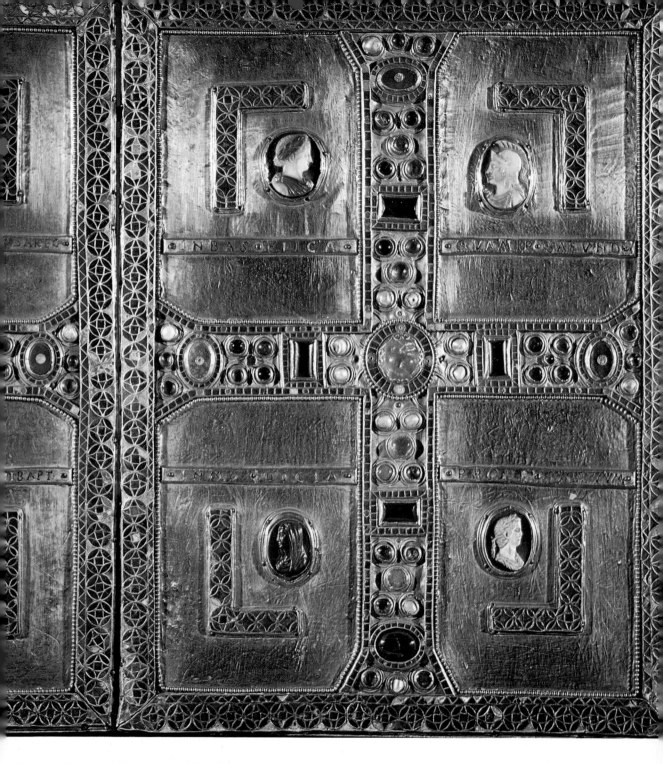

Covers of the *Gospel Book of Queen Theodolinda*. c. 600. Gold with precious stones, pearls, and cloisonné enamel, $13^3/_8 \times 10^1/_4''$. From Italy. Cathedral treasury, Basilica San Giovanni Battista, Monza

This is one of the most curious pieces in the treasury of the Cathedral of Monza and one that is perhaps unique in art history. The hen is surrounded by seven chicks picking up corn off a raised platter. Their bodies are in chased metalwork and all the details of the feathers and claws are brought out in realistic relief. Garnets represent the eyes. The astonishing realism is reminiscent of Late Roman work, but it is difficult to date this group, and its attribution to Lombardic craftsmen is disputed. It appears in a fourteenth-century relief in the cathedral together with representations of other gifts, and of their donor, Theodolinda.

Hen and Chicks. c. 600 (?). Silver gilt. From Italy. Cathedral treasury, Basilica San Giovanni Battista, Monza

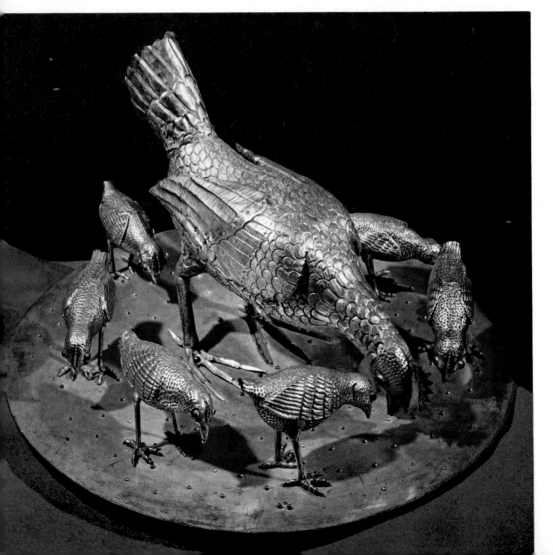

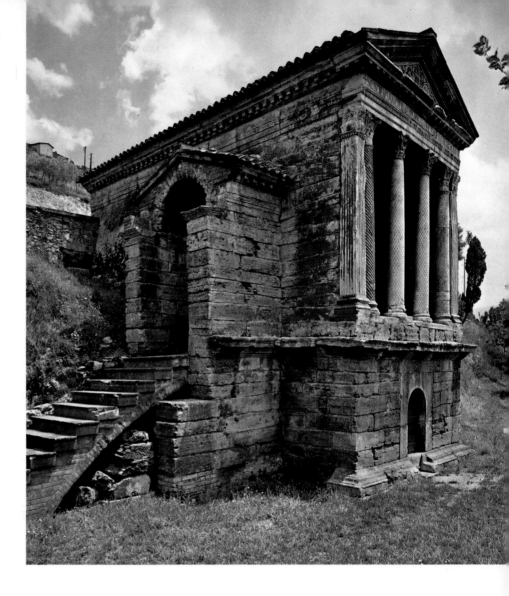

When the Lombards invaded northern Italy, they brought no architecture of their own with them, but, like all the Germanic tribes, used existing buildings or had new ones erected by indigenous masters who naturally began by clinging to tradition. Just as the Ostrogoths adopted the Late Roman and Byzantine form of columned basilica for their churches, so the Lombards largely followed classical models for theirs. The chapel of Clitumnus near Perugia is a very interesting example of this. At first sight it looks like a classical pagan temple. Its dating is disputed. The two outer columns of the four-columned facade are joined to the walls of the portico which is reached by steps to a small annex either side—non-Roman features. On the tympanum, tendrils with flowers surround the central cross. The *apsis aedicula* in the interior however speaks clearly the language of early medieval form.

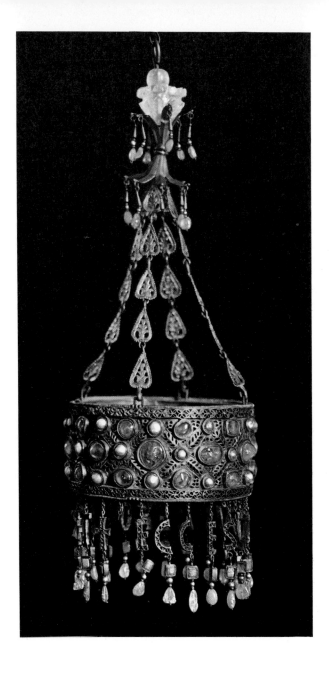

Votive Crown of King Recceswinth (649–72). Gold, with pearls and sapphires. From Guarrazar near Toledo. Musée de Cluny, Paris

The first Visigothic tribes invaded the Pyrenean peninsula about A.D. 470. In the early sixth century, they were followed by a larger number of their race, though by the mid-sixth century the Byzantines, whose own influence—and Christianity itself—was destined to fall before Islam in 714, had already conquered southern Spain. Only in the north did there survive Visigothic groups from whom, from Carolingian times onward, the reconquest of Spain proceeded. Between the two periods of occupation, Roman and Moorish, King Recceswinth succeeded in uniting Romans and Visigoths under a common law, and the art of the Visigothic kingdom evolved without interruption. But neither he nor his successors managed to abolish widespread social abuses, and it proved relatively easy for the Arabs to establish themselves.

The *Votive Crown* and Recceswinth's *Cross* were found in 1858 in a priest's grave near Toledo, together with other treasures from Visigothic kings. Perhaps they had been brought to safety there from the encroaching Arabs. The crown of pierced goldwork encrusted with sapphires and pearls hangs from heart-shaped links which in turn are suspended from a central fixture like a bud of precious stones. The gold walls of the circlet itself are pierced with Saint Andrew's crosses, as appear on the cross of the king in Madrid. The commemorative inscription is both decorative and informative; the individually suspended golden characters underneath read: RECCESVINTHUS REX OFFERET. A cross of pearls and gems with pear-shaped pendants hangs through the center.

Certain stylistic details and the circular pattern of red cloisonné enamel on the edges of the crown seem to indicate Byzantine origins, but it is not at all certain whether the work was imported or made on the spot.

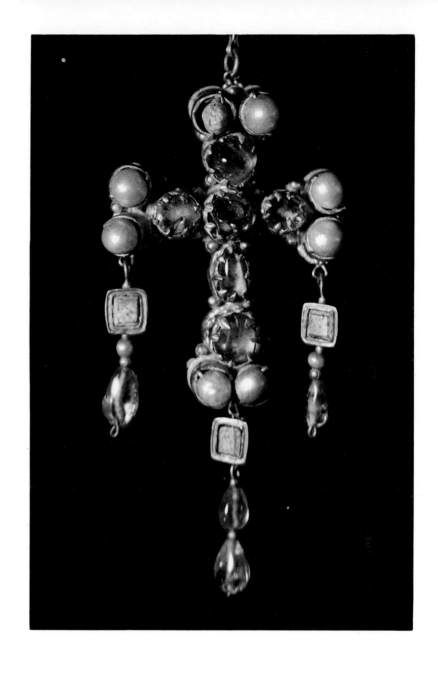

Cross of King Recceswinth. Gold, with pearls and sapphires. From Guarrazar, near Toledo. Musée de Cluny, Paris

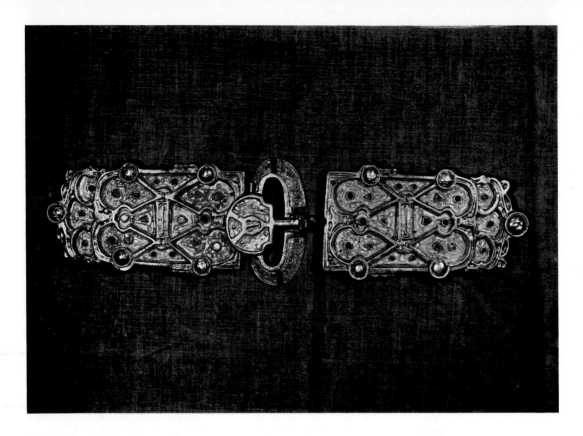

Belt Buckle of Queen Arnegunde. Sixth century. Silver gilt, filigree, and colored inlaid work. Treasury, Saint-Denis, Paris

The founding of the Merovingian kingdom of the Franks finally shifted the old political center of Europe from the Mediterranean to central Europe; this was one of the most important events in Western history. In the course of time, the fusion of the Roman culture of the political structures of the times of the Caesars with the outlook of the new Teutonic peoples led to the formation of modern Europe. The adoption of Christianity was a decisive factor, and its effect on the ways of thought of the new races cannot be overestimated.

Most of what we know of the life and culture of these new federations of peoples comes from burials. Written records are extremely rare and usually relate to the Romanized portions of the populations. The royal burial place of Saint-Denis dates from about 565–70; it has yielded a number of gold cloisonné pieces and in addition, this splendid belt buckle. It is of silver, partly covered in gold leaf, inlaid with glass and almandines. The two parts are symmetrical, and the fillets of the silver ground form drop-shaped and rhomboid patterns.

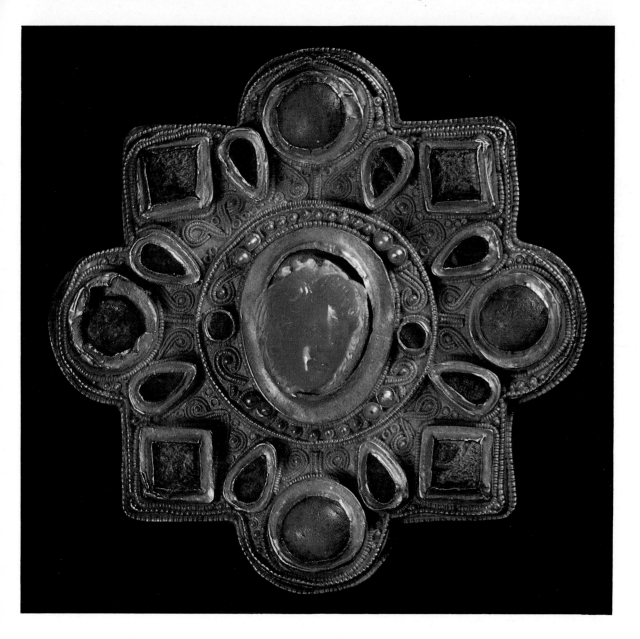

Disk fibula. Seventh century. Gold with inlays, diameter 3$^1/_4$″. From Mölsheim. Hessisches Landesmuseum, Darmstadt

This quatrefoil fibula found near Worms may be of Mediterranean origin. An Augustan cameo with a head of Medusa is set in the center. Possibly this is designed to ward off evil. It is surrounded first by pearls, filigree work, and red almandines, then by projecting frames alternately set with pear-shaped red almandines, and square and round, light and dark, green enamels. The borders and free surfaces are in gold filigree. No doubt this precious work belonged to a high-ranking personage.

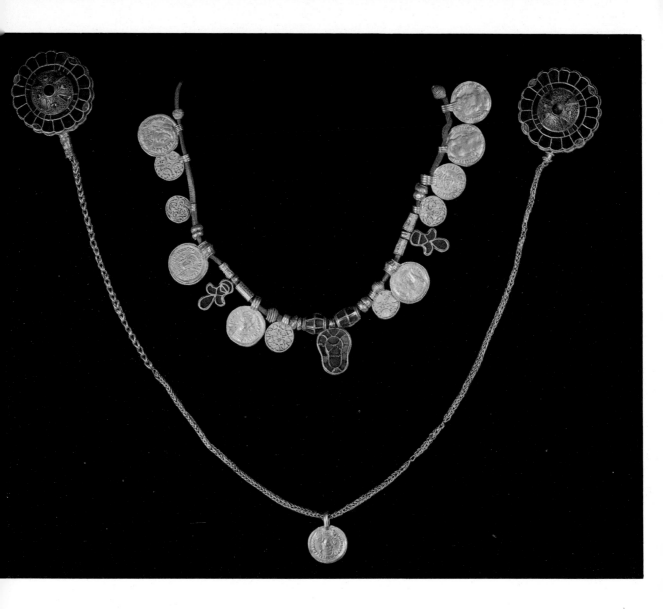

A number of graves were uncovered during diggings at Cologne Cathedral in the vicinity of a Merovingian chapel. The coins of the Late Roman emperors they yielded suggest a date in the first half of the sixth century, i.e., during the reign of King Theodobert I (533–48). Their contents are in a good state of preservation, especially in the case of a grave of a woman where we have an unusually complete picture of the personal belongings of a lady of the Frankish high nobility.

The disk fibulas from a breast ornament, illustrated here, were almost certainly connected to the coin pendants by the gold chain. Each fibula consists of a central cross surrounded by a circular pattern of filigree, encircled by two rows of almandines, while the corners between the arms of the cross are filled with greenish enamel. Such a work is inconceivable without contact with the Mediterranean.

This is borne out by the fact that on the necklace, along with other pendants in gold cloisonné work, there were numerous coins with portrait heads of late Imperial times, as well as, in the pockets of the dead woman, half siliquae of Theodoric and Althalaric which were certainly still current at the time of burial.

The tradition of decorating objects of personal use dates back in the Frankish kingdom to Roman times. Here punch tools were used to stamp recurrent patterns. Articles of this kind have also come to light in other large burial places of the time, such as the great Frankish grave near Krefeld.

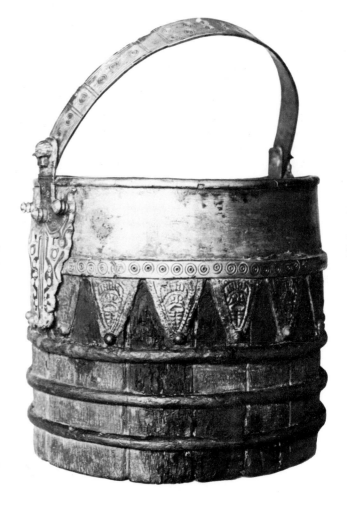

◄ Rosette fibulas and gold chain from a necklace and collar with coin pendants. Mid-sixth century. Frankish. Römisch-Germanisches Museum, Cologne

Bucket. First half of the sixth century. Frankish. Römisch-Germanisches Museum, Cologne

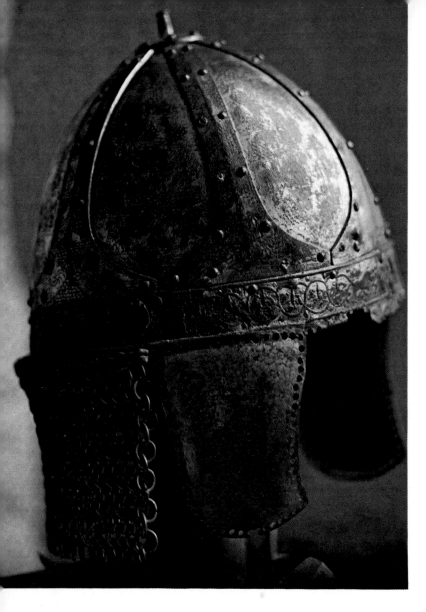

Helmet. c. 600. Bronze, partly gilt, height 6³/₄", diameter 9". From Morken (Erft). Rheinisches Landesmuseum, Bonn

This helmet was found, together with other rich attributes, in a wooden chamber beside the body in a princely grave near a fairly large Frankish cemetery. Originally it was lined with leather. The chain mail at the neck has been renewed. Its panels are engraved with a delicate pattern and the headband is ornamented with three human faces between monsters reminiscent of lions, with vines of the Christian paradise entwined between them. Other helmets of this era depict horsemen and warriors, no doubt going back to Late Roman models. This is another example of the introduction of Mediterranean pictorial motifs into the rather more abstract ornamental repertory of the Germanic tribes.

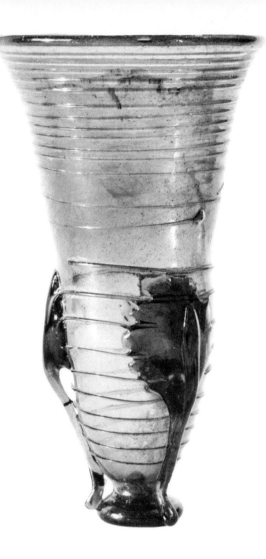

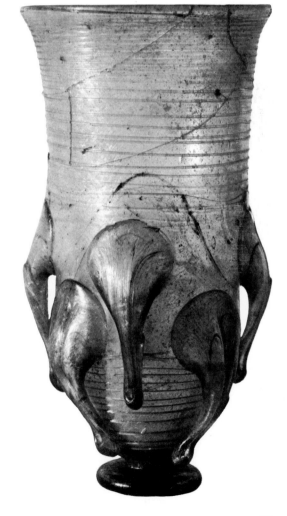

The Gallic craftsmen in the Rhineland favored a curious form of glass beaker in which the outer wall of the vessel is drawn down into a number of hollow lobes.

The models that inspired the Germanic glass blowers were Roman. Although the Franks could not equal the technical and artistic ability of the Romans, these beakers are interesting examples of their attempts to create something of their own in this field.

As in the other Germanic kingdoms, the polychrome style spread throughout the kingdom of the Merovingians and thus soon became the common property of all the Germanic tribes in Europe. Not only liturgical vessels but also secular ornaments exploited increasingly the artistic possibilities of gold cloisonné and cloisonné enamel. Cloisonné patterns surround the border of the paten here in rectangular lines and curves, emphasizing the central cross. The curiously elaborate chalice, rather hesitantly poised on its ribbed base, shows the same technique on its handles, which take the form of serpentine creatures. This important work would be inconceivable without the example of Late Roman Mediterranean vessels.

Gourdon Paten. First third of sixth century. Gold with filigree and cloisonné enamel, $5 \times 7^7/_8''$. Cabinet des Médailles, Bibliothèque Nationale, Paris

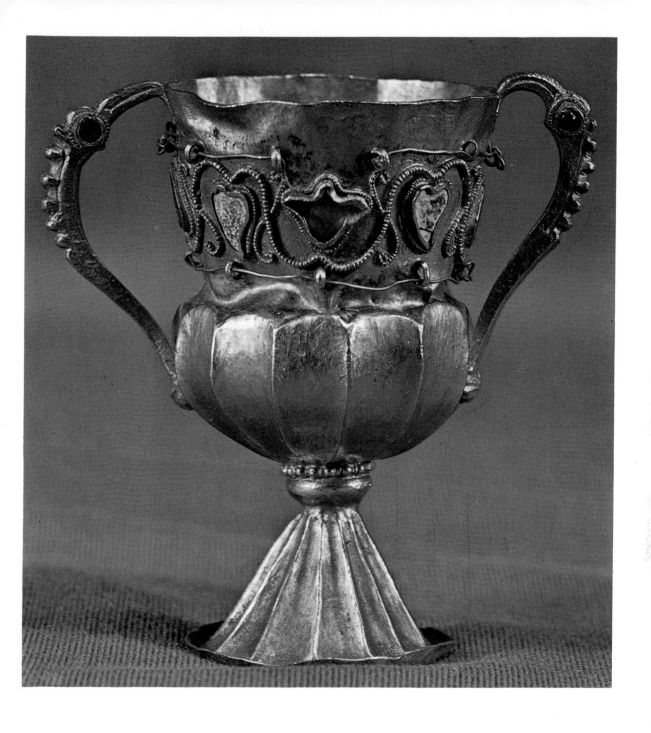

Gourdon Chalice. First half of sixth century. Gold with inlays, height 3″. Cabinet des Médailles, Bibliothèque Nationale, Paris

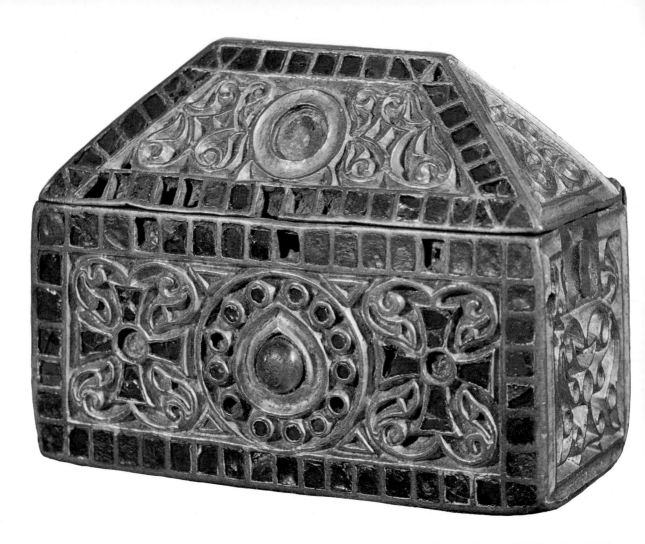

Small reliquary casket. Second half of seventh to eighth century. Copper gilt with inlaid work, height 2³/₈″. West Frankish Burgundian. From Veluwe. Aartsbisschoppelijk Museum, Utrecht

The cult of relics that began in late Merovingian times meant an increased demand for receptacles, often taking simple houselike forms. The walls were generally covered in rich decoration in different techniques. Besides the more abstract formal language of gold cloisonné, reliquaries also showed other traces of Byzantine art, such as foliage on classical lines, where plantlike tendrils with semipalmettes wind round cruciform and circular glass inlaid pieces.

The Beromünster reliquary, commissioned by Bishop Warnebertus of Soissons who died in 676, illustrates particularly clearly the working together in Merovingian art of highly disparate elements. On the back, vegetal forms of Byzantine Mediterranean origin thread over the ground, sometimes in symmetrical patterns, while loose, stringlike animal forms with separate limbs and heads cover, in Germanic style, the front wall of the casket from which the two crosses and the palatine rosette of the lock stand out clearly. On either end the master achieved a persuasive fusion of the two styles.

Reliquary of Warnebertus. Second half of seventh century. Copper gilt with inlays, length 4⁷/₈″. Convent of Beromünster

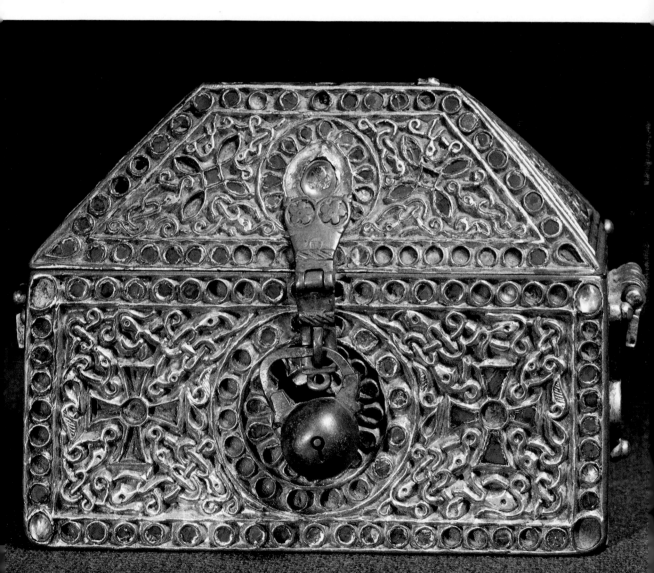

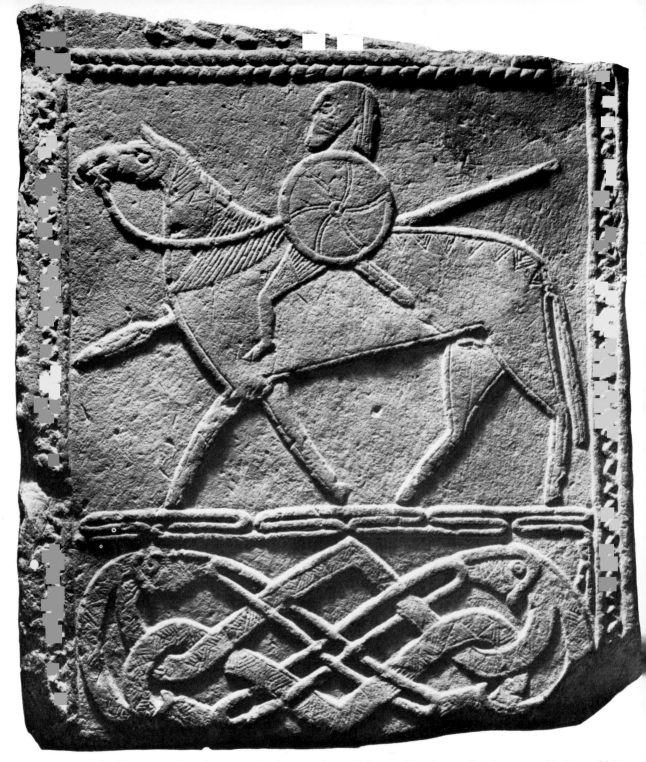

Funerary stele of horseman. Seventh century. Sandstone, height 30³/₄″. From Hornhausen. Landesmuseum für Vorgeschichte, Halle

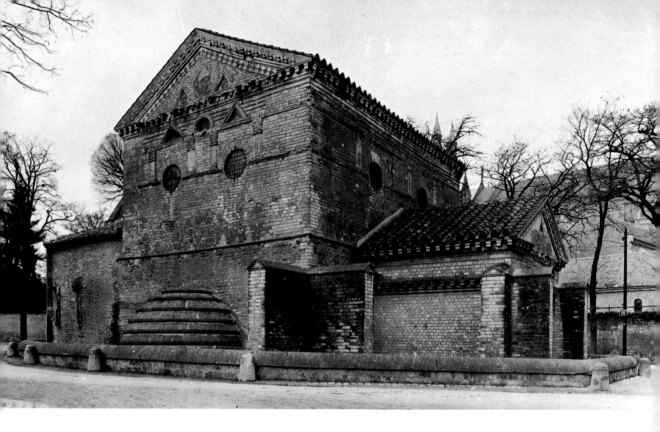

Baptistery, Poitiers. Exterior. Eighth century and earlier

There is a small group of figurative stones whose purpose has not yet been clearly established; they are chiefly found in Sweden and most often depict horsemen. The relief from Hornhausen (see opposite), a rare find in that area, shows the outline figure of a horseman holding his spear, above the intertwined coils of a serpent with two heads. The horseman may have been either pagan or Christian. The same theme appears fairly frequently on disk fibulas and is a very interesting example of the use made of what were perhaps Roman models.

Very little pre-Carolingian architecture has survived from the kingdom of the Franks, and we know little more than the ground plans tell us. However, a small group of baptisteries stands in the South of France. The Fréjus baptistery (see over) dates back to the fifth century. This small building is rectangular outside, octagonal within, with alternate semicircular and rectangular niches, and surmounted by a dome. The baptistery of Venasque (see over) presumably dates from the sixth century. The date of foundation of the baptistery of Poitiers (see above) is uncertain, though probably later. This small, square building has three bays and a small apse. Its outer and inner proportions, and the outside of the apse, indicate Carolingian influence.

Baptistery, Fréjus. Fifth century (page 36)

Baptistery, Venasque. Sixth century (page 37)

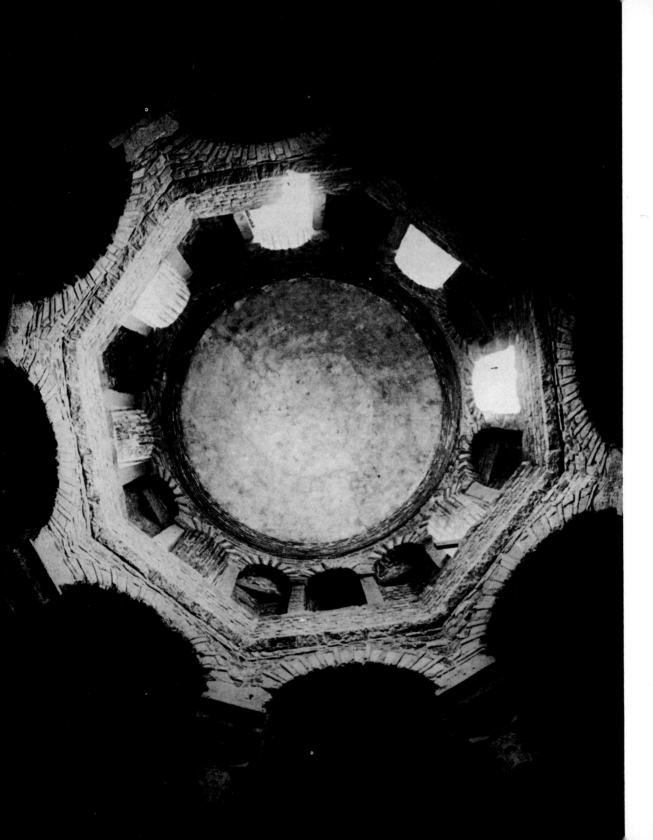

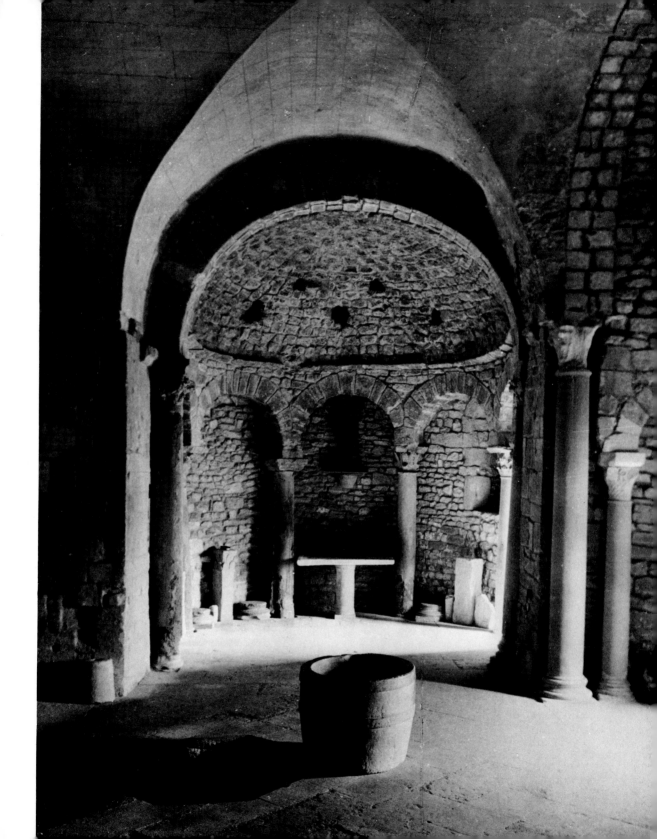

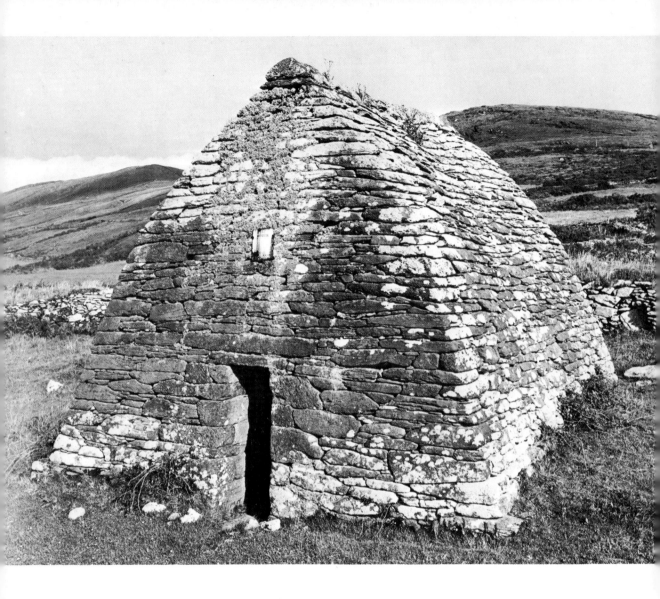

The resurgence of religious life in England and Ireland touched the whole of Europe. Although Ireland had not been a Roman province, Christianity had gained ground there as early as the fifth century. As on the Merovingian continent, the architectural heritage from that date is slight. It is known that a number of ecclesiastical buildings were made of wood. The few churches still extant are simple, single-nave structures, often without a separate chancel. But even the earliest of them are surmounted by pseudo-barrel-vaults of stones gradually corbeled forward. Often their masonry is dry-stonework alone, and their sloping outlines outside remind one of an upturned boat. This was a native method of building, also widespread throughout the Mediterranean area, which reappeared here. Often these modest places of worship belonged to former monasteries. They are in great contrast to the impressive achievements in book illumination, which was the characteristic artistic expression of the spirit of the age from the sixth to the eighth centuries. From these monasteries, the missions to the Franks and the other Germanic tribes set out in successive waves.

◀ Gallerus oratory, western Ireland. Sixth-seventh centuries

Brixworth church, Northamptonshire. Seventh century

In about the mid-seventh century, after the withdrawal of the Romans and the settlement of the Angles and Saxons, Christianity gained more and more ground in the seven kingdoms of England. Early church buildings indicate trends which also appeared in continental pre-Romanesque architecture. Particularly noteworthy are the lofty proportions and, at times, the open rafters of the roof. Some of the churches are also surprisingly long. Apart from widespread hall churches, one also finds in England the three-aisled type in the form of columned basilicas. Brixworth is perhaps the earliest example of this kind. The pillars, of wall-like thickness, rise from a long, rectangular ground plan and carry arcades of round arches. The Roman bricks emphasize this since the aisles have been destroyed, as our illustration makes clear. The windows above the pillars interrupt the masonry of the clerestory in a quite un-Romanesque fashion. Brixworth church is an example of the many early churches which were usually destroyed by the Norman invaders. We only know a small number of them from excavations.

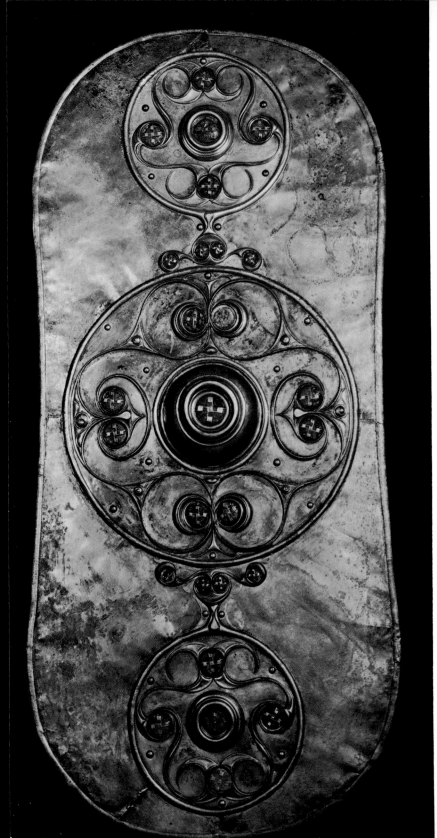

Celtic shield. Second century (?). Bronze, originally gilt, length 30¹/₄". From Battersea. British Museum, London

The Celtic world of forms was one of the most important sources of inspiration for Irish and Anglo-Saxon art. Celtic art in Britain extends from the late La Tène period to the high achievements in book illumination in early medieval times. During the post-Roman period, Roman foliage patterns exerted a great influence on this art, in particular the acanthus leaf which was merged in a delicate interplay of forms spread with great assurance over the background, as on this famous bronze shield from Battersea. The shield is a splendid example of the Celtic love of colored enamel inlaid work, often in purple, which stands out most effectively from the dark bronze ground.

Under the influence of Eastern Christian and Germanic art, Irish art forms began to change from around the mid-seventh century. Animals, interlaced bands, and spirals, taken over from earlier centuries, now all appeared together. The chalice in chased silver is decorated with bands of gold leaf at the formally most significant points; on these bands the various decorative patterns appear one after another, some of them in filigree. Bosses of colored enamel separate at intervals the individual patterns. The extraordinary delicacy of this masterpiece is evidence of the high craftsmanship of Irish gold- and silversmiths.

Ardagh Chalice. c. 720. Chased silver, gold inlaid, and enamel. The National Museum of Ireland, Dublin

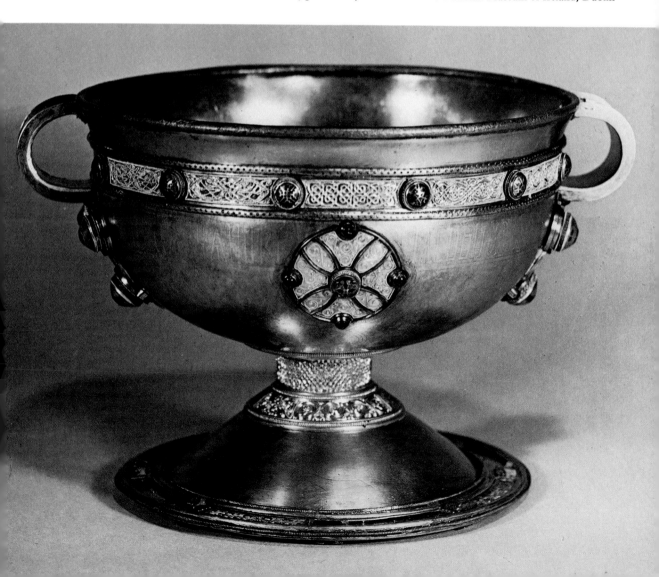

Fibula. Sixth century. From Barrington. University Museum of Archaeology, Cambridge (England)

Like a kind of leitmotif, the so-called fibula appears and reappears throughout early art history. Clasps, beloved since the Bronze Age, developed into two kinds of fibulas: one-part, and two-part types. They soon went beyond the simple function of holding drapes in place and became badges of rank. From the time of the Roman disk and animal fibulas, the fastening pin had been attached to the back, leaving the front free for decoration. The type of brooch fibula illustrated here, with a rectangular plaque at the top, became very popular from the Merovingian age onward. The plaque, with the pin on the back, is attached to a foot of almost baroque ornateness that was worked after being cast.

Ixworth Cross. Late sixth or early seventh century. Gold cloisonné, diameter 1½″. Evans Collection, Ashmolean Museum, Oxford

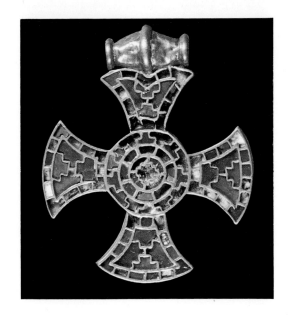

This gold breast cross, inlaid in polychrome gold cloisonné, was found in West Suffolk. It was never completed and was buried with its owner. One of a whole group of its kind, it can be compared to the Lombard gilt crosses; like them it indicated the Christian faith of its owner.

The pale gold ring found in a meadow at Barrington, Hampshire, was definitely intended to witness to a faith. The oval medallion of slightly darker gold with a profile portrait of a church dignitary is encircled by an inscription: NOMEN EHLLA FIDES IN XPO. This is framed by several rows of twisted flattened gold wire and granulation, rather recalling gold bracts.

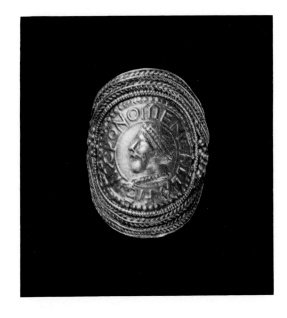

Ring of Ehlla. Seventh century. Gold, height 1½″. Ashmolean Museum, Oxford

The colorful technique of gold cloisonné arrived in England as it did on the continent, though not until the sixth century. Certain elements, such as the geometric shapes of the stones, are more distinct than in continental works and result in a very definite emphasis of the pieces as ornaments. The color of the materials also contributes toward this effect. This splendid brooch is enhanced by bands of interwoven filigree, and colored inlaid work.

Kingston Brooch. Seventh century. Gold cloisonné and filigree, diameter 3^1/$_4$″. Walker Art Gallery, Liverpool

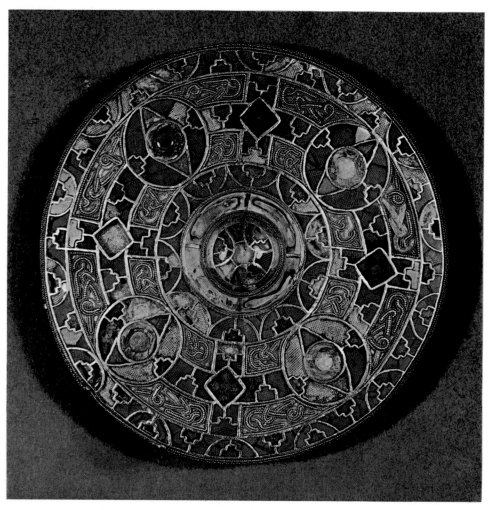

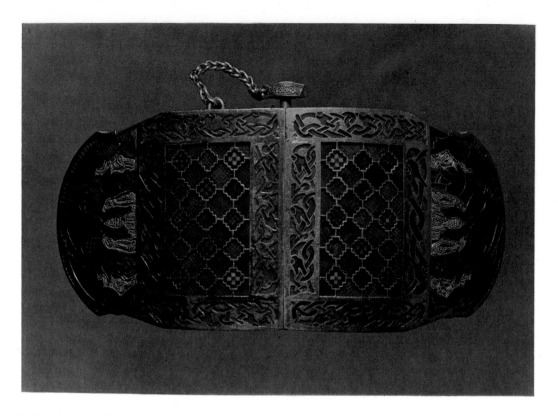

Belt buckle from ship burial at Sutton Hoo, Suffolk. Seventh century. British Museum, London

In England as on the continent, the finds from princely burials give the best picture of the high artistic standards of the age. The unusually richly furnished ship burial at Sutton Hoo brought a number of pieces in gold to light. The cloisonné surfaces of this belt fastening, and of the purse lid (see over), are a particularly interesting stylistic variant: very complex animal forms are cut out on little gold plaques and filled with correspondingly shaped stones. The purse lid is also decorated with birds, reminiscent of those found in Merovingian works: each pair of profiled birds crowds in on a frontal human figure.

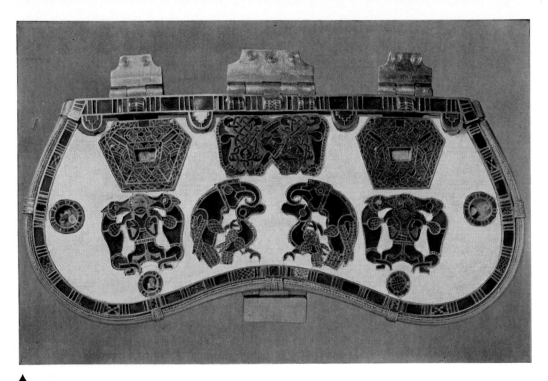

Purse lid from the ship burial at Sutton Hoo, Suffolk. Seventh century. Bone or ivory (?) ground (restored), with gold plaques inset with garnets and glass. British Museum, London

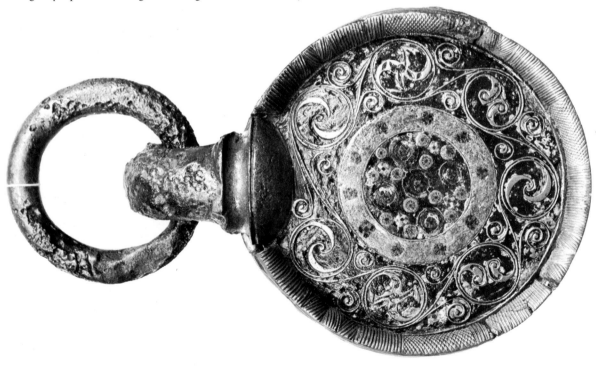

The discoveries at Sutton Hoo are also an outstanding example of how different influences converged in England. Splendid Celtic spiral decoration dominates on the mirror, while the heads on the end of the whetstone or scepter recall Scandinavian work.

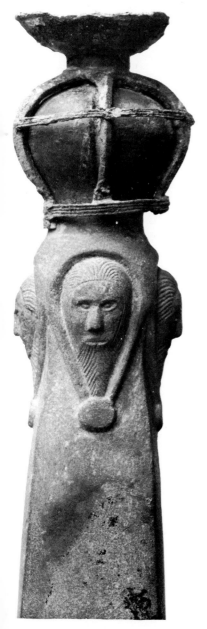
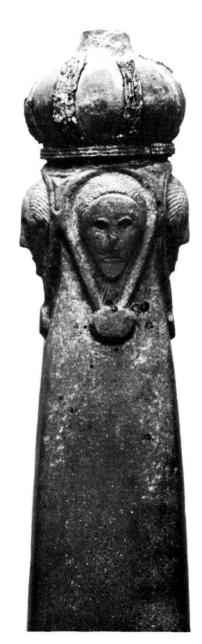

Mirror (page 46), and scepter or whetstone (details), from the ship burial at Sutton Hoo. Seventh century. From England. British Museum, London

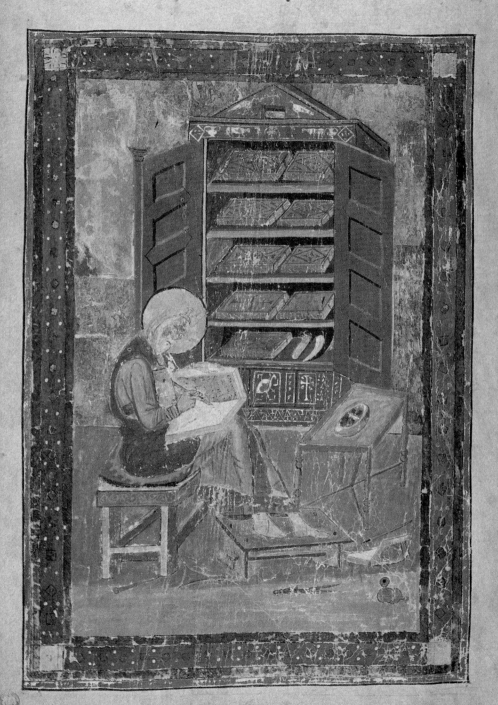

CODICIBVS SACRIS HOSTILI CLADE PERVSTIS
ESDRA DO FERVENS HOC REPARAVIT OPVS

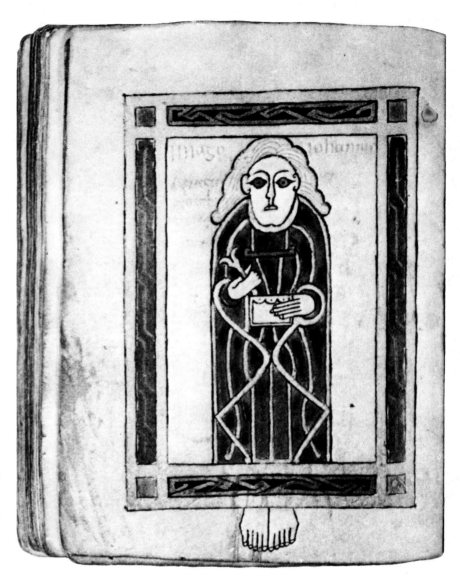

Toward the end of the seventh century, large-scale book illumination developed quite unexpectedly in the Irish-influenced Anglo-Saxon monasteries. Abbot Benedict Biscop of Jarrow and Wearmouth brought back from several journeys to Rome a number of relics and textiles, but above all, books, the greater part of them from the library of Cassiodorus. One of the copies transcribed then is preserved in the *Codex Amiatinus* (see opposite) which the abbot desired to give to the Pope and which remained in Italy after his death. The Late Roman pictorial world suddenly introduced into Irish Anglo-Saxon art in this way was expressed in simple, schematic human figures. A good example is the *Cadmug Gospel* (see above), owned by the missionary Boniface, who was later canonized. The activity of English and Irish missionaries in Germany also introduced this book illumination to continental monasteries and led to the formation of centers of widespread importance, particularly at Echternach and Trier.

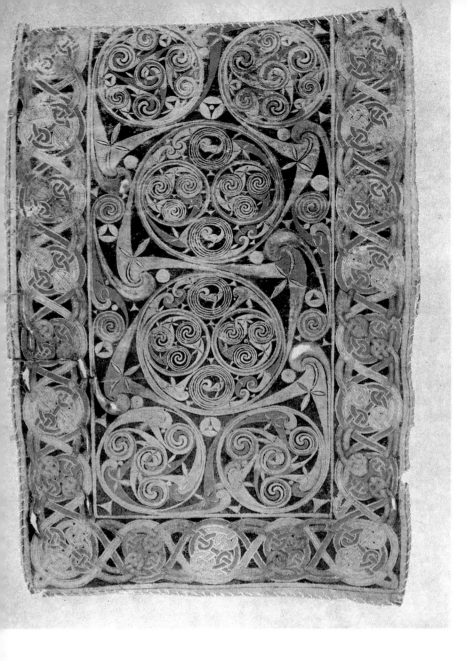

Book of Durrow. Second half of seventh century. Trinity College Library, Dublin

One of the most important artistic inspirations of Irish Anglo-Saxon illumination was the native late Celtic spiral and interlace ornament. The earliest of the great gospel books, the *Book of Durrow,* juxtaposes ornamental elements of different origins, while the coloring, as in most of these Gospels, is confined to interrupted areas of red, light yellow, and green, together with a brownish black. As in the *Book of Kells* (see opposite), human figures are interspersed in the abstract decoration.

Great initial pages alternate with full-page miniatures, either purely decorative (though possibly with a secret significance) or portraits of Evangelists. Various artists would share the work. Outstanding miniatures in the same style can be seen in the *Lindisfarne Gospels* and the *Echternach Gospels* (see over).

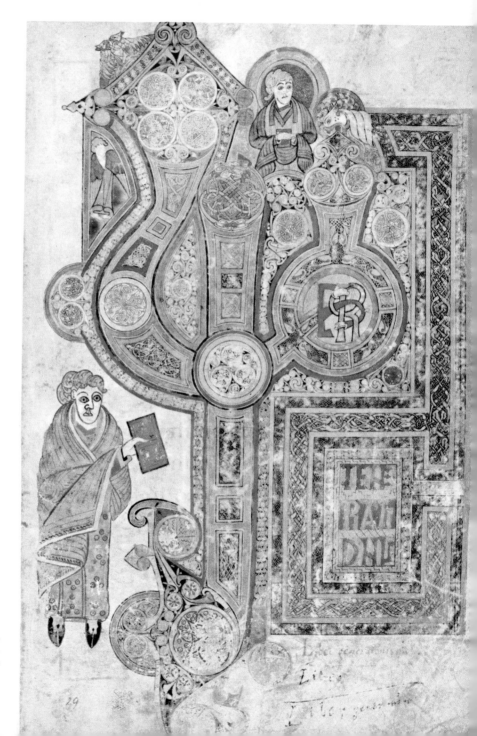

Initial page from the *Book of Kells*. c. 700. Miniature on parchment. 13³/₄ × 10⁵/₈″. Trinity College Library, Dublin, Fol. 29 r.

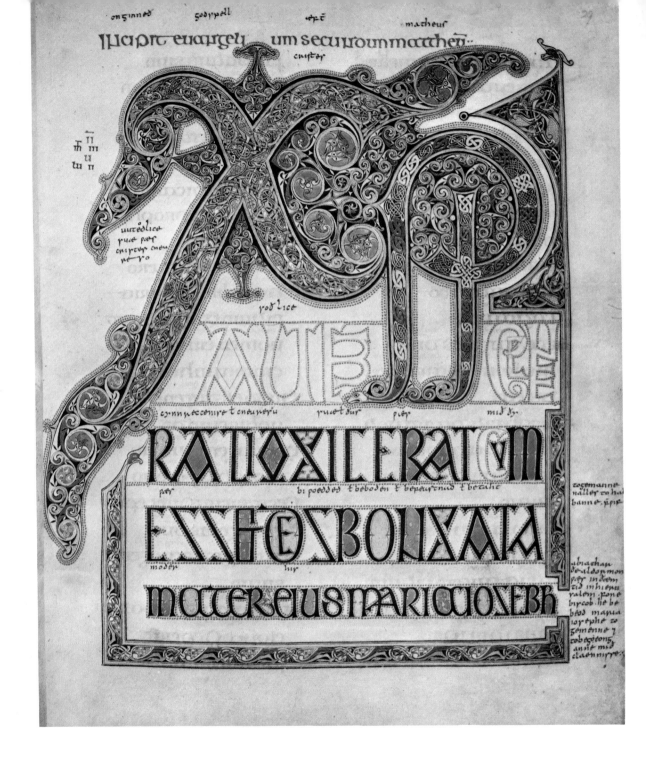

Initial page from the *Lindisfarne Gospels*. c. 700. British Museum, London

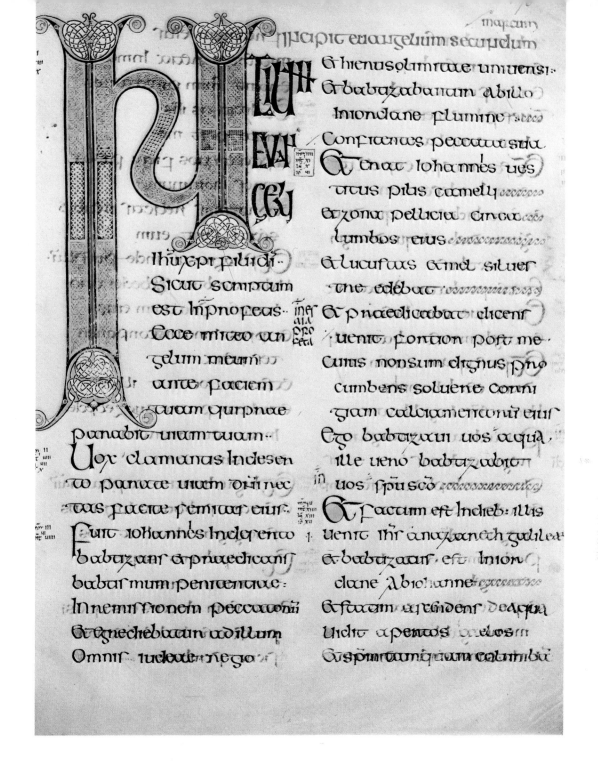

Page from the *Gospels of Echternach*. c. 690. Bibliothèque Nationale, Paris. Cod. Lat. 93 89

Thanks to a custom strange to our outlook today, a number of interesting works of gold and silver used as weapons survive in Schleswig-Holstein and Denmark. In the first five centuries A.D., votive gifts—weapons, utensils, and jewelry—were buried on behalf of a divinity in certain parts of a moor. A fertility cult has been suggested as the explanation for this. Of particular interest are the Germanic copies of Roman works, of which several were also buried.

Imported Roman works were the inspiration for the Germanic products, and particularly for the technique of chip-carving, sometimes in spiral patterns. The naturalistic Roman representations of animals were entirely transformed by contrast into fabulous, serpentine beings: their bodies were broken up into geometric elements and then connected together with very intricate bands of Mediterranean interlace. The animals were not only ornamental but no doubt also had a symbolic meaning which we do not know today. The sheath handle from Nydam Moor shows the characteristic combination of Late Roman techniques with the new animal style, in which the forms are emphasized with niello work.

Sheath handle. Fifth century. Silver, niello and chip-carving, height 6¹/₄″. From Nydam Moor. Schleswig-Holsteinisches Museum, Schloß Gottrop

In the 1880s, several ship burials were discovered during excavations to enlarge the cemetery at Vendel. They had been partly destroyed in ancient times and to some extent plundered. The rest of the surviving, unusually rich offerings were better preserved in the ship graves than they would have been in fire graves, since the heat of a funeral pyre could not damage them there. The custom of ship burials presumably did not begin until the so-called Vendel Age. In grave 12 the corpse was buried together with horses and other domestic animals. The belt mounts of bronze gilt, illustrated here, are among the best works of their kind. They were cast, then worked with the graver, and sometimes decorated in niello. The rich animal ornament on the mounts reveals certain Anglo-Saxon influences.

Above and below. Belt mounts. Bronze gilt. Seventh century. From Vendel. Statens Historiska Museum, Stockholm

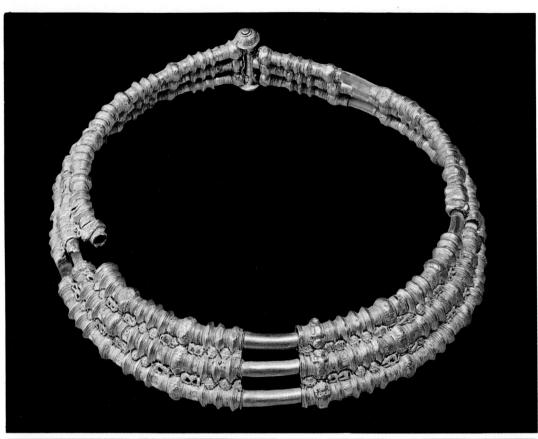
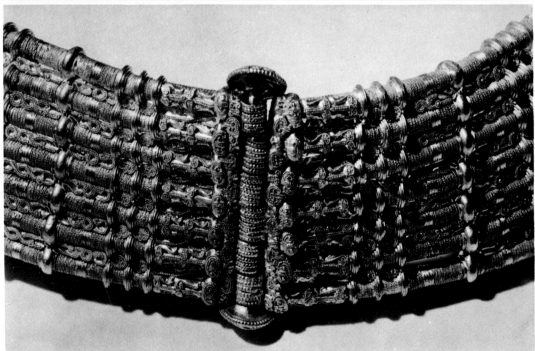

Gold collar. Sixth century. Diameter 8″. From Alleberg. Statens Historiska Museum, Stockholm

We owe our knowledge of the art of the Germanic gold- and silversmiths in the North almost entirely to diggings. In many cases wars may have caused the owners to bury their belongings; they later found no opportunity to recover them, so they have come to light by chance today. Among the most important examples of Northern jewelry are the Swedish gold collars. The collar from Alleberg (opposite) is formed of three ribbed, filigree tubes separated by animals, human figures, and masks. The Möne collar (below and below left) is formed of seven rings and, here too, squat little figures nestle between them. Thanks to the use of filigree, and granulation—a technique where delicate wires and little balls are welded to the rings—the light is broken up into a thousand fragments, bringing the beauty and brilliance of the noble metal wonderfully to life. No doubt contemporaries attributed magic powers to these outstanding works, as is suggested by the figurative images. Today, it is their incredible delicacy which chiefly amazes us.

Gold collar. Sixth century. Diameter 9″. From Möne. Statens Historiska Museum, Stockholm. (Below opposite, detail)

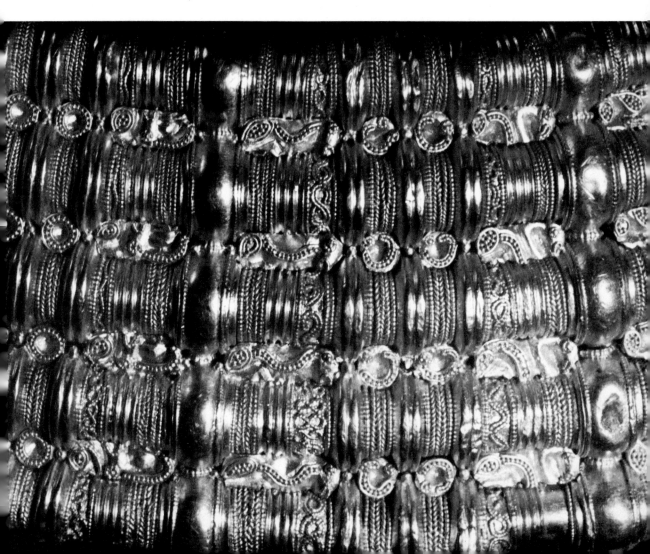

The splendid columned basilican style endured longer in Rome than in most parts of the former Roman Empire. In these churches, at first sight giving such an impression of uniformity, the builders reused columns from diverse ancient sites. In this way they brought variety to the rhythm of their arcades—the heights of the columns are noticeably different. Stonework from pagan buildings, particularly columns, often caught the fancy of the early medieval masters, and sometimes its reuse even had a schematic character, as in the case of the Ravenna columns brought to Aachen to symbolize the continuity of the Roman Empire with the empire of Charlemagne. Churches such as San Giorgio also show how the basilican form taken over from Antiquity became a model which the Early Middle Ages eventually made its own.

San Giorgio in Velabro, Rome. 827–44

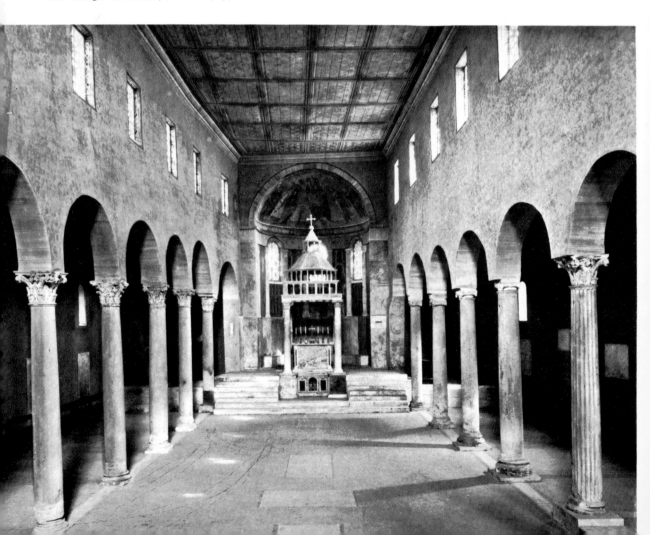

Saint Andrew. Early eighth century. Fresco in Santa Maria Antiqua, Rome

After the expulsion of the Goths by the Byzantines, the Virgin suddenly appeared everywhere as the patron saint of new churches. Pope John VII (705–7) commissioned a number of frescoes for the presbytery of the church of Santa Maria Antiqua on the Palatine. It is noteworthy that he summoned Byzantine artists for this. The remarkable colored medallions with portrait of the Apostles are the last Byzantine paintings in Italy still surviving. Works of this kind must have impressed Charlemagne, since he keenly encouraged the decoration of transalpine churches with paintings.

Saintly Deacon. c. 817–24. Mosaic (detail) in the apse of Santa Prassede, Rome

Pope Paschal I. c. 817–24. Mosaic ▶ (detail) in the apse of Santa Prassede, Rome

It was not only in the Frankish North that mosaic work was encouraged, thanks to Charlemagne. It was revived in Rome, too, at the beginning of the ninth century, particularly in the decoration of the church of Santa Prassede by Pope Paschal I. The apse is radiant with a heavenly landscape showing Bethlehem and Jerusalem. Between the towns stand the thirteen lambs, the Lamb of God above the rivers of Paradise, and Christ descending from the clouds. Among the saints, one may note the stern impressive figure of the young deacon, whose features contain something of the keen fervor of the times. The donor, Pope Paschal I, holding a model of the church and with the square nimbus of the living, is depicted with the same expressive force and emanates the same solemn dignity. In spite of the overall conservatism and hieratic conception, this Roman work shows the high level mosaic art could still attain in Carolingian times.

Perhaps the increased interest in the Carolingian Empire also inspired the Romans to turn to wall painting again. In these fragments of an Ascension, the rich language of gesture and demeanor of the Early Middle Ages has entered the world of classical tradition. The figures of the Apostles are an interesting fusion of classical monumentality and agitated modern lines. The donor, Pope Leo, a figure of convincing dignity, holds a large Bible, and the assurance of an age of faith speaks from the inscription: "That this painting outshines all others in beauty is thanks to the priest Leo, who fashioned it with zeal." Today the better preserved cartoon makes the compositional structure more evident; the former rich color has faded to a few red or gray tones.

Fragments of an *Ascension of Christ*. c. 850. Lower church, San Clemente, Rome

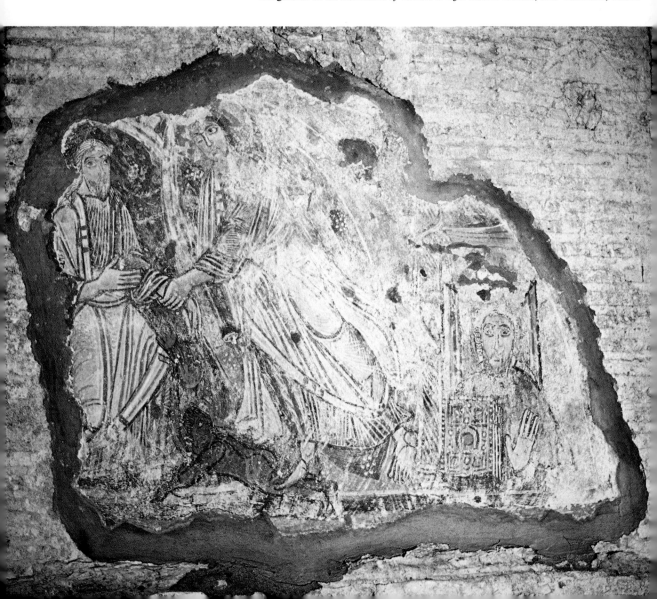

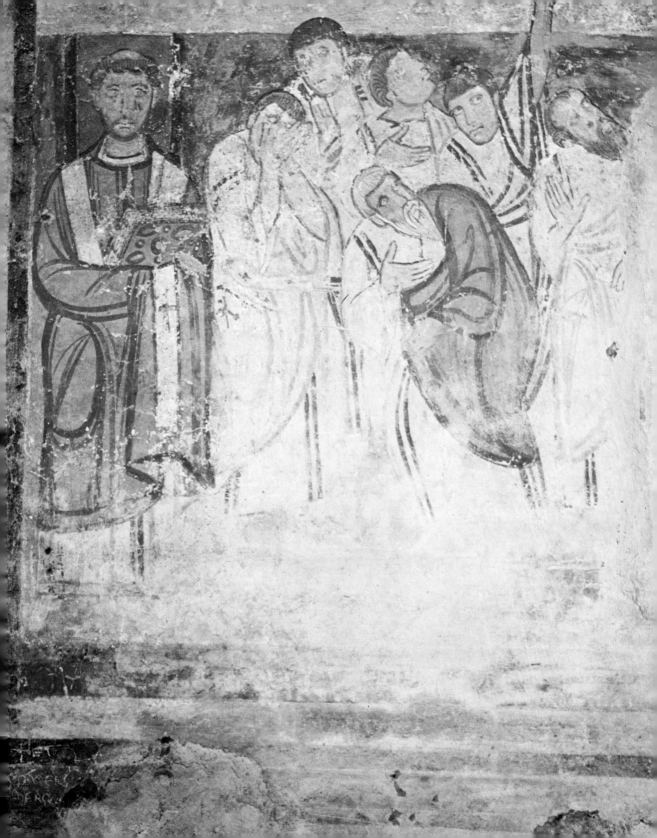

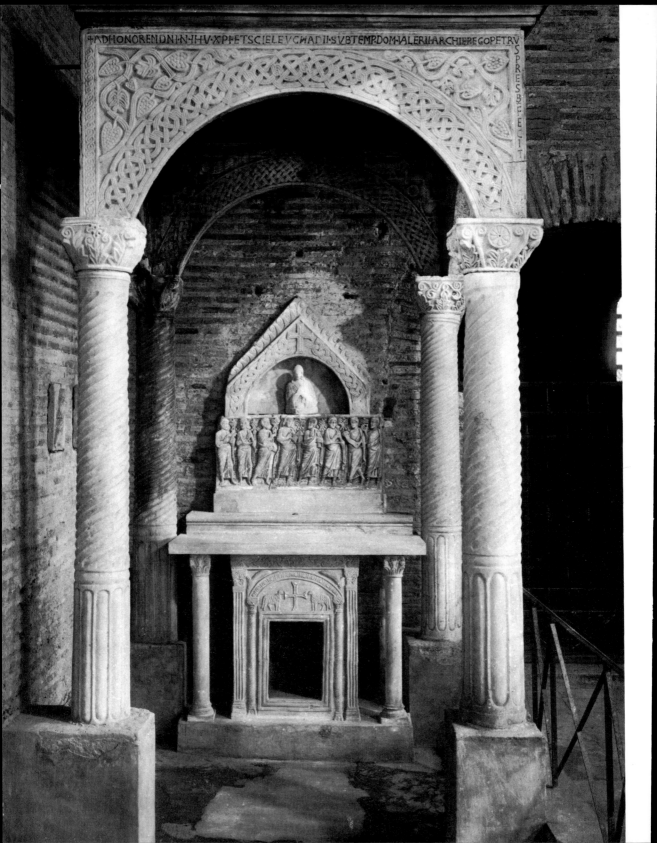

◀ *Ciborium of Eleucadius.* Early ninth century. San Apollinare in Classe, Ravenna

In Italy, even in pre-Romanesque times, one often finds a stone altar canopy in the form of a baldachin resting on pillars. Originally, curtains hung between the columns and the superstructure concealed vessels for the sacred elements. The Ravenna ciborium altar (opposite) was made under Archbishop Valerius, and is richly decorated with foliage and triple bands of intricate interlace work in low relief. Little figurative art survives from this era, and so it is only from works of this kind or from the numerous altar panels that we can form an idea of the visual arts at that time. The panel from Aquileia is a clear example of the love of strict order. Animal forms on the Byzantine model, with symbolic Christian significance, appear in the panels within the framework.

Panel from screen. Cathedral, Aquileia

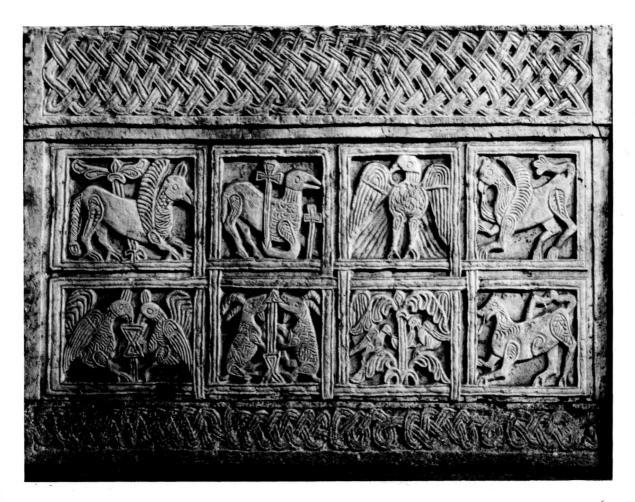

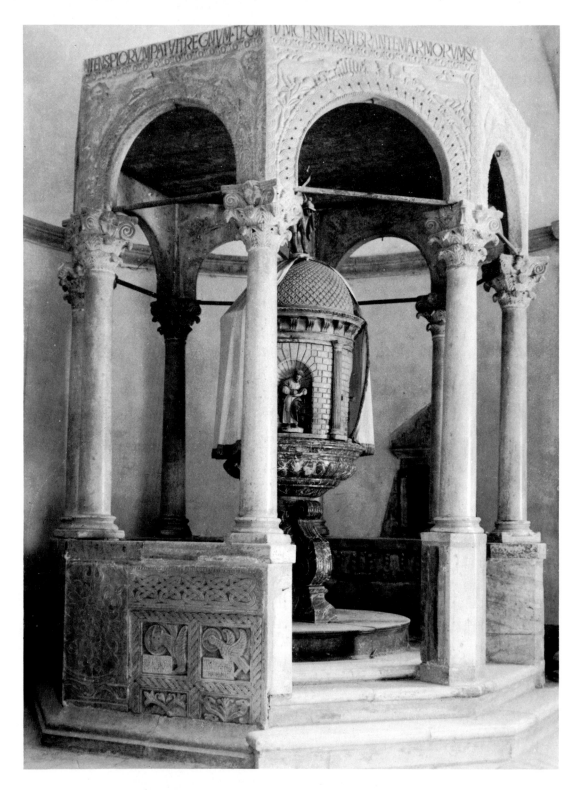

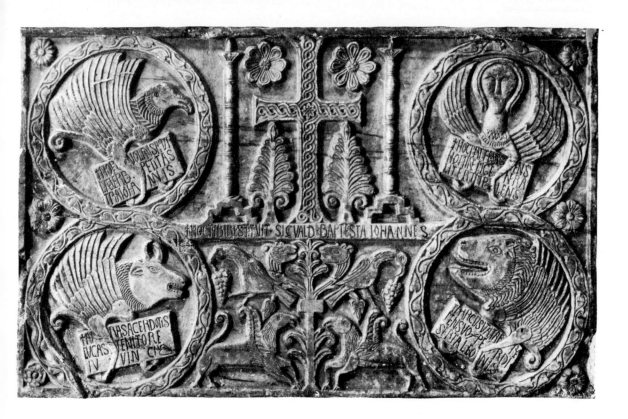

Sigwald Relief. Third quarter of eighth century. Part of the canopy over the font. Cathedral, Cividale

There were other cultural centers in northern Italy besides Ravenna, particularly in the Lombard domains, which produced very interesting works in low relief. We can date the ciborium above the baptismal font, fashioned in symbolic octagon shape by the patriarch Calixtus, through an inscription. Classical columns, very like those in the so-called *Tempietto*—also in Cividale—support the arches which are emphasized by foliage patterns and by the grape and vine tendrils so beloved of early Christian art. The line of one of the arches is emphasized by interlace work. When the patriarch Sigwald had to restore the columned baldachin, he gave a panel showing the True Cross as the symbol of everlasting life, above a tree with eastern griffins and doves—a motif taken from textiles. It is surrounded by expressive, primitive medallions with the symbols of the Evangelists.

Ciborium above the baptismal font. Cathedral, Cividale

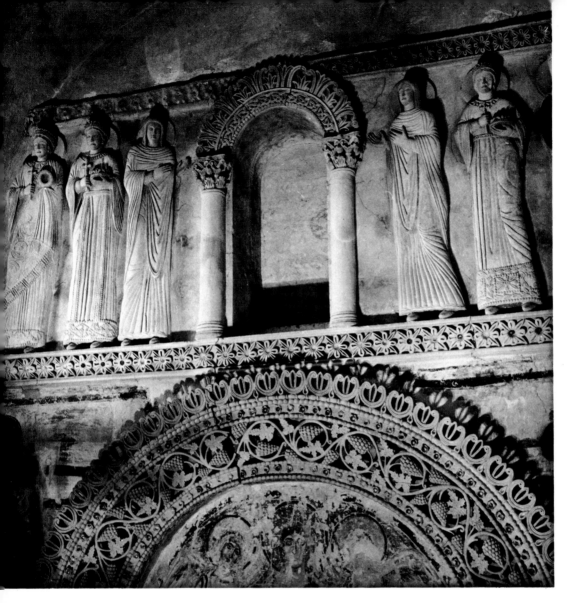

Six female saints. Eighth century. Stucco on the interior entrance wall of Santa Maria-in-Valle, Cividale (so-called *Tempietto*)

This small, almost square, church contains a valuable stucco frieze of six female saints. They stand in a solemn row, some in regal dress, and the style is reminiscent of ivories. They are among the very rare surviving specimens of human figures in early medieval architecture. Equally remarkable is the high standard of the rest of the stucco work, particularly on the arch with its pattern of vines and grapes. The small church probably dates from the time when the city was the seat of the patriarch Calixtus of Aquileia and became the ecclesiastical center of northern Italy. Carolingian influences only appeared later, when Charlemagne took over the kingdom of the last of the Lombard kings, Desiderius, in 774, and held him prisoner in Corvey. Of the surviving

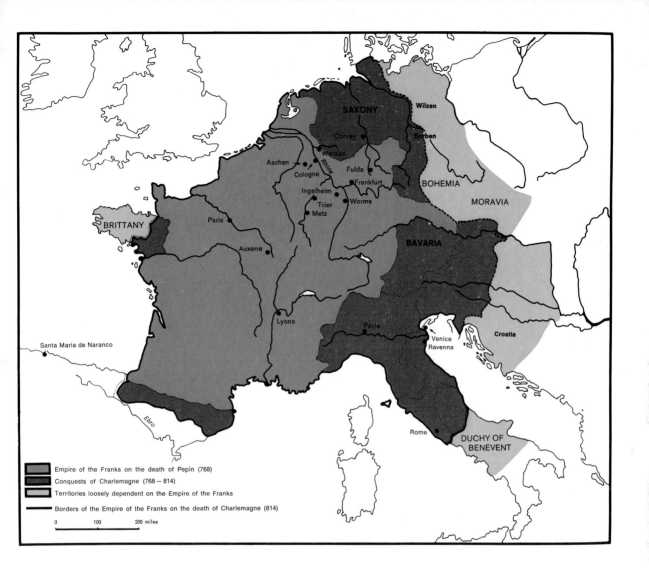

SAXONY

Wilzen

Corvey

Serben

Werden

Aachen

Cologne

Rhine

Fulda

BOHEMIA

Frankfurt

Ingelheim

Worms

MORAVIA

Trier

Metz

Paris

BRITTANY

BAVARIA

Auxerre

Santa Maria de Naranco

Lyons

Pavia

Venice
Ravenna

Croatia

Ebro

Rome

DUCHY OF
BENEVENT

Empire of the Franks on the death of Pepin (768)

Conquests of Charlemagne (768 – 814)

Territories loosely dependent on the Empire of the Franks

Borders of the Empire of the Franks on the death of Charlemagne (814)

0 100 200 miles

Central Europe at the Time of Charlemagne

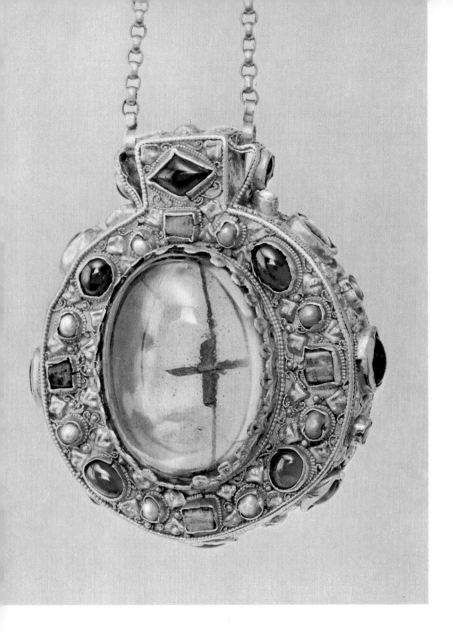

Talisman of Charlemagne. Ninth century. Chased gold in filigree, with precious stones, and pearls, $2^7/_8 \times 2^1/_2''$. Cathedral, Reims.

goldwork from the time of Charlemagne, only this pendant reliquary can be ascribed with some certainty to the Emperor himself. According to an old tradition, Otto III found it round Charlemagne's neck when he had the grave opened in 1000. Like the Germans, the Carolingians attributed magic powers to gold and precious stones, which is why they are found particularly often on reliquaries. The two large central sapphires in the form of a pilgrim's flask from the Holy Land, one of which is now replaced by glass, originally contained hair of the Virgin; today they contain a particle of the True Cross. The rich, capsular filigree setting in gold is inlaid with a regular pattern of garnets, emeralds, and pearls; to them sapphires and amethysts are added on the narrow sides. The style and technique are similar to that of the portable altar of Arnulf (see page 131).

Equestrian statue of Charlemagne (?). Ninth century. Bronze, height 9½″. From the cathedral treasury, Metz. The Louvre, Paris

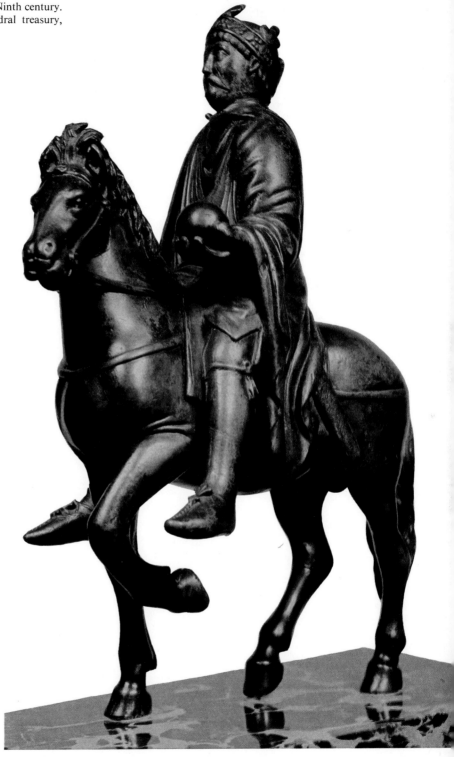

This bronze statuette (cast on its own in several parts) on the model of Roman equestrian statues, is believed to represent the Emperor Charlemagne. It still shows traces of gilding. The Frankish dress corresponds to a description by Einhard; the round style of the head is very similar to some of the medallion coins of Charlemagne.

The mustache, the wreath of lilies, and the form of the sword sheath are characteristic of a Carolingian ruler. This work, whose origins and occasion are quite unknown, was probably made only after Charlemagne's death. The distinctly Roman horse suggests the late period of the Court School under Charles the Bald, especially since the representation of a globe first appears in portraits of this Carolingian ruler. It may have been a commemorative statue, an idealized image of the first Western Emperor, if not an authentic portrait.

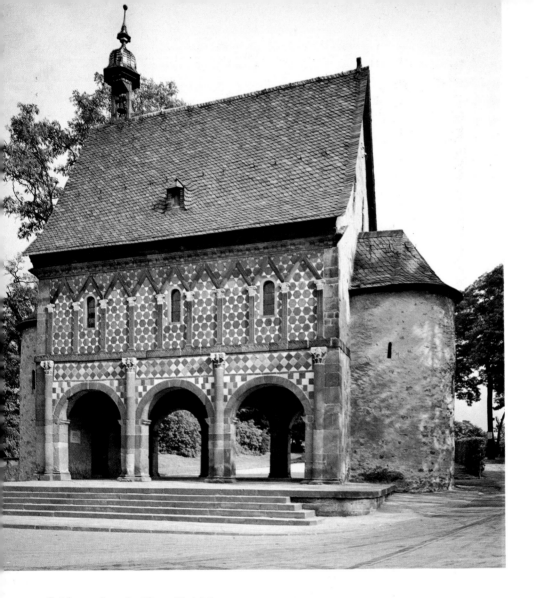

Gatehouse, Lorsch. After mid-eighth century

The gatehouse at Lorsch, in the unique form of an ancient Roman triumphal arch, stands before an extended atrium leading to the main door of the former abbey church of Saint Nazarius. The simple building is flanked by two partly reconstructed staircase turrets giving access to the chapel of Saint Michael on the upper story. The facade, however, is elaborately ornamented: massive half-columns support the entablature, above which rise pilasters culminating in triangular gables. Behind these architectural features, uniform rows of variously shaped red and white plaques cover the walls, giving a surface of bright and quite unclassical contrasts.

Perhaps after the example of San Vitale in Ravenna (dedicated 546–47), which—as his transfer of the equestrian statue of Theodoric perhaps proves—was certainly well known to Charlemagne, the palatine chapel at Aachen arose as an octagon with a sixteen-sided ambulatory round it. A mighty westwork, flanked by two round staircase towers, thrust forth from the central mass of the building. It had a vestibule, and in its upper story, a gallery for the imperial throne with a small rectangular eastern altar space opposite. To the north and south lay side chapels, and to the west an open atrium from which a two-storied gallery led to the living quarters of the palace. Today, the Gothic additions make the original Carolingian work, with its rough undressed stone walls relieved on the upper story by no more than classical-style pilasters at the angles of the octagon, seem comparatively modest from the outside.

Aachen palatine chapel (exterior). 790–805

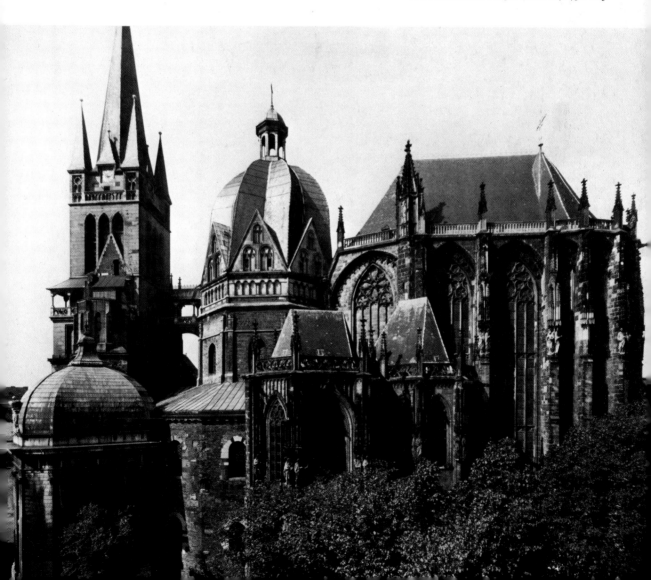

The main entrance is the so-called *Wolf's Door*. The two enormous bronze leaves of the door were each cast as a piece. Profiled frames, inset with classical ornaments and arranged in four rows, organize the surface into rectangular coffers; lions' heads serve as handles. Since remains of the casting workshop have been found, it is certain that the doors were made at Aachen, though the origins of the casters are unknown. Just as the Imperial coronation sealed the entrance of the Empire into the political heritage of the Roman Empire, so it may be said that the relatively high stylistic and technical assurance of these Aachen bronze works marked the resumption of an imperial art in a way that contemporaries saw as only fitting in the city they already considered the new Rome.

Aachen palatine chapel (interior) ▶

In the interior (right), the octagon, surrounded by walls four and a half feet thick, for the most part arcaded, measures almost a hundred feet up to the crown of its cupola. Each of the eight sides has two main arches one above the other, both rising from great piers. They are separated from each other by a heavy molding projecting at the upper story level. Within each of the upper arches, there are two pairs of columns, in part spoils from Roman times, placed one on top of another. The lower two columns are linked by three smaller arches in a kind of bridge, on which stand the upper two. This motif was unknown in Antiquity and is also absent at Ravenna.

Main entrance to Aachen palatine chapel

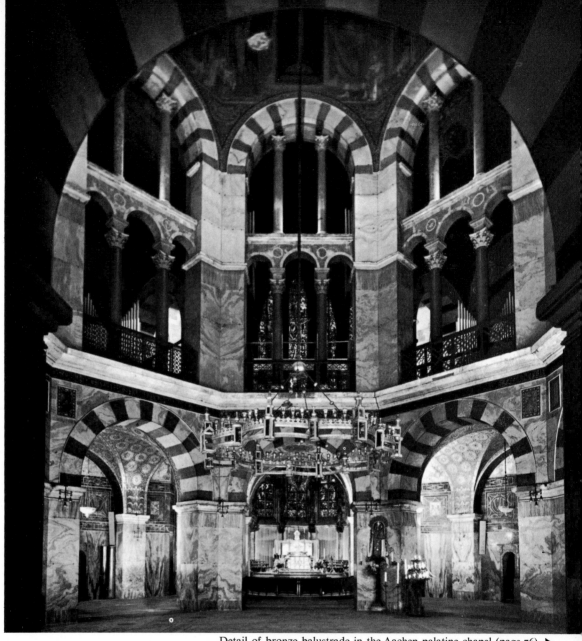

Detail of bronze balustrade in the Aachen palatine chapel (page 76) ▶

Throne of Dagobert. Cabinet des Médailles, Paris (page 77) ▶

The details themselves on the bronze balustrade at the upper story level become more and more classical in form, culminating in a very delicate acanthus pattern. Presumably the so-called *Throne of Dagobert* comes from the same workshop. The Aachen palatine chapel is a very rare example of a structure of the Dark Ages which goes on being repeated elsewhere until the eleventh century. It is the copies which clarify the special qualities and symbolic importance of the Aachen masterpiece: indeed, the palatine chapel seems to have represented perfection to contemporaries.

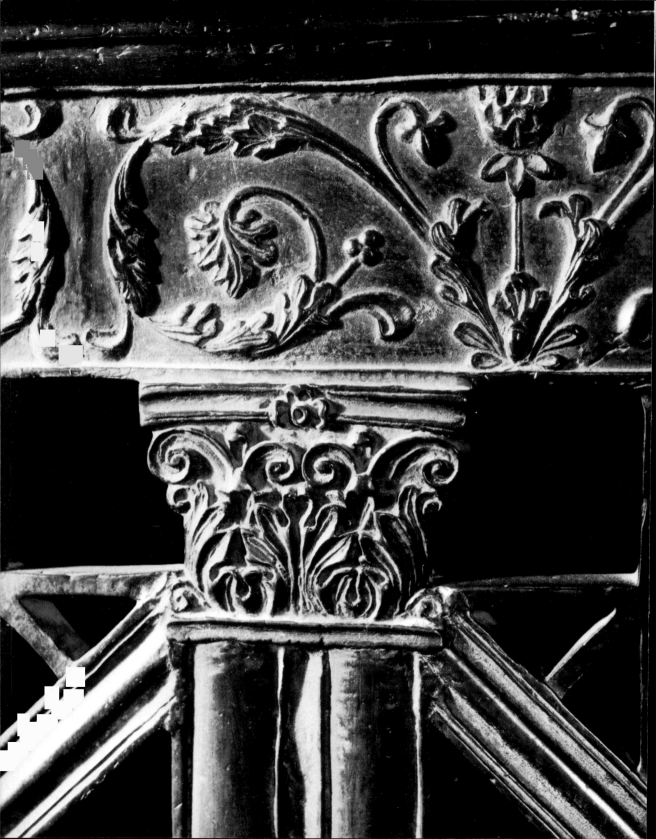

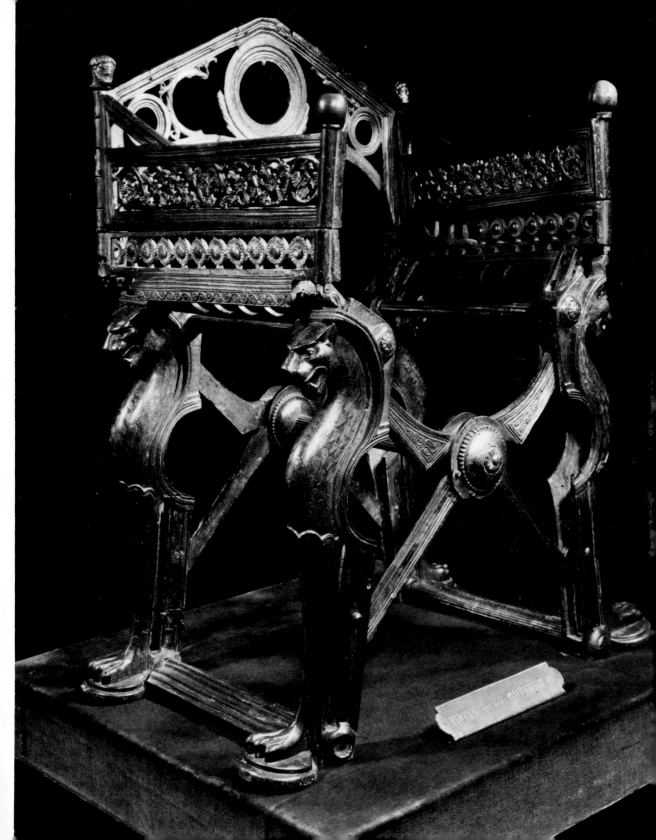

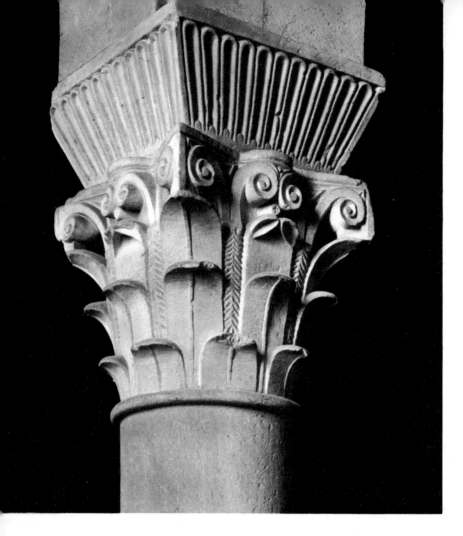

Capital in the church of Saint Justinus, Höchst. Second quarter of the ninth century.
Limestone

The church of Saint Justinus at Höchst, of which Archbishop Otgar of Mainz is said to have been the builder, stands out among the few surviving Carolingian basilicas by the magnificent ornamentation of its capitals. The Corinthian capital was still the model, as is shown by the way the tongue-shaped leaves with central ribs rise one above the other on the four sides. Narrow chip-carved grooves surround the upper sides, and volutes furl out from them at the edges and in the center. The capital is surmounted by relatively high, trapezoid, grooved abutments. The remarkably smooth treatment of the stone and the delicacy of the work show Carolingian art in an almost classical phase where details from models were not just copied but were simplified into new key motifs.

The present appearance of Aachen Cathedral disguises the original significance and position of the westwork. This is not so in the case of the former abbey church of Saint-Riquier. Angilbert, abbot of the monastery and secretly married to Charlemagne's daughter Bertha, built the three-aisled basilica with its eastern transept and crossing tower, as well as a long sanctuary corresponding to a similar westwork, in place of an older building. We do not know how the interior of the westwork looked, for written sources tell only of its liturgical purpose; apparently the patron of the church was worshiped in the eastern choir, and the Saviour in the sanctuary on the upper level of the westwork. Perhaps this building became the model for other similar churches, partially revealed in ground plans, the significance of which has not yet been fully explained. Evidently it had various functions, the most obvious of which was its use by the Emperor on visits to the abbey, or as a place of worship for a further saint as well as the Saviour.

Former abbey church of Saint-Riquier in Centula. Second building, 790–99. Engraving of 1612 after a drawing by Petau in the chronicle of the monk Hariulf. Bibliothèque Nationale, Paris

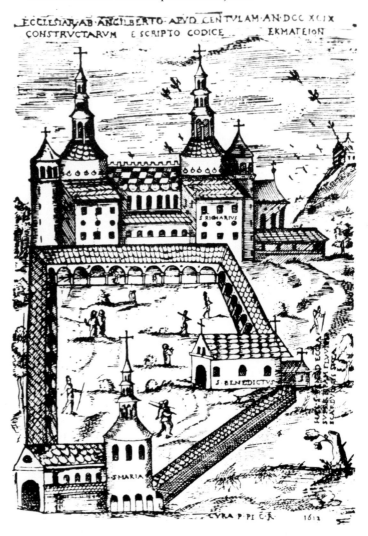

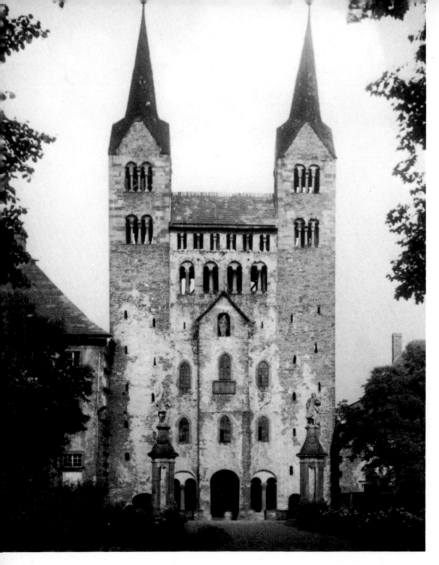

The westwork of the abbey church of Corvey is the only surviving example of its kind. Its present appearance is very different from the original, yet it gives a good idea, having been restored, of the impressive effect a great Carolingian church must have had. Formerly there was a central tower flanked by a pair of lower towers raised in Gothic times. As at Aachen, there was an atrium in front of the church. A narrow projection, with twin windows on either side, contains the entrance portal opening onto a small hall. Four columns with Corinthian capitals carry the low vault of the ante-church—a square structure flanked by narrow corridors to the north and south—while the eastern corridor running between the westwork and the main body of the building is somewhat wider, giving access to the church itself and to the upper level of the westwork. The space of the upper level is divided up in the same way as below, though this time there are two stories and a number of arcades in the walls. The western projection on the exterior forms part of the westwork, but its first-floor opening and floor level go down deeper. The sparse architectural decoration and the magnificent capitals show traces of painting, the scheme of which can only be guessed at now. This loss makes all the more difference because it was only through painting that the original architectural conception really came to life.

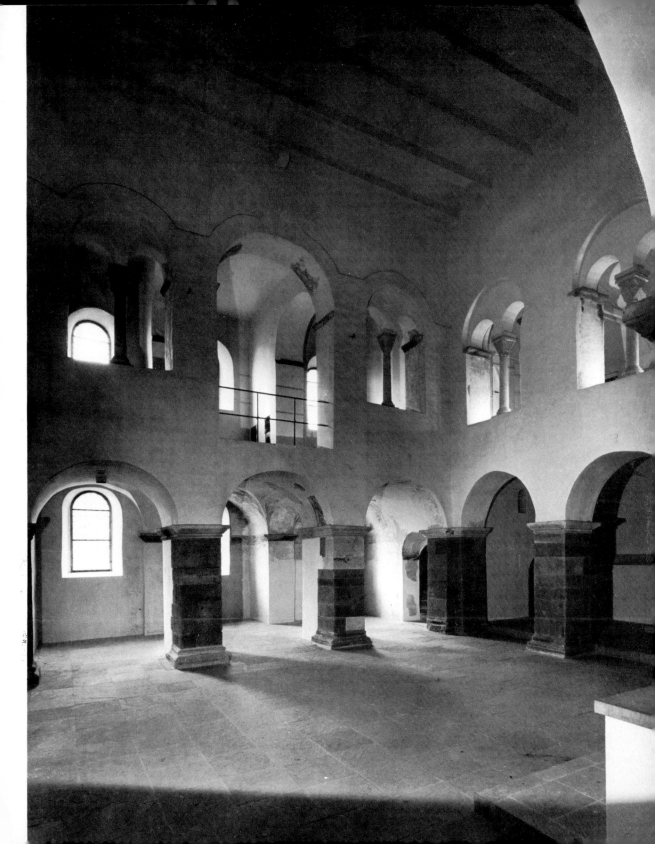

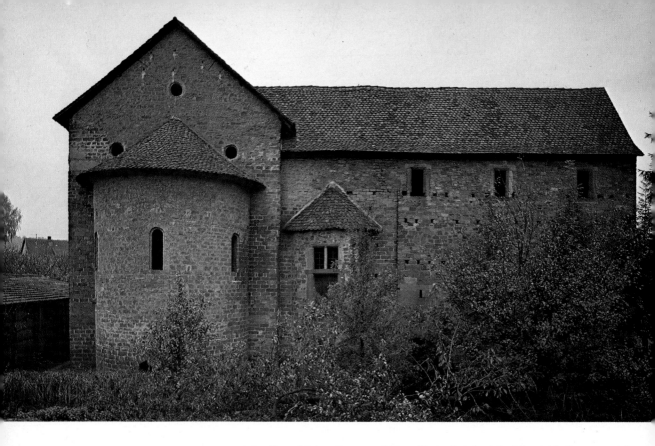

Basilica of Saints Petrus and Marcellinus, Steinbach in Odenwald. Consecrated 827

Most Carolingian churches are now destroyed, and all that we know are the ground plans from diggings or from the later, much changed forms. So the church at Steinbach is very important, since it was only partly destroyed and few later alterations were made. It was built by the Emperor's biographer, Einhard, who had relics of the two martyrs Peter and Marcellinus brought to it from Rome.

In Frankish architecture the basilican form is not to be taken as a matter of course, for hall churches were to be found spread all over Spain, France, and Italy. A cross section of Einhard's basilica shows a complicated spatial arrangement. The nave is still intact with, on either side, six square·piers, and, above simple abutments, round-arched arcades beyond which were flanking aisles, now destroyed. To the east, beyond traces of an encompassing arch, lies a semicircular apse. The two easternmost arches of the arcades on either side are larger since they each originally led to a bay with an apse. From the outside these look somewhat like transepts and are lower than the nave because of the transverse slope of their roofs, though higher than the aisles would have been. Since there used to be three porticoes to the church, it must have had remarkably varied lines. The exterior shows no treatment in the sense understood in later Romanesque architecture and thus is a little like the palatine chapel at Aachen. It is reminiscent of the church of Saint Alban in Mainz. In the interior, the use of brick pillars on the Roman model, instead of the columns found in early Christian basilicas, clearly emphasized the masonry of the wall. They thus became an essential part of the structure—hence why they were so much a cherished part of later architecture.

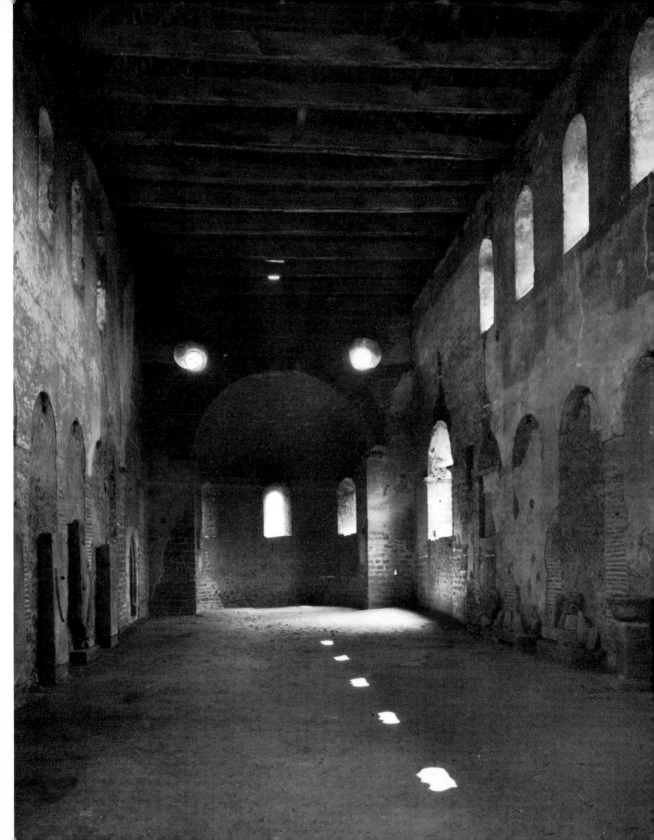

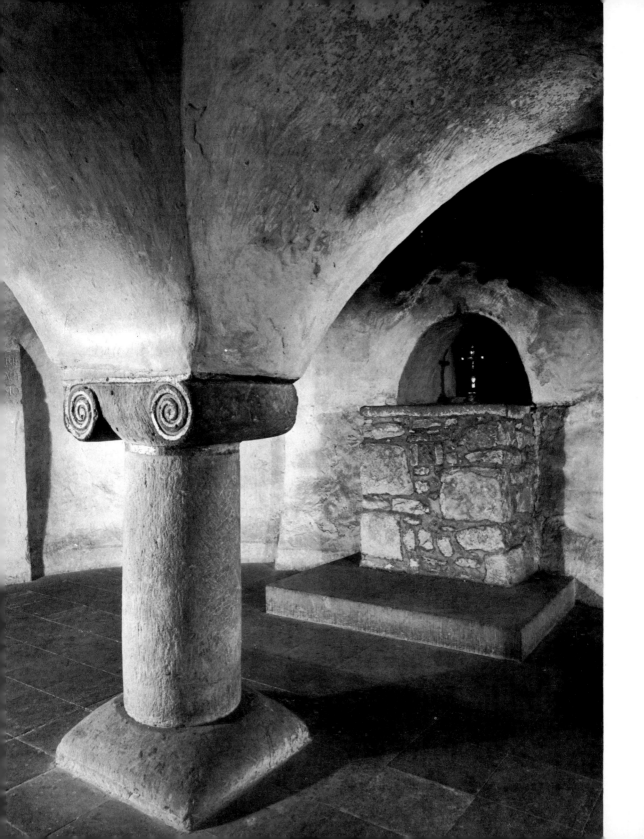

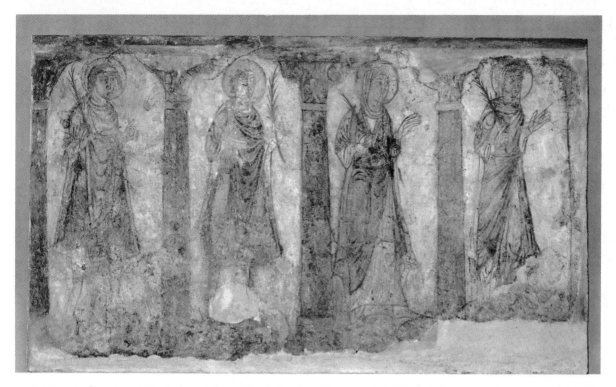

Procession of Martyrs. Late ninth century. Wall painting from the crypt of Saint Maximin, Trier. Diocesan Museum, Trier

The main churches of the ninth and tenth centuries imitated Aachen in their polygonal ground plan, but the former cemetery chapel of Saint Michael in Fulda, built by Abbot Eigil in 820–22, follows the early Christian type of round burial church. We can perhaps view it as the earliest representation on German soil of the Ascension Rotunda of the Holy Sepulcher. Unfortunately only the crypt remains. In the center, a short column with a sturdy Ionic capital supports the vault. This has been interpreted as being symbolic of Christ carrying the universe. A vaulted ambulatory with four entrances surrounds it, and the tomb of Eigil lies behind the eastern altar.

According to written records, the Carolingian age must have produced extensive cycles of wall paintings, but only fragments survive. The cycle discovered at Trier in 1917, in a subterranean late classical memorial chapel beside paintings of the profession of faith of the canonized bishops Nicetius, Agricius, and Maximius, is the best-preserved in Germany. A painting of the Crucifixion, with figures of Mary and John, Stephaton and Longinus, was found behind a block altar, flanked on either side by a procession of four martyrs between painted pillars. Also on the vaulting were figures of Evangelists and prophets amid sham architecture. The smaller than life-size, dignified, and deliberately traditional figures with expressive gestures are drawn with emphatic lines and are typically medieval in appearance. The color is predominantly ocher, typical of Carolingian painting.

Chapel of Saint Michael, Fulda. 820–22

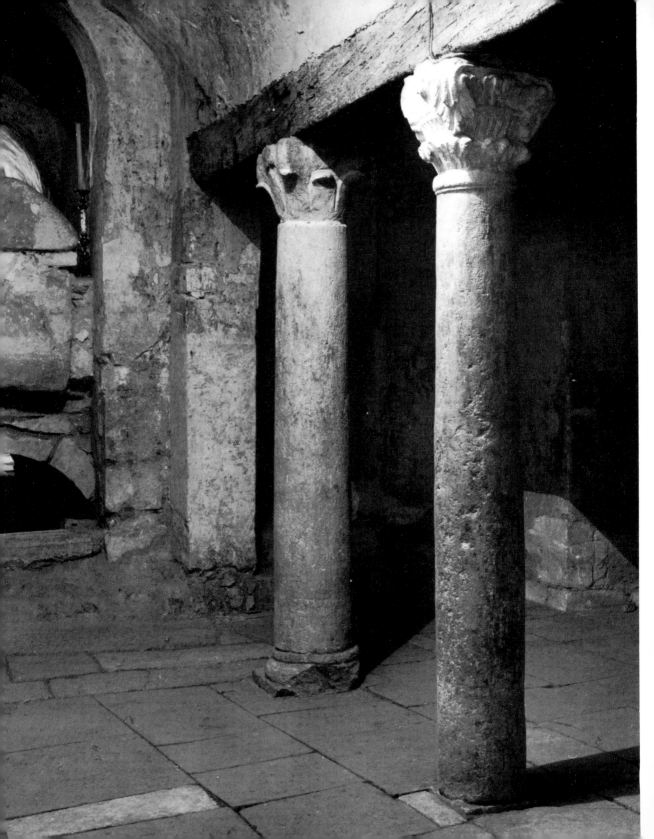

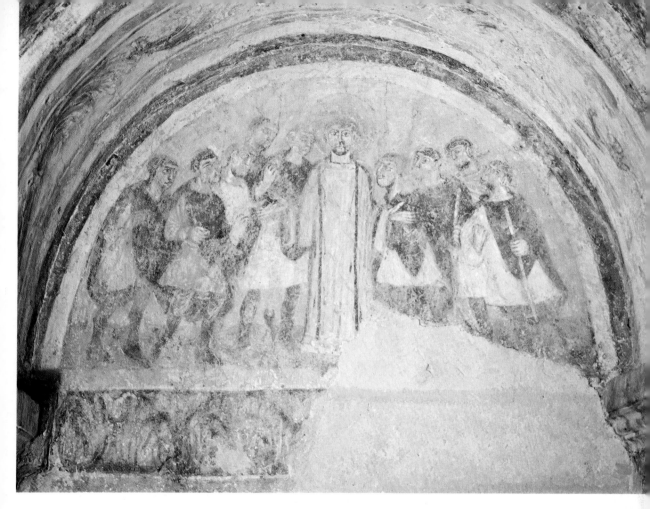

Saint Stephen Assailed by the Sanhedrin. Mid-ninth century. Wall painting in the crypt of Saint-Germain, Auxerre

From early Christian times, crypts—subterranean places of worship—had served for the special and individualized veneration of saints whose remains were often buried there. Several types of crypt developed in Carolingian times, among which the hall crypt pointed to the future. At Auxerre, four columns divide a barrel-vaulted hall into three aisles; to the west a likewise barrel-vaulted transverse area adjoins it, originally containing the sarcophagus of Saint Germanus and connected to the choir by a *fenestrella*. The whole is surrounded by an ambulatory also accessible from the choir. After a fire, the space with the saint's tomb was extended and the hall part itself became a burial chapel.

In the great lunettes depicting scenes from the life of Saint Stephen, Carolingian art, in its far-reaching renunciation of spatial illusion, achieved a new quality. The painting now seems to adhere more closely to the wall, and its expressive power comes from its connection with the surface. Saint Stephen is shown standing in the center wearing the white dalmatic of the deacon, an unfrightened and impregnable figure, while nine members of the Sanhedrin assail him. The other lunettes show Stephen before the high priest and during his martyrdom. Splendid foliage work enhances the surrounding architecture.

Crypt of the former abbey church of Saint-Germain, Auxerre. 841–859

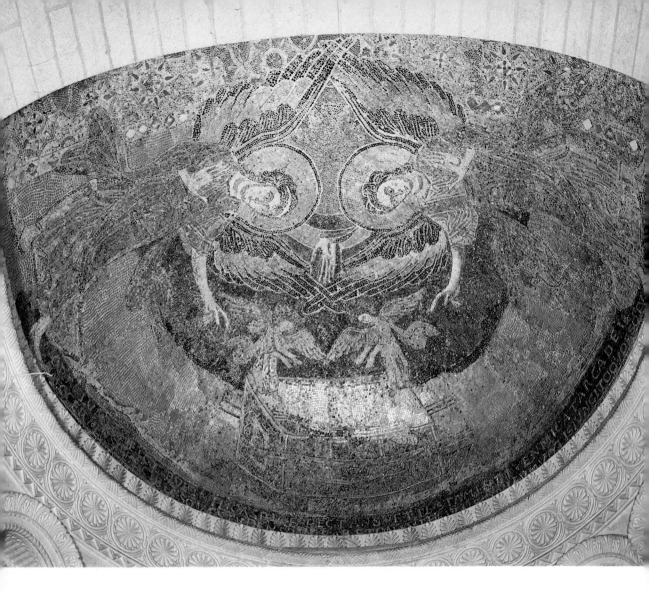

The Ark of the Covenant. c. 806. Mosaic in the apse of the palatine chapel of Theodulf, Germigny-des-Prés

The dome mosaic in the Aachen palatine chapel, which was entirely altered during the Emperor William I's time in the nineteenth century, is a work which Charlemagne no doubt commissioned as an act of reaffirmation and revival of the Christian tradition of Italy. We have another work of this kind in the palace chapel of his colleague, Bishop Theodulf of Orléans. The focus of attention in the picture is the Ark of the Covenant suspended against a blue heaven filled with golden stars, and flanked by two small golden cherubim with, over them, two large angels in classical dress. The hand of God, breaking through a garland of golden rays between the angels, points to the Ark. Far below where the donor's inscription is, the bishop has inscribed his own name. The composition of this apse mosaic reflects the official Imperial attitude to the Byzantine iconoclastic dispute, adopted by Theodulf, in a fashion difficult for us to grasp today.

Theodulf believed that pictures fashioned by the human hand ought not be worshiped, since the only work of art inspired by God was the Ark, while the Byzantines, on the contrary, saw the Ark as Old Testament evidence of the worship of images. Stylistically the mosaic is related to several miniatures by the Court School, which agrees with written sources connecting it with the Aachen palatine chapel.

In Asturias, where the Visigoths retreated, a solitary Christian Kingdom endured during the Carolingian age, despite Arab rule over the Iberian peninsula, from which a relatively compact group of buildings has survived comparatively unharmed.

Beside the road through the pass of León, lies the small church of Santa Cristina de Lena. Its narrow mass strives up aloft and the the interior is surprisingly rich with its series of blind arches round the walls, rising from different types of columns and complementing the transverse arches of the barrel vault. On the eastern narrow side, the chancel is raised up beyond an arcade of three arches separating it from the central space. To the west is a gallery. Numerous types of ornament, including chip carving and plaited work, decorate this church. Its unique form and outstanding ornament illustrate many of the trends within pre-Romanesque art.

Santa Cristina de Lena. Interior to the southeast. Mid-ninth century

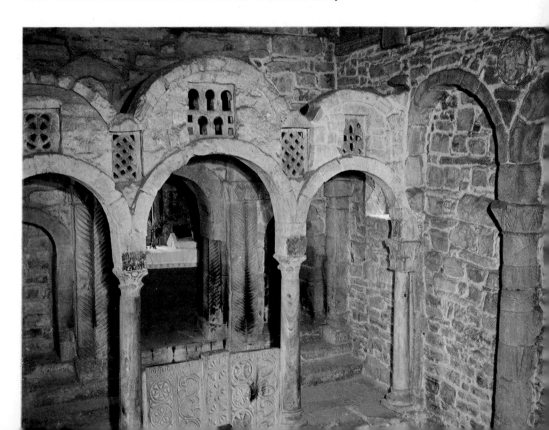

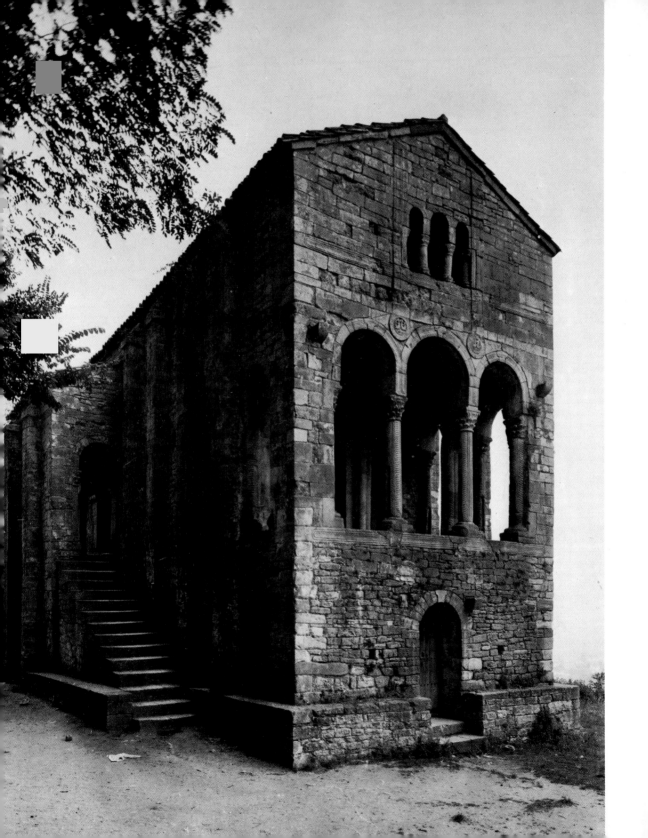

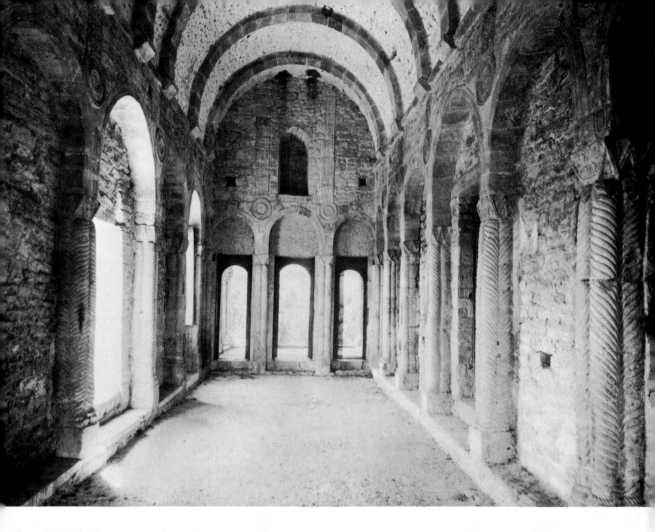

Santa Maria de Naranco. Exterior and interior. Completed 848

Santa Maria de Naranco in Oviedo, dating from the time of King Ramiro I (842–50), closely resembles Santa Cristina de Lena in many of the details and particularly in its slender proportions. Again it has a barrel vault; perhaps it formerly served as a royal hall on a site notable for its beauty, before being turned into a Christian church. Noteworthy also are the buttresses on the exterior of the two-story building. The interior is reached by a flight of steps, leading to porches on either side of the long sides of the church. The splendid hall, surprisingly, has loggias on the narrow sides and on one of the long sides which can only be reached from within and are apparently evidence of the former secular function of the building. The arrangement of the interior, which has still not been fully explained, with blind arcades of varyingly patterned columns, is closely related to Santa Cristina de Lena, for which it was very probably the inspiration.

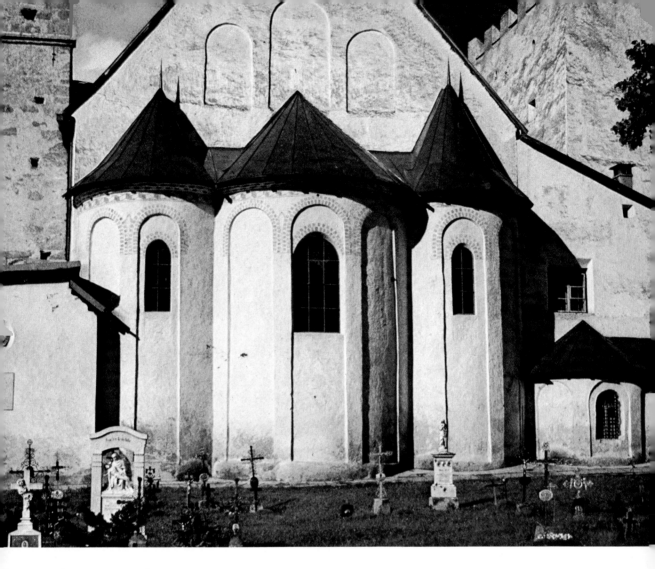

Saint Johann, Müstair. Ninth century

A group of churches of a quite individual type still stands in the Alps, particularly in the canton of Grau-
bünden in Switzerland and to a certain extent in the Tirol. In these churches three apses form the east end of an
otherwise plain interior. According to the records, Charlemagne himself founded Saint Johann, which re-
mained an imperial monastery from 806 to 881. There may have been strategic reasons for this. The effect of
the simple, box-like interior was later greatly impaired by the addition of Gothic pillars and vaults.

This small church houses an outstanding cycle of Carolingian frescoes; some of those behind the Gothic vaults have been known since 1896, while others on the walls were uncovered later. One decoratively framed system extends throughout the interior with a series of saints and some hundred scenes from the Old and New Testaments.

The scene illustrated below shows that the artist was familiar with the great Italian cycles of frescoes; it also recalls the spatial concepts of Antiquity. Christ, in classical dress with a cruciform nimbus, is slightly larger than the other figures. Certain elements appear rather stylized, but the main emphasis is laid on the gestures and the enlarged eyes in a truly medieval manner. Reds predominate, but there is also frequent use of blue. Since the artist used a mixture of *buonfresco* and tempera, the brush strokes in white heightening the highlights or bringing out inner detail have flaked off in places. This makes the painting appear flatter and less expressive than it was originally. The Emperor's decision in the *Libri Carolini* concerning the Byzantine iconoclastic dispute had given representational art, in particular painting, a new field of action, and the Life of Christ henceforth became a major theme of Western art.

Healing of the Dumb Man. Early ninth century. Fresco. Saint Johann, Müstair

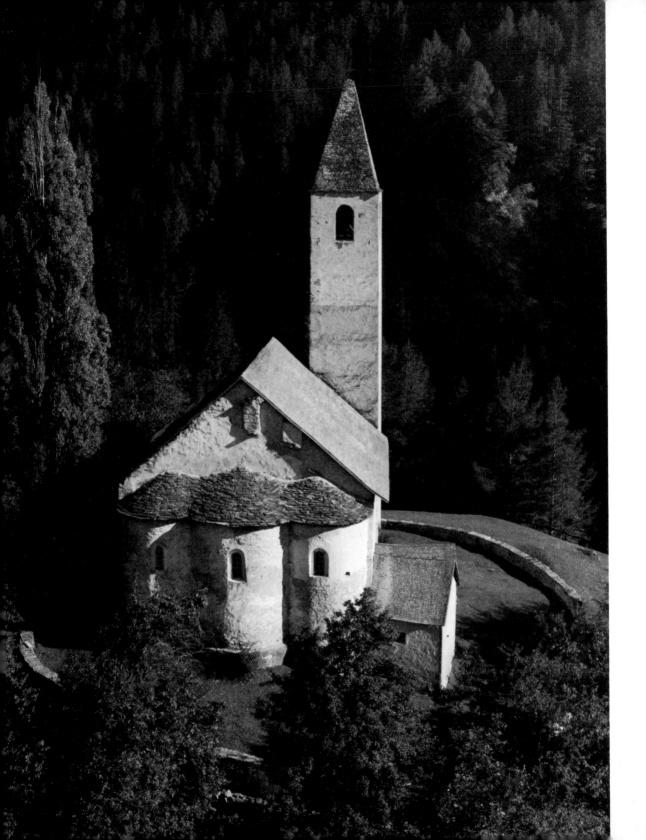

Former convent church of Saint Peter, Mistail. Second half of eighth century

This small church also has the characteristic three apses side by side on the exterior, perhaps symbolizing the Holy Trinity—a form transmitted from the Mediterranean to Graubünden— and giving the building its distinctive character. The church of Saint Peter may be slightly older than Müstair. Fortunately the splendid interior is intact; its monumentality is emphasized by the three rising, slightly horseshoe-shaped (and thus early) apses.

Priestly Donor. First half of ninth century. Fresco. Oratory of San Benedetto, Malles

The relatively well-preserved wall paintings in the three apses of the oratory of San Benedetto show Christ between two angels in the center, Saint Stephen in the right apse, and Saint Gregory in the left apse. The two portraits of donors (on the narrow panels between the apses) are very important works. The priest, characterized as a living person by his square nimbus, holds a model of the church. The very exact detail and his posture recall the paintings of Müstair not far off, but, probably because of the forceful drawing, the overall effect is more Romanesque. It is typical of churches in this region, such as Santa Prassede and San Clemente, that the portraits of the donors occupy important positions.

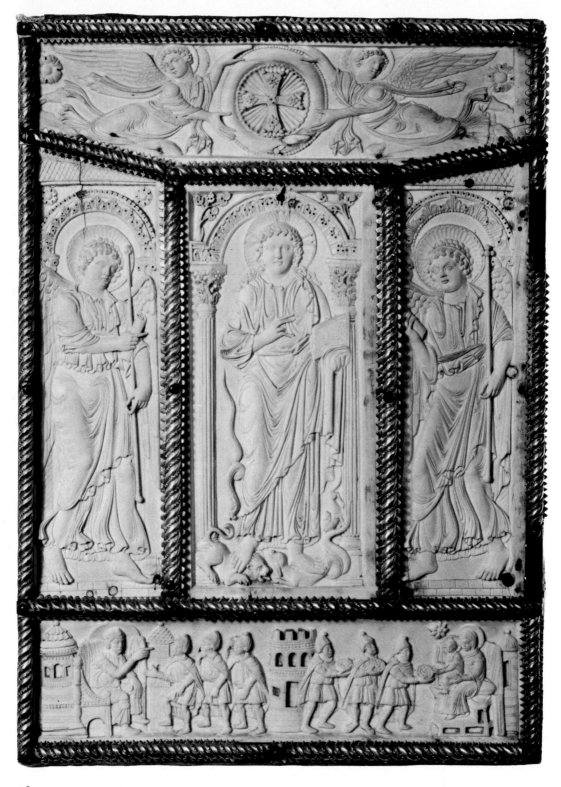

Cover of the *Lorsch Gospels.* c. 810. Ivory,
$14^{7}/_{8} \times 10^{3}/_{8}''$. Museo Sacro, Vatican, Rome

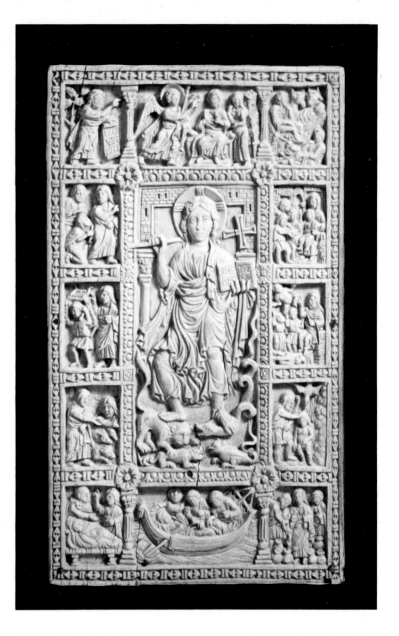

Very little figurative sculpture is preserved from the time of Charlemagne. Ivories and miniatures are, therefore, the most important art forms we know from this period. After the bound *codex* had become the usual form of book in the fourth century, the development of book illumination had become possible (though it was always surrounded with an aura of luxury) for the adornment of the Holy Scriptures as the spiritual focus of the Church. Naturally the precious contents of the manuscripts were treasured within splendid covers, of which the ivory ones have survived the onslaughts of time better than the gold ones, easy to melt down.

There are two panels belonging to the *Lorsch Gospels.* The portrait of the Virgin is now in London. The relief of Christ by the Court School, which reached the Vatican by way of Ottheinrich of the Palatinate, shows the grace-bestowing Saviour, the Book in His hand, as the overcomer of Evil, symbolized by the lion, the dragon, the basilisk, with an angel either side as well. In the upper register two angels bear the Cross, while in the bottom register there are two scenes with the Magi. The Court School had a predilection for large, Late Roman, five-part or *consular* diptychs as models, and the full, frontal figures clearly reveal their Roman derivation.

Christ in Triumph. Early ninth century. Ivory book cover, $8^{1}/_{4} \times 5''$. Bodleian Library, Oxford

The cover of the gospel book from Oxford is also by the Court School. Christ, bearing the Cross-staff on his shoulder, is framed by twelve narrative scenes from the New Testament based on different models. Although the theme is the same, the style here is much more animated than on the Lorsch cover.

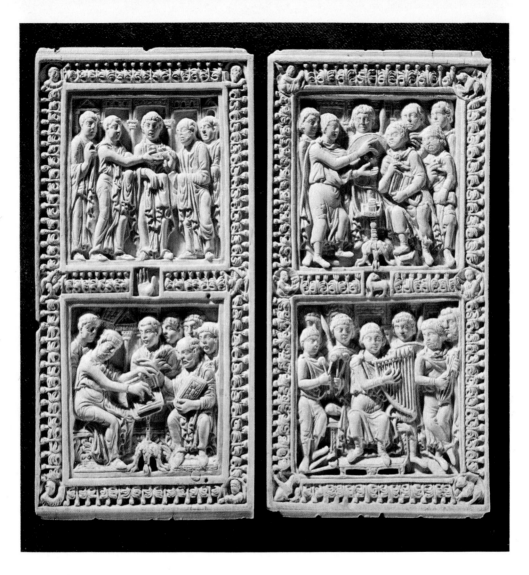

Cover of *Dagulf's Psalter*. 783–95. Ivory, $6^5/_8 \times 3^1/_8''$. The Louvre, Paris

The cover of *Dagulf's Psalter* is stylistically very close to the Oxford cover. The Psalter was a gift for Pope Hadrian I (772–95), commissioned by Charlemagne as we know from the dedicatory poem by Dagulf which also describes the cover. This is also how we know that the plates belong to the Codex; they are the only plates that can be dated with some certainty. The crowded, highly sculptural reliefs on the cover relate the origin of the Psalter in King David.

The Court School owes its foundation to a number of commissions by Charlemagne, who had learnt something of the splendor of ancient manuscripts. In promoting this art form, he was adhering to the traditional practice of his predecessors of East and West Rome. It is not only in this sense that Carolingian illumination is an art of renaissance. It also bridged the gulf that had separated the immediately preceding period from the formal world of late Antiquity. At the time of the Merovingians, and in the English and Irish scriptoriums, figurative painting, like other contemporary art forms, had become increasingly restricted. Germanic interlacing, fabulous animals and spirals, oriental and Celtic forms had completely driven out the conventions of perspective and three-dimensional forms. The first work by the Court School, the *Godescalc Gospels* of 871–83, written on purple parchment, outshone generally the manuscripts of the indigenous monastery schools,—in particular in the renewed portrayal of the human figure. In typically medieval fashion, the

Initial page from *Dagulf's Psalter.* 783–95. Court School of Charlemagne. $7^1/_2 \times 4^3/_4''$. Österreichische Nationalbibliothek, Vienna. Cod. 1861, fol. 25 r

school only copied already existing paintings, instead, as one might expect, of making studies from nature. It used various sources, some of them Byzantine. The initial page to Psalm I of *Dagulf's Psalter,* written in gold minuscules, still has interlacing, but the characters themselves are markedly classical.

The Evangelist Matthew, from the Gospels of Centula. Late eighth century. Miniature on parchment, 13³/₄ × 9³/₄″. Court School of Charlemagne. Bibliothèque Municipale, Abbeville, Ms 4, fol. 17 v

Apart from the Eusebian canonic tables (i.e., tables of concordance of the Gospels) with their splendid decoration, one of the favorite themes of Carolingian illumination was the Evangelists. They are often shown writing under a round arch, enthroned rather than merely sitting. In line with Late Roman tradition, they are once again full-page, body-colored miniatures, small paintings rather than decorations, and therefore the first achievements that can really be called illumination. Matthew is characterized in the lunette by his attribute, the angel; he is seated before a curtain, in an attitude of elegant pathos, enveloped in rich folds of classical drapery. The manuscript belongs to the gifts from Charlemagne to his son-in-law Abbot Angilbert of the Centula monastery, and is a strong proof of the Carolingians' formal mastery of their classical models.

To a certain extent this miniature is a mirror image of that of the Evangelist Matthew, and the composition is very similar; but Mark obviously comes from a different manuscript by the same school. According to a poem added later, it was commissioned by a certain "Ada," whom local tradition identifies as a sister of the Emperor. In the convincing treatment of space and the masterly quality of the painting and draftsmanship of the figure, which fills the architectural frame in a magnificently natural fashion, the Court School had reached an artistic highpoint.

The Evangelist Mark, from the *"Ada" Gospel*. c. 800. Miniature on parchment, 14³/₈ × 9³/₄". Court School of Charlemagne. Stadtbibliothek, Trier, Cod. 22, fol. 59 v

The full-page miniature of the Evangelist Luke from Fulda clearly echoes the style of the Court School. But at the same time it is flatter and has taken on a character of its own in expression and color.

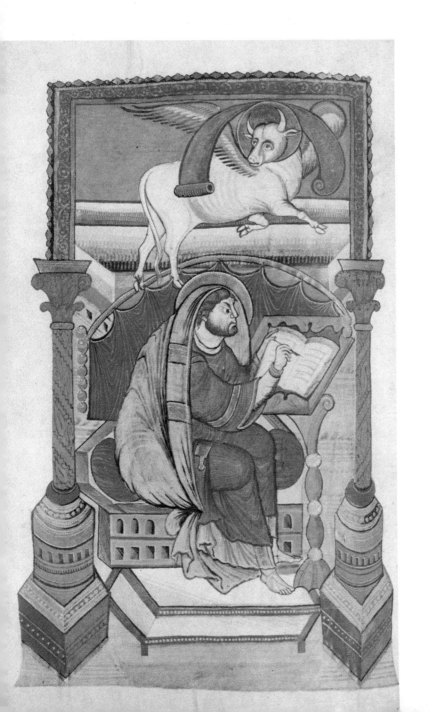

The Evangelist Luke, from a gospel book from Fulda. Miniature on parchment, $13^3/_8 \times 9^1/_2''$. Universitätsbibliothek, Würzburg, M. p. th. fol. 66, fol. 105 v

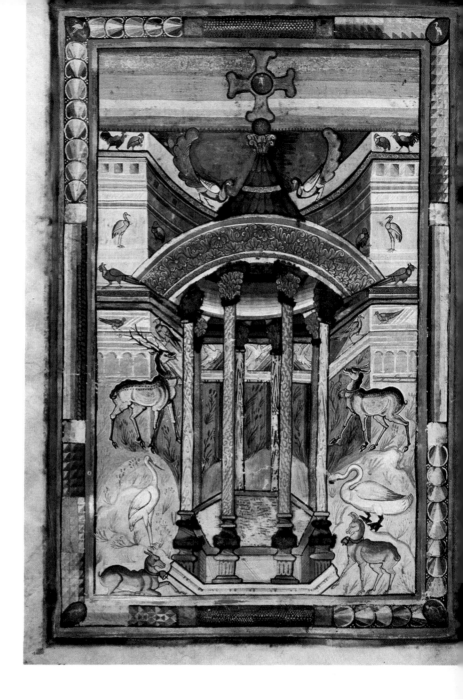

Allegories such as the Fountain of Life are among the most beautiful works by the Court School. This manuscript is written entirely in gold. It may have belonged to Charlemagne, whose son Louis the Pious presented it to the church of Saint-Médard. The fountain with the waters of life, a copy of a classical round temple, symbolized Baptism and Paradise, while at the same time it stood for the life-promising Tomb of Christ. It is surrounded here by allegorical animals.

Even in the lifetime of Charlemagne, a completely new expressive form of painting appeared which took its name from the *Vienna Coronation Gospels.* The miniature showing the holy evangelists enveloped in classical drapery surprises by its almost Hellenistic style of painting and by the mysterious turquoise landscape which is very remote from the clear, classical order of the Court School. We do not know whether we owe this stylistic change to Byzantine artists or whether it was due to Einhard's taking over the Court School. What is certain is that this group of illuminations exerted a decisive influence on later Carolingian work, as shown by the virtuoso, almost impressionistic painting of Saint Mark in the *Ebbo Gospels* by the school of Reims (opposite).

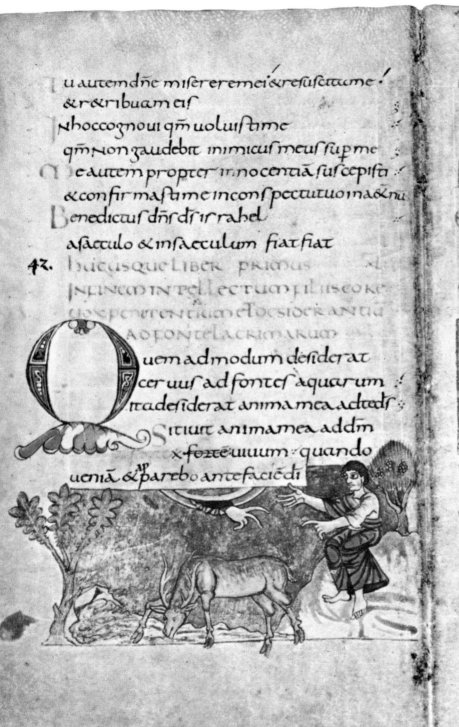

tu autem dñe miserere mei & resuscita me
& retribuam eis

In hoc cognoui qm uoluisti me
qm non gaudebit inimicus meus sup me

Me autem propter innocentiã suscepisti
& confirmasti me in conspectu tuo in aeternũ

Benedictus dñs ds israhel
a saeculo & in saeculum fiat fiat

42. Hucusque liber primus
in finem intellectum filiis core
quo peniterent&iam et desiderantia
ad fontem lacrimarum
Quemadmodum desiderat
ceruus ad fontes aquarum
ita desiderat anima mea ad teds
Sitiuit anima mea ad dñm
& fontem uiuum quando
ueniã & parebo ante faciẽ di

concaluit cor meu
& in meditatione

Locutus sum in lingu
notum fac mihi d

Et numerum dierum
ut sciam quid desi

Ecce mensurabiles
& substantia me
ante te

Uerum tamen uni
omnis homo uiu

Uerũtamen inima
sed & frustra cor

Thesaurizat & ig
cui congregabit

Et nunc que est e
nonne dñs
& substantia me

Utrecht Psalter. c. 830. 13 × 10″. From Hautvillers (Reims). University Library, Utrecht. Ms. 484

The style of the *Ebbo Gospels* is continued, in the medium of pure line drawing, in the many scenes of the *Utrecht Psalter*. Several individual scenes are assembled into groups conceived in a lively and forthright manner with the painter's rather than the draftsman's eye—more rounded than strictly linear. The whole serves as a kind of summary of early medieval and early Christian iconography. It has been shown that Carolingian illuminators made a number of original designs in close stylistic imitation of their models, which may have been of an earlier date, perhaps around 400. Moreover, there are striking iconographic resemblances between the *Utrecht Psalter* (above) and the psalter from Stuttgart (left), which is related to Italian illumination. The most impressive achievement of these two manuscripts rests in the bringing together of many themes from the Old and the New Testaments— this was a complete innovation in Carolingian illumination—and in the transmission through them of the technique of pen-and-ink drawing to Saint Gall and to England.

Psalter. c. 820–30. 10¹/₂ × 7″. From Saint-Germain-des-Prés. Württembergische Landesbibliothek, Stuttgart. Bibl. fol. 23

Just as Carolingian illumination was carried on in the monasteries of Reims, so a scriptorium that was later to become famous was formed in the monastery of Saint-Martin in Tours under Alcuin. In the beginning this school laid most stress on the accurate copying of texts, but later it concentrated on the illumination of magnificent manuscripts. It reached its first artistic highpoint in the *Bamberg Bible,* whose very small figures, arranged in rows, are defined in their silhouettes by the wild, convulsed, tree-like forms separating the scenes. This was a scheme which the Late Middle Ages often adopted in wall painting.

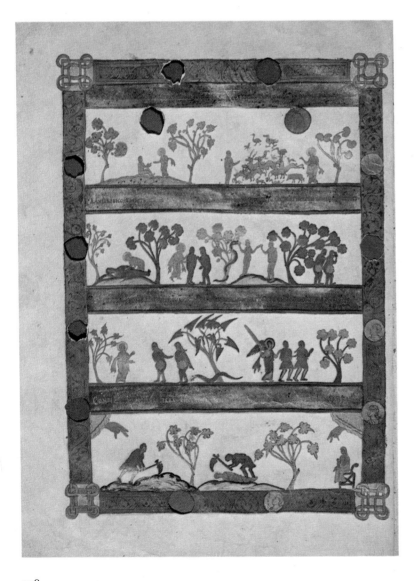

Personification of the Quadrivium (four out of the seven liberal arts, from the *Arithmetic* of Boethius. c. 845. Miniature on parchment, 9 × 6³/₄". School of Tours. Staatliche Bibliothek, Bamberg, Class. 5

Genesis Scenes from the *Bamberg Bible.* Mid-ninth century. Staatliche Bibliothek, Bamberg

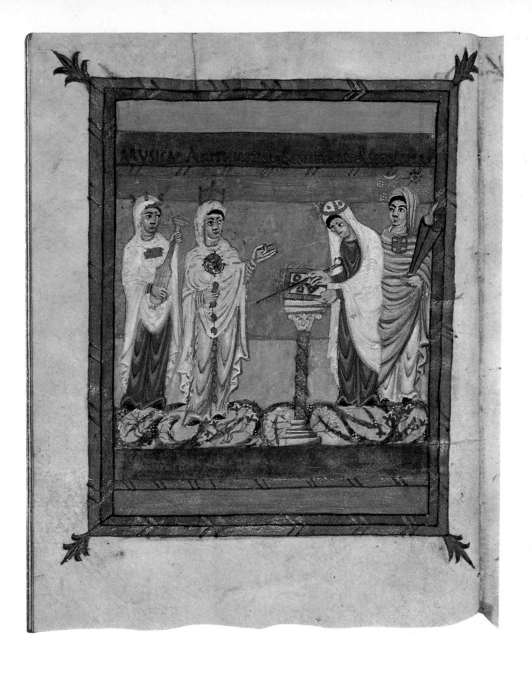

The monastic scriptoriums not only produced theological works, but they also transcribed ancient manuals of the sciences for posterity. The Roman scholar Boethius' work *De institutione arithmetica libri II,* dating from the time of Theodoric the Great, is one of the most important early medieval manuals. It was written at Tours for Charles the Bald. The illuminator depicted four of the foundations of Late Roman culture in typical fashion as surprisingly differentiated female personifications. From left to right the figures are Music, Arithmetic, Geometry, and Astrology, each defined by her attributes.

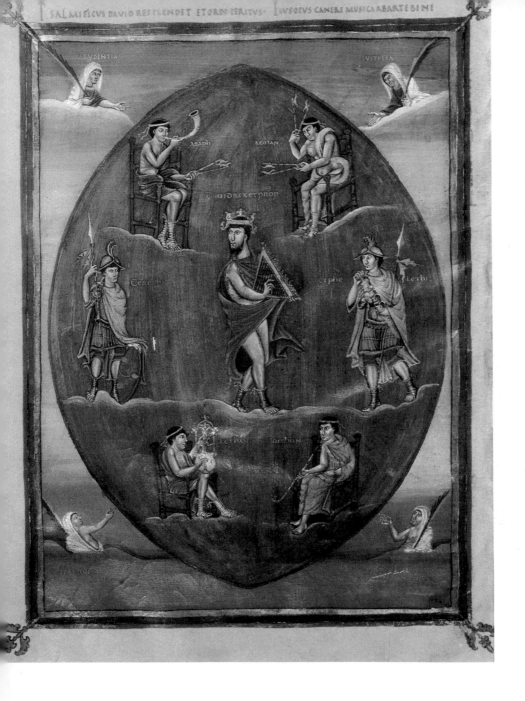

Stylistically, this Bible, illustrated above and also dedicated to Charles the Bald, is very close to the *Arithmetic*. Again the classical inspiration is evident but the stricter arrangement and greater assurance of the design reflect the new visual concepts of the Early Middle Ages.

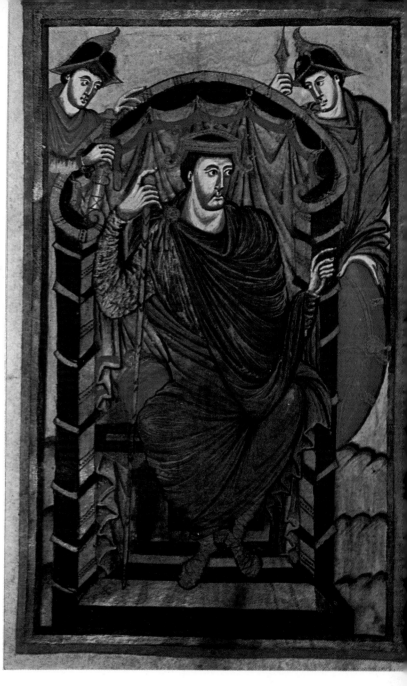

Emperor Lothair, from the *Gospels of Emperor Lothair*. 849–51. Miniature on parchment, 12⁵/₈ × 9⁷/₈″. School of Tours. Bibliothèque Nationale, Paris, Lat. 266, fol. I v

We owe another important work to the school of Tours, the *Gospels of Emperor Lothair*. It dates from almost the same time as *Count Vivian's Bible*. The portrait of the enthroned Emperor is a masterpiece of this scriptorium. The Emperor, who made many gifts to the monastery, is seated on a classically draped throne, behind which stand two armed figures holding sword, lance, and shield. Only a few years later, the Norman attacks put a stop to the activity of the school, but its art lived on in the works created for Charles the Bald reflecting the final style of Carolingian illumination.

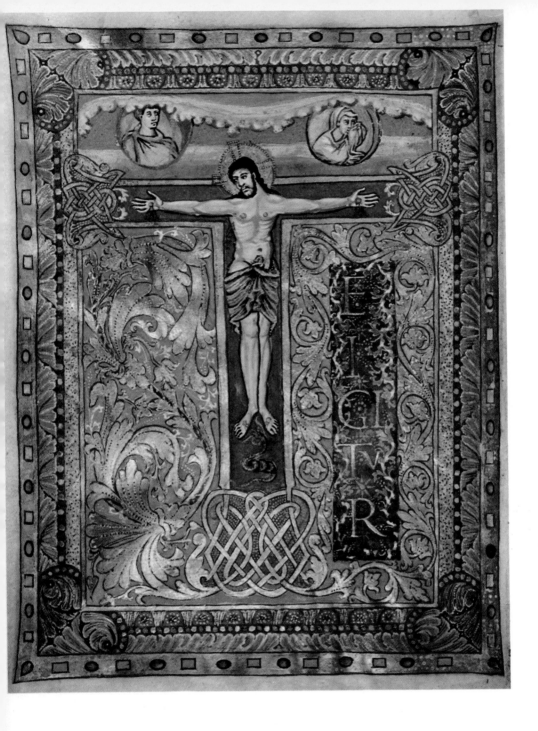

Crucifixion upon the Initial 'T'. from the *Coronation Sacramentary of Charles the Bald*. c. 780. Miniature on parchment, 10⅝ × 8¼″. Court School of Charles the Bald. Bibliothèque Nationale, Paris. Lat. 1131, fol. 6 v

From the *Bible of Charles the Bald*. 870–75. $17^{3}/_{4} \times 13^{1}/_{2}''$. San Paolo fuori le Mura, Rome

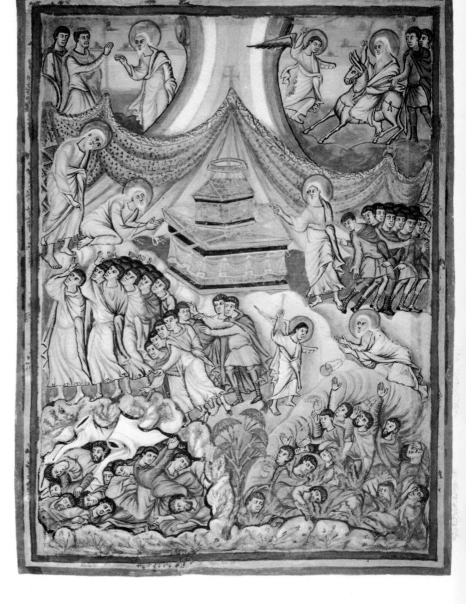

The last phase of Carolingian illumination combined the styles of all the preceding schools in a splendid, almost baroque eclecticism. This is apparent both in the *Coronation Sacramentary of Charles the Bald* on the left and in this magnificent manuscript from Rome with its sequence of Old Testament scenes, which can very probably be related to Charles' second marriage in 870. It contains the largest cycle of Carolingian illuminations we know.

Christ in Majesty (page 114) from the cover of the *Codex Aureus* of Saint Emmeran. c. 870. Chased gold, pearls, and precious ▶ stones, $16^{1}/_{2} \times 13''$

Enthroned Emperor (page 115) from the *Codex Aureus*. Miniature on parchment, $15^{1}/_{2} \times 12''$. Court School of Charles the Bald. ▶ Staatsbibliothek, Munich. Cln. 14000

The *Codex Aureus* of Saint Emmeran in Regensburg (see over) is one of the most magnificent works created for Charles the Bald. It came to Regensburg as a gift from the Emperor Arnulf. The artistic and technical excellence and the subtlety of the cover with the golden Christ in Majesty in the center of the Cross are complemented by the baroque richness and glowing colors of the miniatures. Works of this kind were a deliberate adherence to Carolingian tradition.

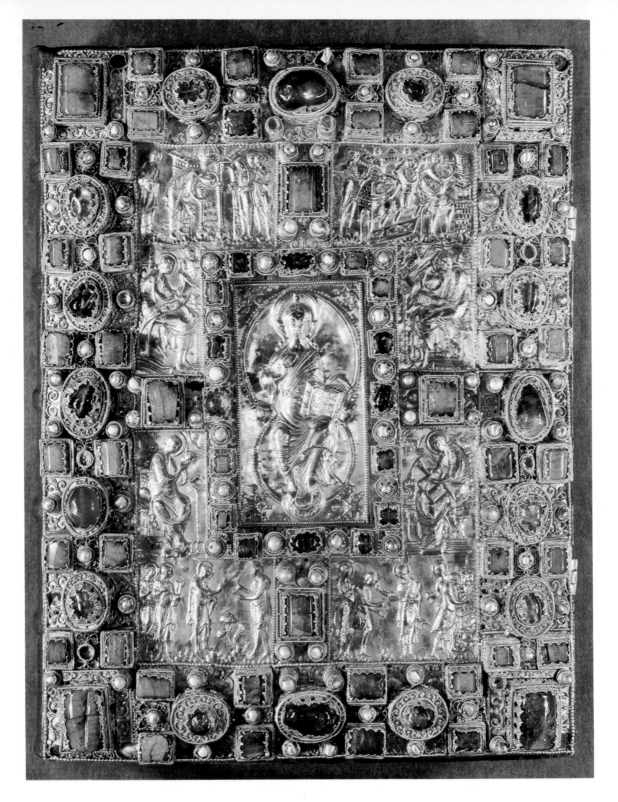

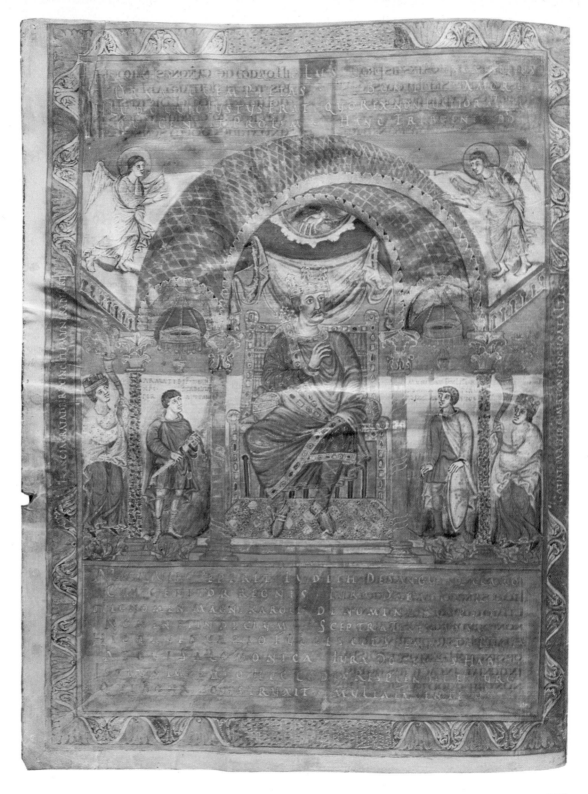

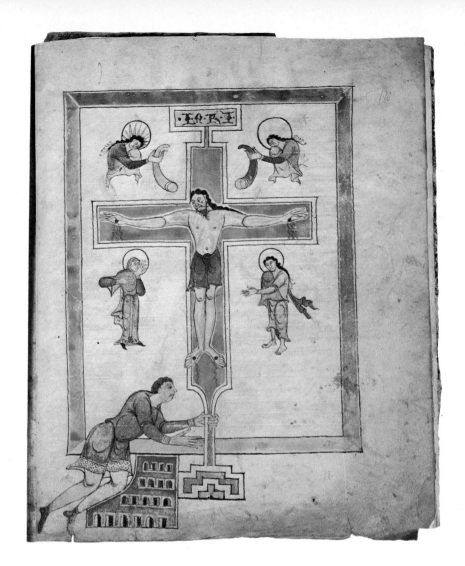

Louis the Pious, from Hrabanus Maurus, *De laudibus sanctae crucis.* c. 840. Miniature on parchment, 15⁷/₈ × 12¹/₈″. School of Fulda. Biblioteca Apostolica Vaticana, Rome, Reg. lat. 124, fol. 40

Adoration of the Cross, from the *Psalter of Louis the Pious.* Second quarter of ninth century. Miniature on parchment, 11¹/₂ × 9³/₄″. From Saint-Omer. Staatsbibliothek, Stiftung Preussischer Kulturbesitz, Berlin, Ms. thel. lat. fol. 58

In this precious work (above), the ornamental decoration of the pages written in gold dominates them. An exception to this style is the miniature of the *Adoration of the Cross,* which was added in southern Germany in the later ninth century.

The future archbishop of Mainz, Hrabanus Maurus, a pupil of Alcuin and Abbot of Fulda, dedicated a copy of his much-admired poems to Louis the Pious. The illustration opposite shows the grandson of Charlemagne as a Christian warrior for the Cross.

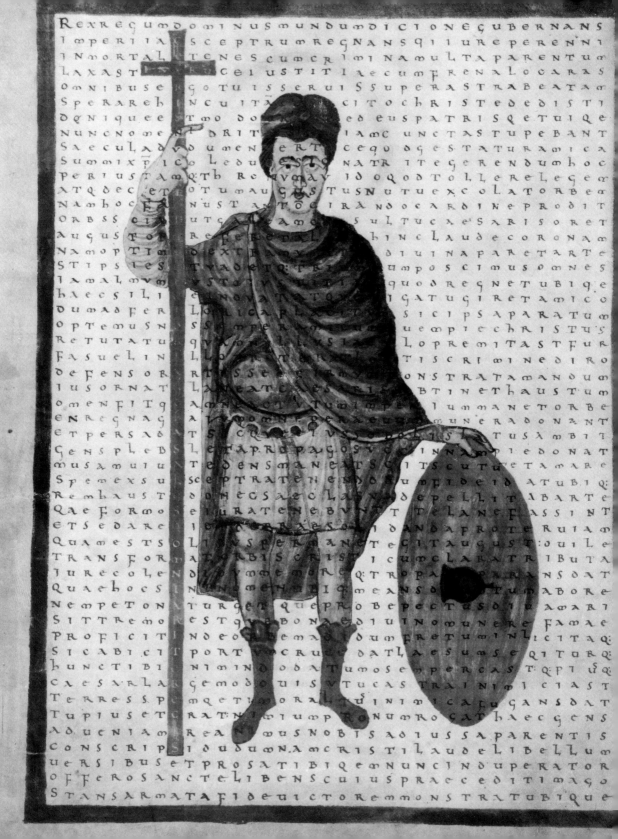

Horsemen, from the *Psalterium Aureum* executed for Abbot Salomon. Late ninth century. Illumination to Psalm 60. Stiftsbibliothek, Saint Gall

Individual monasteries tended more and more to evolve into artistic centers in which illumination assumed a special importance. Saint Gall, founded by Irish monks, the library of which still houses *codices* stemming from the date of foundation, found inspiration from all parts of the Frankish kingdom. The monks loved decorative initials, and combined interlace work and acanthus leaves into rich and balanced compositions. The group of horsemen accompanying Psalm 60 also reflects the animated, linear style of the school of Reims.

This Gospel Book is the only sign we know of a monastic scriptorium in Augsburg. It is written on purple parchment and canonic tables are its chief decoration. Two pages of cruciform miniatures were added later, which has led to very different datings ranging from late Antiquity to Ottonian times.

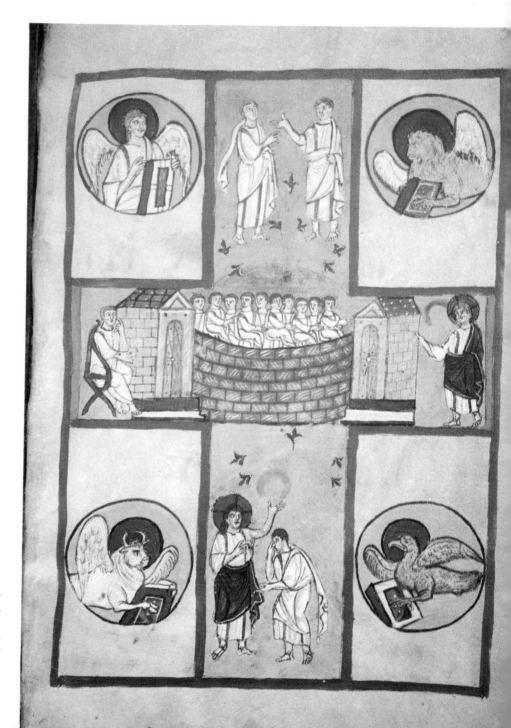

Scenes from the Life of Christ and Symbols of the Evangelists, from a gospel book. Early ninth century. From Augsburg. Bayerische Staatsbibliothek, Munich, Clm. 23 6 31, fol. 197 r

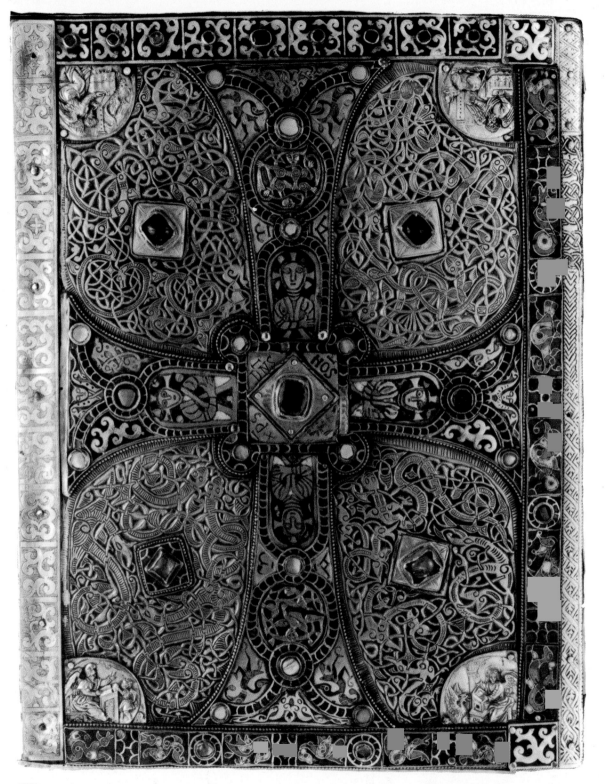

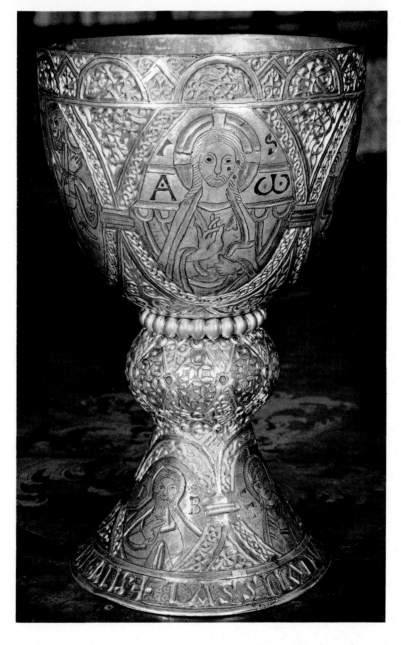

First Lindau Book Cover. Late eighth century. Silver gilt, niello and insets of enamel and almandines, $13^3/_8 \times 9^7/_8''$. From Saint Gall (?). Pierpont Morgan Library, New York

As far as one can tell from surviving works, precious altar vessels of gold and silver, worked in the most varied techniques, were the dominant forms of Carolingian art. The splendid book covers enclosing the Word of God also belong to this group. The origins of the *First Lindau Book Cover* (left) are uncertain. The composition, related most likely to that of the cover of the *Gospel Book of Queen Theodolinda* in Monza, with the half-figures of Christ on the arms of the Cross combining to form a symbolic figure overlying interlaced animal forms on the rest of the ground, suggests Anglo-Irish influences. With the turquoise enamel and the almandines set in a glowing gold ground, this is a magnificent, colorful work.

The Tassilo Chalice. c. 770. Copper gilt, height $10^1/_8''$, diameter of the cup $6^1/_8''$. From Northumbria (?). Kremsmünster Convent

According to the inscription round the base, Duke Tassilo and his wife Liutpirc were the donors of this votive foundation chalice, which can therefore be dated to the second half of the eighth century. Of all altar vessels, this chalice stands out by its extraordinary profusion of decoration and figurative work, and remained a unique example of its kind till Romanesque times. Five large oval engravings in silver niello show Christ in Majesty—with a golden, cruciform nimbus, sitting on a throne of which the back is inscribed with the letters A and ω—and also the four Evangelists with their symbols. The little free surface remaining is covered with interlaced foliage, interspersed with northern animal ornaments, and chip-carved palmettes.

Similar medallions at the foot of this noble chalice show the patron saints of the donors (the Virgin, Saint Theodolinda, John the Baptist, and the Martyr Theodore), while the central nodus is decorated with the most ornate rhomboid rosettes. The iconography was probably inspired by an apse composition. The chalice's date and origins are not certain. Formerly it was thought to come from Salzburg, because of the combination of Mediterranean techniques and Anglo-Irish influences, but more recent scholarship has ascribed it to Northumbria.

The variety of metalwork techniques in the Tassilo Chalice shows the importance attached to church vessels in the early Middle Ages: "... for it is in vessels, and not in paintings, that the sacrifice is made to God" *(Libri Carolini II, 29)*.

From the seventh century on, a papal privilege allowed higher clergy and princes to have Mass read at small portable altars. The wooden core of such an altar was covered in gold, silver, or ivory and surmounted by a stone slab on which the chalice stood during the service. The *Adelhaus Portable Altar* is one of the earliest examples of a porphyry slab flanked by two silver plates of a similar type. They are engraved with Greek medallion crosses in cloisonné enamel and with symmetrical patterns of interwoven bands, while the long sides are bordered by bands of cloisonné enamel, each with a row of cruciform medallions. Certain stylistic connections with the Milan *paliotto* and the Lombardic gilt crosses suggest a north Italian derivation, but its origins have not yet been definitely ascertained. It appears to be the only surviving portable altar from the time of Charlemagne.

Apart from liturgical vessels, several Carolingian gold reliquaries also survive. The purse-shaped ones are the most important group, and they clearly show their inspiration from those in cloth.

Adelhaus Portable Altar. c. 800. Porphyry with silver and cloisonné enamel, $14^7/_8 \times 5^3/_4$". Augustinermuseum, Freiburg im Breisgau

In the particularly valuable example of early Carolingian work from the monastic foundation of Enger, the wooden core, covered with gold sheet, is inlaid with thirteen jewels in oval molds, including four ancient cameos on the display side. The rest of the surface is decorated with star shapes in cloisonné enamel and almandines. The pattern of precious stones surrounded by pearls clearly brings out the form of the True Cross from which the diagonals radiate to form the symbol of heaven. The symbolic motif of four stones is here extended to twelve, and the lions at the top stand for the watchers at the tomb. Stylistically, this work comes from the west German, Alamannic region. Legend has it that it was a gift from Charlemagne to his godson Duke Widukind of Saxony. On the reverse are arcades with Christ between angels and the Virgin between the Apostles.

Purse reliquary. Third quarter of the eighth century. Wooden core, gilt, with precious stones and cloisonné enamel, $6^1/_4 \times 5^3/_4$″. From Enger. Stiftung Preussischer Kulturbesitz, Kunstgewerbemuseum, Berlin

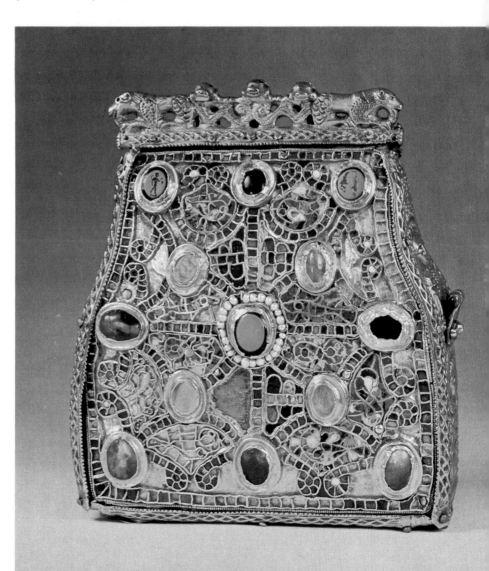

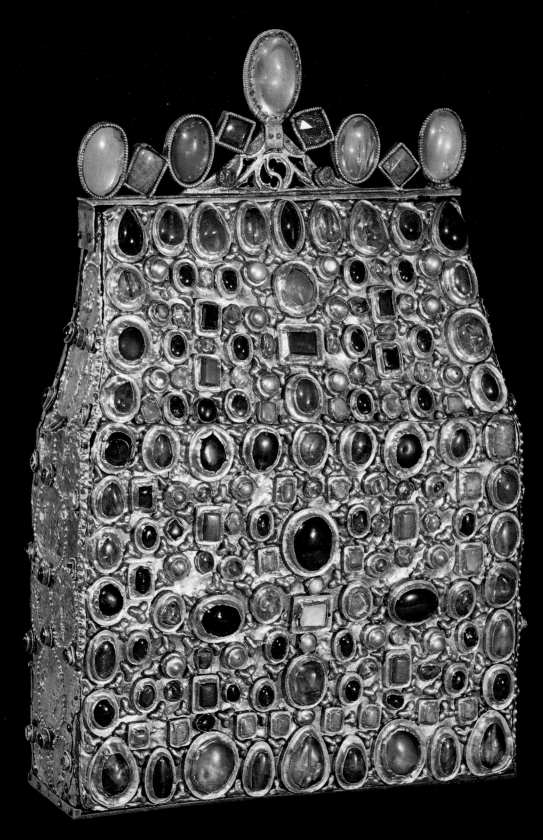

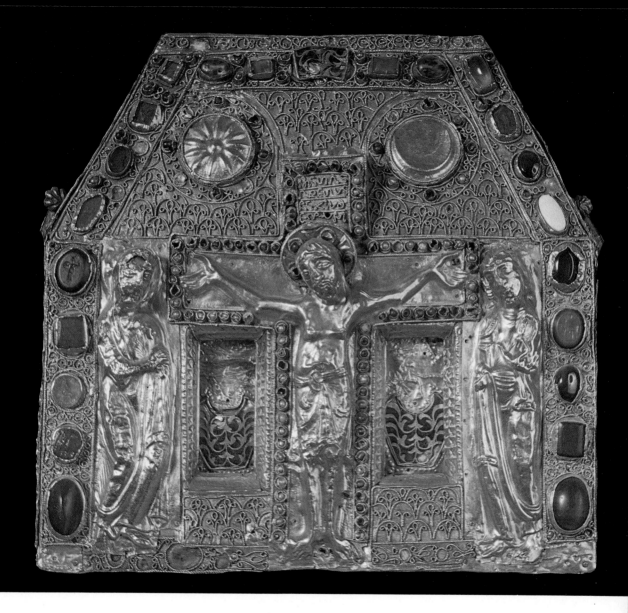

Purse Reliquary of Pepin of Aquitaine. Before 830. Gold with precious stones, over a wooden core. Treasury of the former abbey church of Conques

The purse of Saint Stephen (left) is one of the earliest of the surviving Imperial treasures. Originally it is said to have contained earth with the blood of the first martyr. The cruciform pattern on the display side is not so distinct, because the gold ground is unusually closely filled with different colored jewels and pearls set in molds, as on the earlier reliquary from Enger. The molds follow the slightly irregular forms of the smoothly polished stones, thus making the reliquary reflect a wonderful shimmering light. Certainly this arrangement was symbolic.

Purse of Saint Stephen. Early ninth century. Gold and silver gilt over a wooden core, 12⅝ × 9½″. Court School of Charlemagne. Kunsthistorisches Museum, Vienna

On the narrow ends, medallions alternate with different figures in gold plate like the imitations of ancient cameos in the miniatures by the Court School.

The reliquary (page 125), preserved in the abbey church of Conques, is easier to interpret. During the ninth century, the older, difficult, more allegorical iconography of the smaller reliquaries gave way to figurative scenes, even formed, sometimes, in relief. On the purse reliquary donated, it is said, by Pepin of Aquitaine (d. 830), an embossed, early Romanesque crucifix flanked by the Virgin and Saint John covers a similar Carolingian image, remains of which were found underneath it.

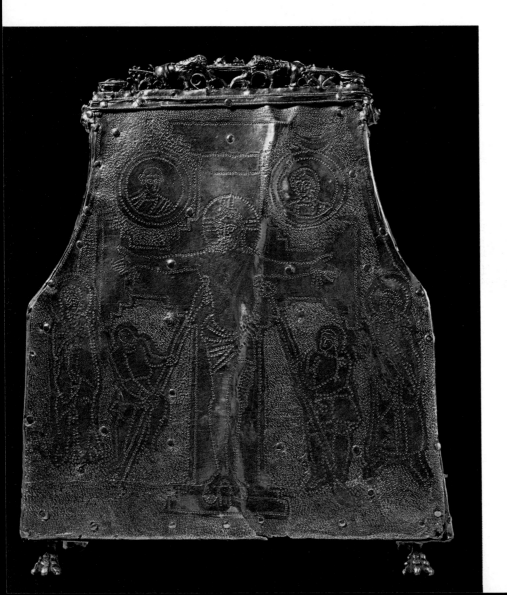

Reliquario del Dente (back).
Cathedral treasury, Monza

On one side of the *Reliquario del Dente* is a *crux gemmata,* the cruciform pattern of colored gems symbolizing the Triumph of Christ. On the other side, a punched image of the Crucified Christ, the symbol of Salvation, completes the scheme of this small work of art. Like the Enger reliquary, it is perhaps based on Byzantine models. These purses often have remains of fastenings for chains or belts, so that presumably they accompanied the owner on the numerous laborious journeys usual at the time.

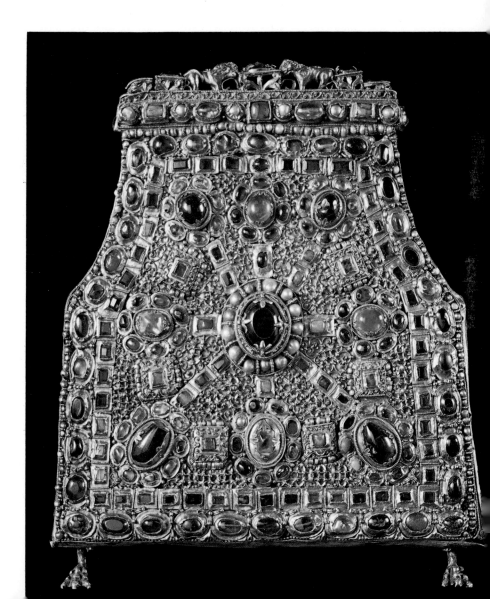

Reliquario del Dente (front).
Cathedral treasury, Monza

Carolingian goldsmiths often made use of classical works, sometimes even placing them in a prominent position; or, as on the purse of Saint Stephen, they imitated a classical model. The paten, which the treasury inventory of Saint-Denis lists together with the ancient chalice of Charles the Bald (now in the Cabinet des Médailles, Paris), is a classical serpentine bowl inlaid with gold dolphins, some of which are now lost. It has a Carolingian gold setting of two rows of precious stones alternating with pear-shaped and trefoil almandines, much like the cover of the *Codex Aureus*.

This is the only surviving ivory chalice from the Early Middle Ages. The silver setting is later. Presumably the chalice was executed by the Court School of Charlemagne, since some of the motifs from the bronze balustrade at Aachen reappear here. The foliage work is probably connected with the motif of the Tree of Jesse.

According to the inscription round the central scene, the Emperor Lothair (855–69) commissioned the crystal plate with scenes from the life of the virtuous Susanna (below). In line with the typological concepts of the Early Middle Ages, these scenes are an allegory of the Church Militant and the Church Triumphant. Like ivory, crystal had a symbolic significance for the Carolingians because of its clear, translucent quality. The small work, stylistically related to the Metz center, shows the amazing ability of this period to convert its particular models suddenly into fresh works of great beauty.

Chalice of Lebuinus. Early ninth century. Ivory, height 4⁵/₈″. Court School of Charlemagne (?). R. K. Lebuinusparochie, Deventer (on loan to the Aartsbisschoppelijk Museum, Utrecht)

Paten of Charles the Bald. Classical bowl, ninth-century setting, diameter 6³/₄″. The Louvre, Paris

Lothair Crystal. Third quarter of ninth ▶ century. Rock crystal, diameter 4¹/₈″. From Metz (?). British Museum, London

Only one of the many Frankish gold altars which written sources record has survived: the *paliotto* (altar frontal) given by Archbishop Angilbert II (824–59) and made by Wolvinus. It covers the altar completely on all sides, and a *fenestrella* on the back gives access to the tomb of Saint Ambrose which was once enshrined there. The frontal is of gold, the other three sides are of silver, partly gilt. It shows Christ enthroned in the center of a large cross among the symbols of the Evangelists. On each side there are six scenes from the Gospels with angels and Apostles. On the narrow ends, angels and saints worship a splendid cross and the reverse side shows scenes from the life of Saint Ambrose. The *paliotto* has a balanced, almost architectural composition, enhanced by colorful bands of cloisonné enamel encrusted with jewels, and a wealth of almost sculptural figurative scenes. Altogether it is a masterpiece of quite extraordinary excellence. It is a result of the interaction of various stylistic and iconographic influences from the kingdom of the Franks and northern Italy. Presumably it was a master from the northern Alps who achieved this artistic synthesis; one can also distinguish the hands of a number of assistants.

Altar of Wolvinus, so-called *paliotto.* c. 840. Chased gold and silver, encrusted with precious stones and cloisonné enamel, $33^1/_3 \times 48''$. Milanese. San Ambrogio, Milan

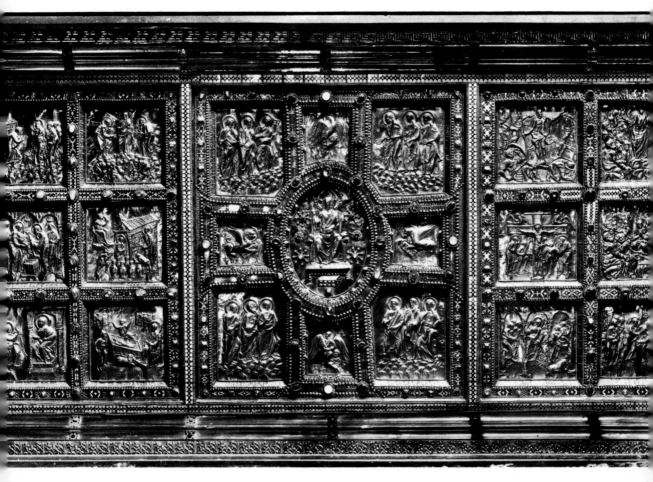

This portable altar is inscribed with a dedication from Arnulf of Carinthia, King of the East Franks, to the monastery of Saint Emmeran in Regensburg in 873. It is one of a group of late Carolingian works whose polychrome style tells of renewed Eastern influences at work. The altar stone of green porphyry bordered by small enamel plaques, like the *Adelhaus Portable Altar*, is surmounted by a two-story canopy, whose wooden core is completely covered with gold sheet lent life and brilliance by its filigree and wealth of precious stones. The chased reliefs on the roof and gables show scenes from the New Testament, including the calling of Peter and the allegory of the birds in the sky and the lilies of the field. Parts of the original crowning gables are lost.

Portable Altar of Arnulf. c. 870. Gold, with precious stones and enamel, and porphyry altar stone, $23^{1}/_{4} \times 12^{1}/_{4} \times 9^{1}/_{2}$". West Frankish. Treasury, Residenz, Munich

One of the most popular media for the visual arts in Carolingian days was ivory. Even the earliest ivories, such as the panels on the cover of *Dagulf's Psalter* showing scenes from the life of King David, are a deliberate return to classical models. Besides scenes with almost classical figures, of which the Lorsch cover is an outstanding example (page 96), one also finds purely ornamental ivories of great beauty. On the front cover of the Würzburg gospels, which is presumably a Breton work, two openwork ivory panels cover a gilt base. Between the very animated, richly modeled acanthus leaves we see the Lamb of God on the left panel, together with the bear, the boar, the lion, and birds in volutes. On the right-hand panel are three large birds. Like a few other, similar pieces, these panels were probably made in the Alamannic area.

Ivory panels from a gospel book from Würzburg Cathedral. Second half of ninth century. Ivory, height 10$^1/_8$″, width together 6$^1/_4$″. Universitätsbibliothek, Würzburg. M. p. th. fol. 67

Little reliquary casket. c. 900. Ivory. From Saint Peter's Salzburg. The Metropolitan Museum of Art, New York City

From Merovingian times on, we know of reliquaries which served as shrines for revered remains. Besides gold, one also finds ivory used on occasion. The box-shaped reliquary from Saint Peter displays a very characteristic, late Carolingian combination of foliage work, animal forms, and earlier circular patterns. After the increasing adoption of Roman formal language transmitted via Byzantium, earlier stylistic trends were beginning to make themselves felt again here. This earlier language had never become entirely extinct; nor was it, like the art of the Court School, restricted to a relatively limited circle. It remained particularly strong in the artistic centers outside the court, where it continued to prevail in later times.

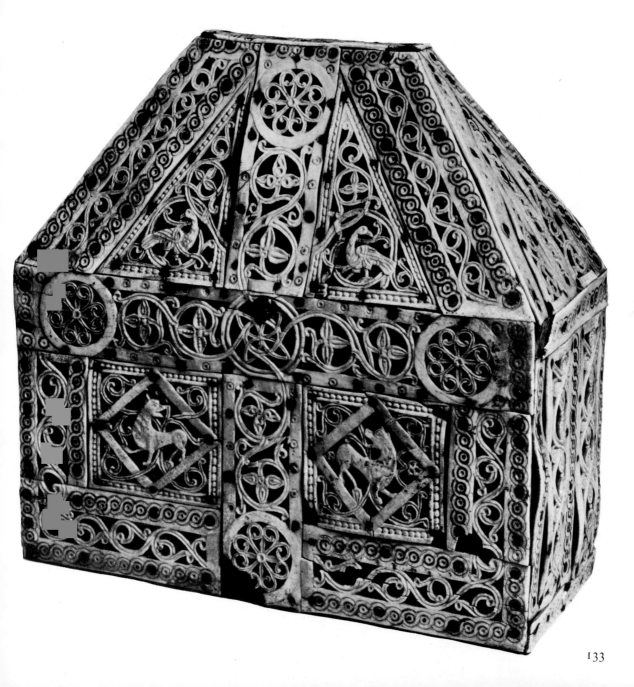

On this little reliquary, perhaps from the south of England, a cordlike grill divides up the display front into twelve separate areas patterned with interlace work and animals sometimes arranged in facing pairs.

Presumably there was a specialized ivory workshop in the cathedral city of Metz, which was under Charles the Bald. The front of the sacred comb (opposite), which comes from the Benedictine abbey of Saint Heribert in Cologne, shows Christ on the Cross between the Virgin and Saint John the Baptist, Stephaton and Longinus, and Sol and Luna; while the reverse symbolizes the Tree of Jesse with twin tendrils of foliage. Like the iconography, the rich acanthus decoration and the openwork surface recall Byzantine works.

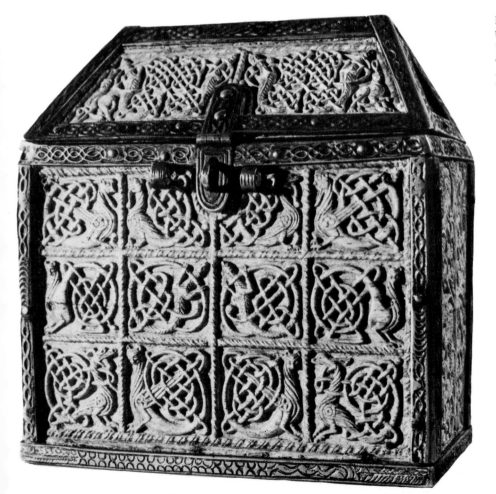

Reliquary casket. Eighth century. Walrus ivory, bronze setting, $5 \times 2^5/_8 \times 5''$. From Gandersheim monastery. Herzog-Anton-Ulrich-Museum, Brunswick. Elfenbeine Nr. 1

So-called *Comb of Heribert*. Second half of ninth century. Ivory, $7^3/_4 \times 4^7/_8''$. Early Metz School. Rheinisches Bildarchiv, Kölnisches Stadtmuseum, Cologne

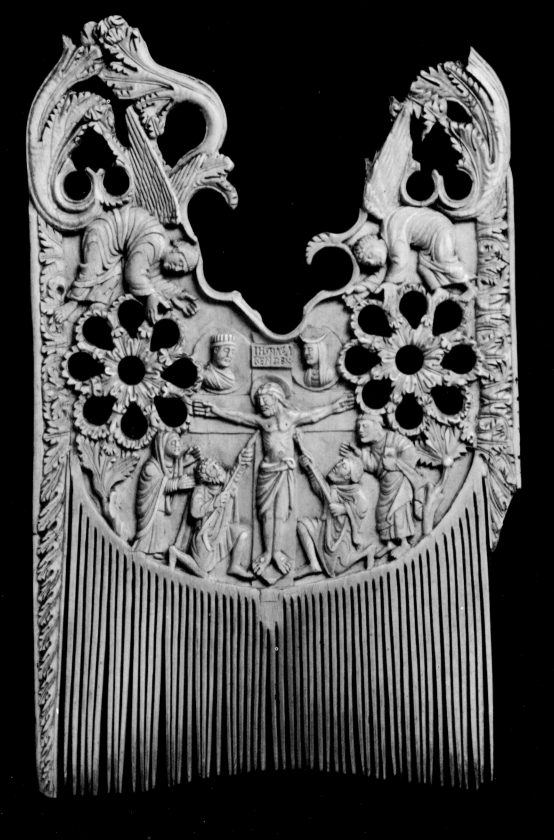

The silver beaker found at Pettstadt is presumably the work of a Frankish master. It is a very interesting example of how different influences converged to produce the typical forms of the Early Middle Ages. The squat, bulging, rather oriental beaker rising from a very modest base has ornamental bands in the Anglo-Saxon manner emphasizing the shape of the beaker and its upper edge below the lip. The irregular ornamental bands of interlace with animal heads were presumably based on insular models which had taken up the Germanic animal style of the eighth century again, for it was rare on the continent at this time. Few works of gold for secular purposes have survived from Carolingian times, and their extent and variety of form can only be guessed at now; so this beaker is an especially important find.

Beaker. Second half of eighth or early ninth century. Cast silver, formerly gilt, height 4″. From Pettstadt, Kreis Bamberg. Germanisches Nationalmuseum, Nuremberg

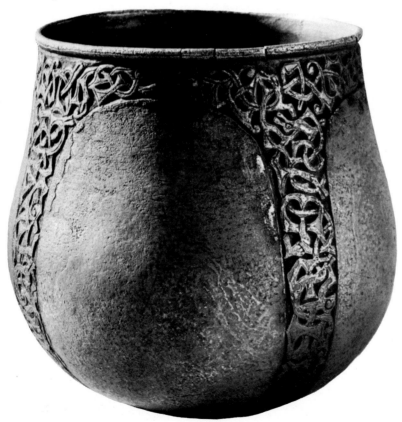

The so-called *Tara Brooch* is one of the most beautiful pieces of metalwork ever made. It is a typical Irish ring brooch with colorful enamel inlays, and it is outstanding evidence of the high craftsmanship of the local masters. In it can be observed the change of Celtic artistic elements into the early Irish style in which individual formal motifs were juxtaposed independently.

Tara Brooch. Eighth century. Gilt bronze, gold, filigree, and jewels. The National Museum of Ireland, Dublin

After the ravages of the Danish marauders, Alfred the Great finally managed to prevent England from becoming a Danish province toward the end of the ninth century. This unique jewel, found by chance, is of gold with filigree, and is shaped like an inverted pear. It may have formed part of a scepter. The front has a cloisonné enamel portrait of the king holding a flower in each hand. The inscription "Alfred mec heht gewyrcan" (Alfred had me made) clearly relates it to the king.

Alfred Jewel. Ninth century. Gold and cloisonné enamel. Anglo-Saxon. Ashmolean Museum, Oxford

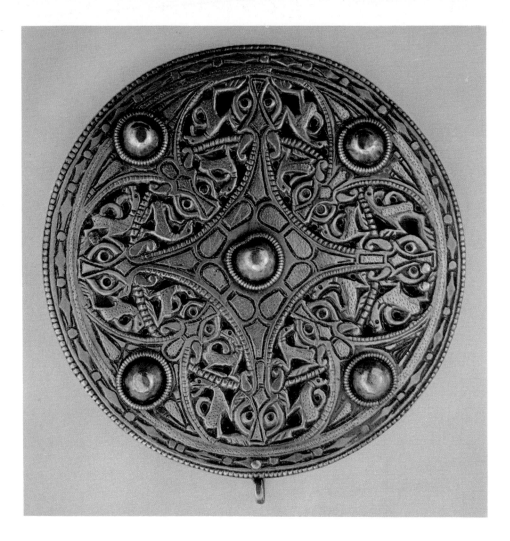

Strickland Brooch. Ninth century. Silver with gold, niello and blue glass, diameter 4¹/₂". British Museum, London

During the long Scandinavian occupation of England, artistic forms, expressing very clearly the artistic influence from the North, did not fail to evolve. Mediterranean forms continued to predominate in Church art, but articles of secular use were modeled predominantly on the animal style from the North. The *Strickland Brooch* has the same technical excellence, colorfulness, and assured composition as Scandinavian works. It is circular with an almost architectural quatrefoil in which a radiating square is inscribed. The outer regions of both patterns form animal heads, which in turn are surrounded by small, antithetical animals. The forceful, animated forms of the jewel probably contain a secret symbolism, the significance of which the owner took to the grave with him.

The Academician's Headpost from the Oseberg ship burial. Ninth century. Wood. Universitetes Oldsaksammling, Oslo

The finds from the ship burial of a queen in Oseberg in Oslofjord give us a good idea of Viking times. Besides exact information on ship building, this burial has provided us with a large number of articles of daily use, ranging from beds and sleighs to household and agricultural implements. The richly ornamented objects show that the art of carving on a large-scale existed in the North, and in it we can even distinguish stylistic differences. This lion's head, with gaping mouth and staring eyes and covered with an intricate pattern of interlace work, tells us more than the sagas about the violent impulses and feelings of the Vikings under whom central Europe suffered so much.

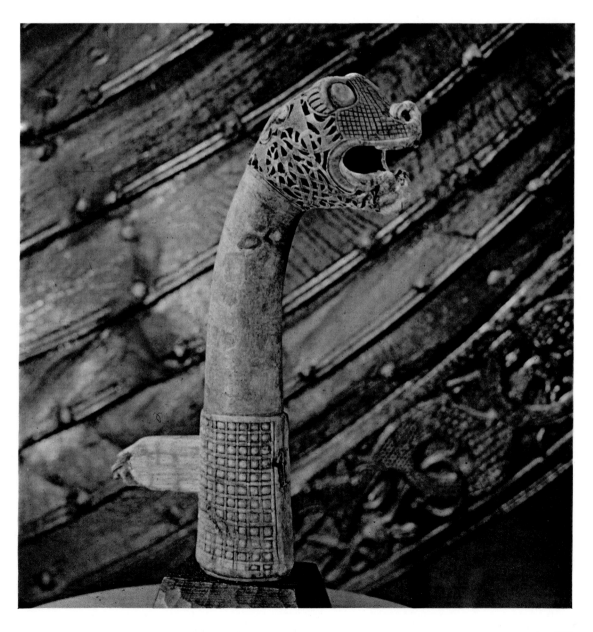

It is not only in carving, but in cast metal too that one finds strange animal heads, like this example from a richly furnished burial in Søllestedt. Realistic features, such as the gaping mouth and the enlarged threatening eyes, alternate with ornamental, mysteriously convoluted interlace work, which lends the head an air of strangeness and menace. This art was far removed from the formal world of the Mediterranean and had grown into something quite independent. At the time of the great Viking migrations and Norman invasions in central Europe, this style became very widespread in the North, England and Scandinavia influencing each other particularly strongly.

Animal head on a horse collar. Ninth century. Bronze gilt.
From Søllestedt, South Fyn. Nationalmuseum, Copenhagen

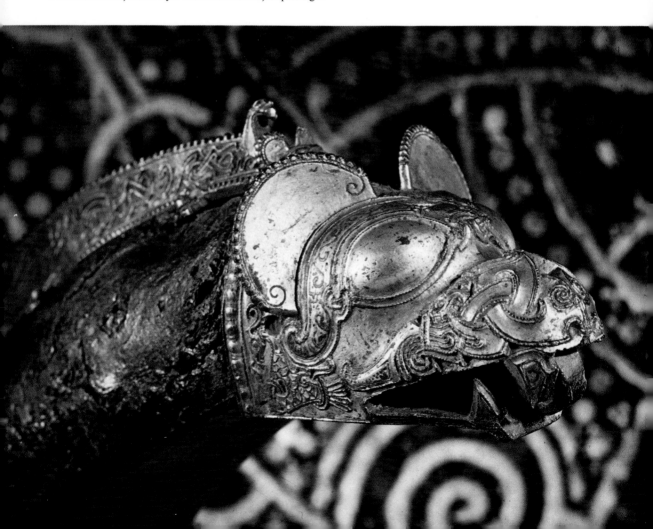

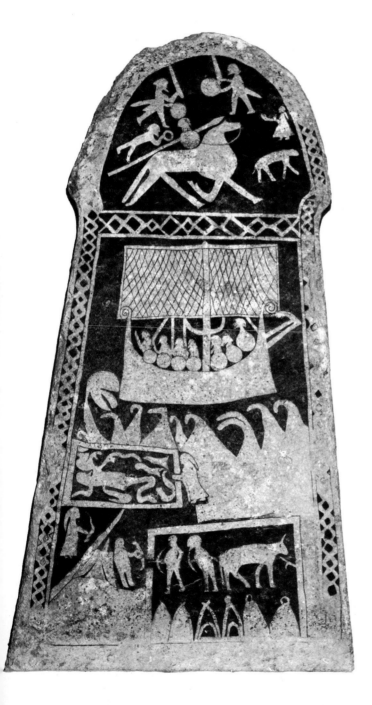

The pictorial stones of Gotland form a special group of monuments. Most of them are tall stone steles of rectangular form, surmounted by a kind of head, representing varied mythological scenes in low relief, some of which were once picked out in color. There are rare cases of comparable works on the continent, such as the equestrian stone of Hornhausen.

In the late steles from the eighth to the ninth centuries, an ornamental band surrounds the outer edge of the stone. The stone itself tells of various events in a kind of pictorial script that has not yet been fully interpreted. Probably the stone also relates events that were only to be written down, in the form of the Icelandic sagas, several centuries later. The motif of the horseman, which may be either Christian or heathen, and representations of ships appear together with scenes of battles and skirmishes. We know of no Late Roman classical models, so these curious stones appear to be a quite independent pictorial art form.

Picture stone. Eighth century (?). Height c. 9′ 6″. From Klinte Hunnings

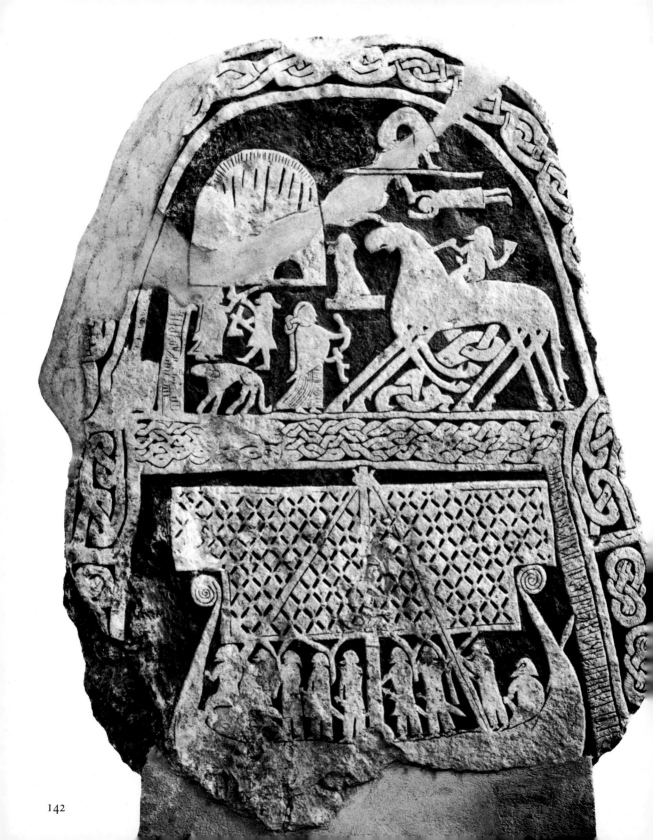

The runic stone of the Danish king, Harald Gormson Blaatand ("Bluetooth"), who died about 986, formed part of a larger Christian place of worship which also had a stave church and two large burial mounds. The northern mound, with the runic stone of King Gorm, dated back to an earlier, heathen site. Toward 960, King Harald was converted to Christianity, and the runic inscription on his stone tells of his conversion of the Danes. The pictures on the stone combine Christian and heathen motifs: on one side interlace work and tendrils twine round a four-footed animal; on the other is a figure of Christ. So, while Christian art was experiencing its second great epoch under the Ottonians in the rest of Europe, Christianity was securing its first footholds in Scandinavia.

Runic stones of the Viking kings Gorm (right) and Harald (left). Tenth century. Jelling (East Jutland, Denmark)

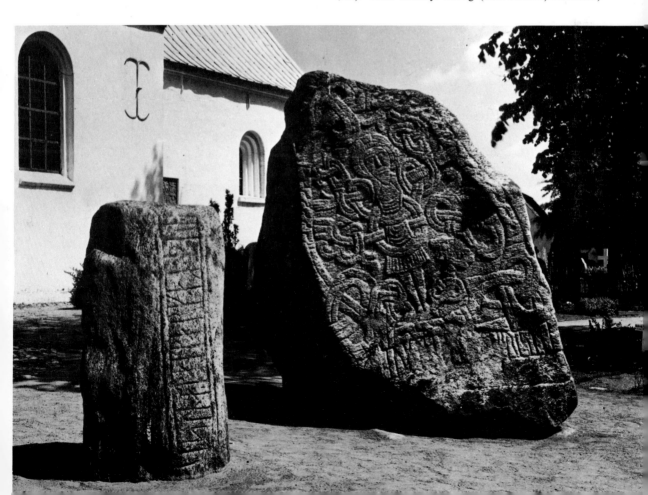

This little wooden casket encased in the ivory of mammoth tusks has been described as the "jewel box of Saint Kunigunde" (Empress Kunigunde, widow of Emperor Henry II, canonized in 1200) since the nineteenth century, although this attribution cannot be proved. The intertwined ornamental foliage, the bands, and the involuted and interwoven animals and birds, are motifs from the late Jelling style of Viking art (c. 980–1050). Presumably this piece was imported.

The three southern and eastern Swedish swords (right) are also Viking works. Their outstanding ornamentation expresses the sophisticated taste for luxury of their highborn owners, while at the same time the style of the ornament is remarkably clear, assured, and balanced.

Casket. c. 1000. Ivory, height 7¹/₈″. South Scandinavian work. Bayerisches Nationalmuseum, Munich

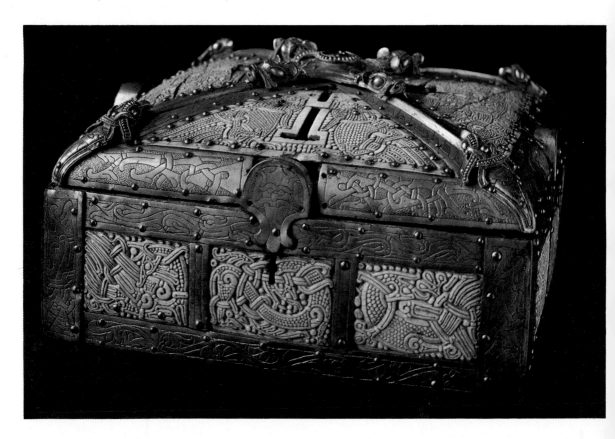

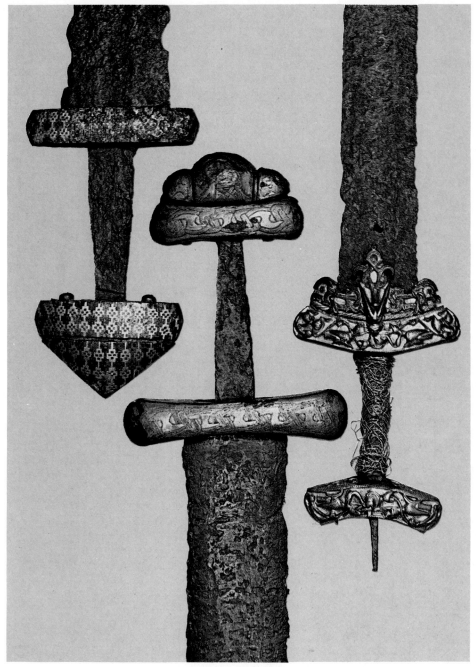

Three Viking swords. Tenth to eleventh century. About one-third life-size. Statens Historiska Museum, Stockholm

Left: sword from Gotland; the pommel and hilt inlaid with silver, copper, and bronze

Center: sword from Upland; the pommel and hilt inlaid with silver and bronze; the blade is named "Ulfberth"

Right: sword from Dybeck/Schonen; the handle is entwined with gold wire; the silver gilt pommel and hilt decorated in the animal style

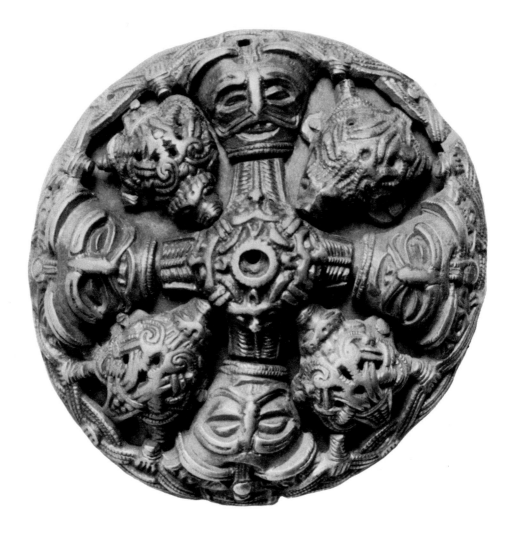

Round brooch. Tenth century. Silver, diameter $3^{1}/_{4}''$.
From Gärdslösa. Statens Historiska Museum, Stockholm

This round silver brooch from Sweden, closely crowded with masks, reaches far into the formal world of the Middle Ages. Human and zoomorphic heads interspersed with plant elements alternate in high relief. Some details are reminiscent of English forms and others of continental Carolingian foliage work. Nordic art adopted these motifs in the second half of the ninth century. In this way, much of the gold and silver from Scandinavia preserves something of the great traditions of Carolingian metalwork, of which so little has come down to us from the period of Charlemagne.

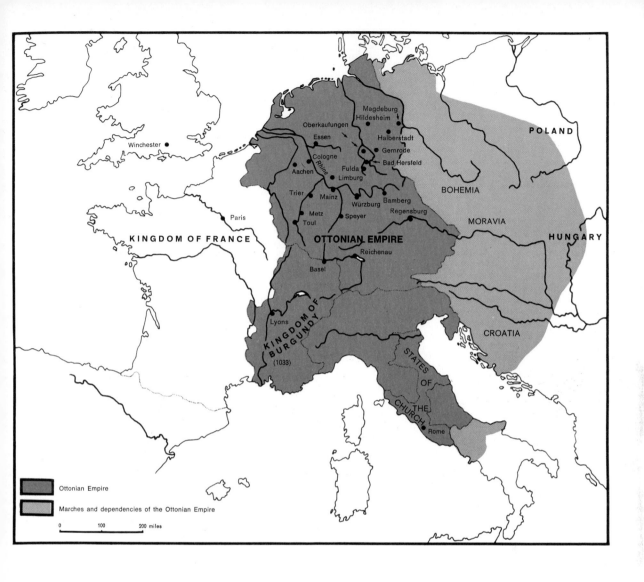

Central Europe at the Time of the Ottonian Empire
and Ottonian Art

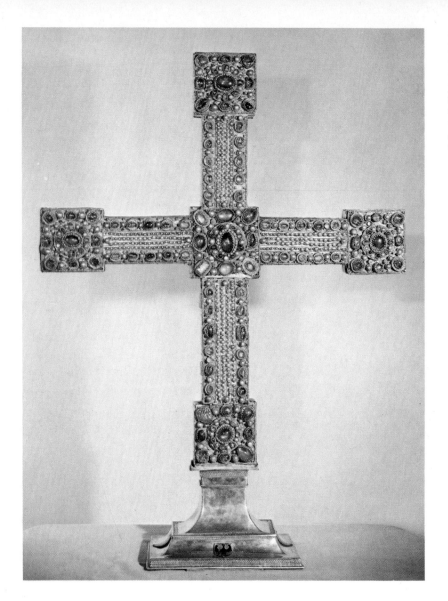

Crown of the Holy Roman Empire. Probably made for the coronation of Otto the Great in Rome in 962. Gold, filigree, precious stones, pearls, and enamel, height 6⅛". The arch was renewed c. 1025 under Conrad II and bears his name, and the cross, a former pectoral cross of Otto I, was added to the front. Treasury, Vienna

Imperial Cross. Early in reign of Conrad II (1024–39). Gold, precious stones, and pearls. Fourteenth-century base. Treasury, Vienna

The Imperial treasures were the outer symbols of the sanctity of the "Roman Empire of the German Nation." They included the insignia of Empire, such as the crown, scepter, mantle, and cross, and the sacred Imperial treasures, i. e., relics like the Holy Lance and fragments of the True Cross.

The Imperial Cross was originally a reliquary. As a "Cross of Victory" (see page 250), it fortified the Emperor in his fight against the enemies of the Empire and the Church by virtue of its relics and the symbolic power of its ornaments.

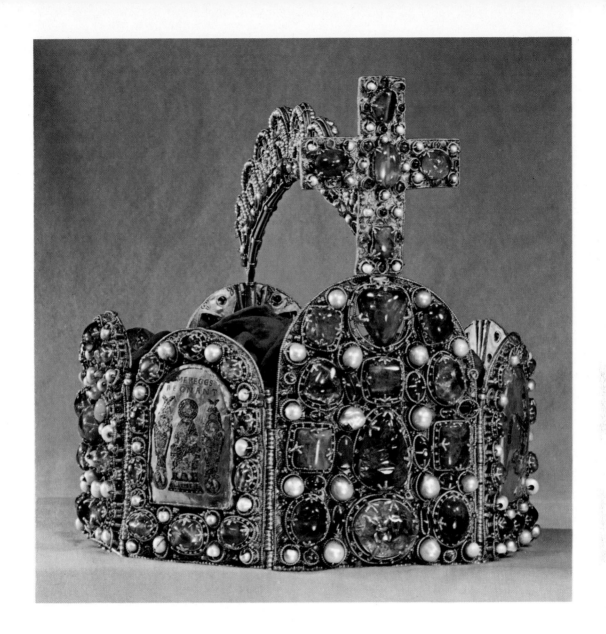

The great technical and material value of the Imperial Crown reflects the dignity and splendor of the Empire. The allegorical octagonal shape of the crown, the deeply symbolic number, order, and color of the jewels, and the pictorial themes on the plaques of cloisonné enamel (Christ and kings from the Old Testament), stand for the Kingdom of God declared in the Old Testament, renewed through Christ, and embracing the whole of the Divine universe.

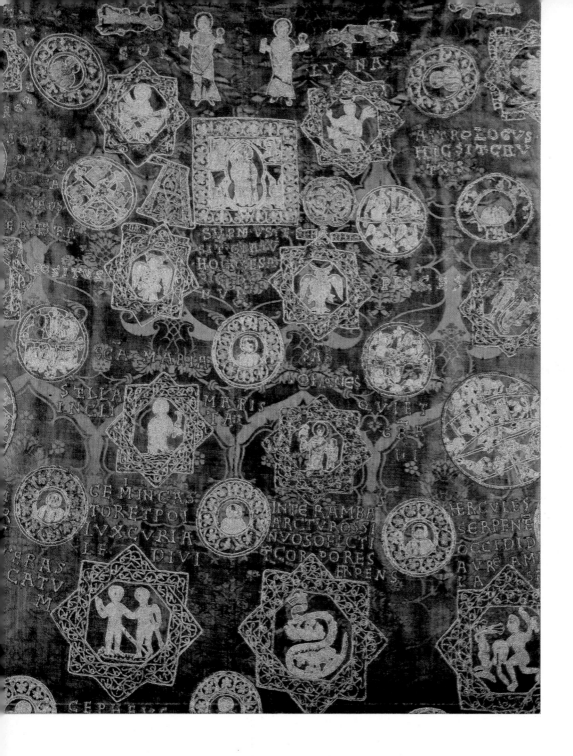

Star Mantle of Henry II, given by Duke Ishmael of Apuleia (d. 1020) who fled to Germany. Cathedral treasury, Bamberg

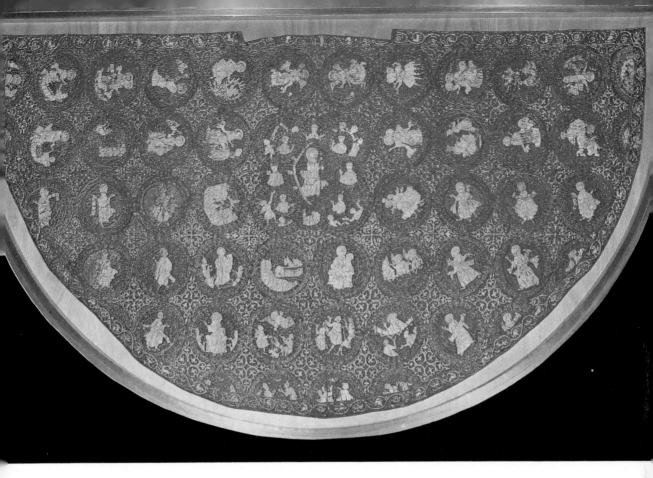

Ceremonial Mantle of Empress Kunigunde, wife of Henry II. Presumably made in the first quarter of the eleventh century in a court workshop at Regensburg, and presented to the newly founded Bamberg Cathedral by the Imperial house. Restored 1955. Cathedral treasury, Bamberg

In Ottonian times, the Imperial ceremonial robes consciously imitated the Mass vestments of the higher clergy in form and pictorial theme. This was done *in imitatio sacerdotii* in order to underline the Christian basis of the Empire. Thus the mantle of Kunigunde (above) has the form of a chasuble. Its pictures illustrate the great Biblical theme of the perpetual return of the Son of God: Christ strides forth from the gates of heaven, surrounded by events from Advent and Christmas.

The mantle of Henry II (left) depicts the earthly and heavenly bodies in its pictorial scheme elaborated upon by inscriptions, as the robes of high priests and emperors in antiquity were traditionally wont to do: Christ as center of the world is enthroned between the Virgin, Saint John, the sun, the moon, constellations, and the symbols of the Evangelists.

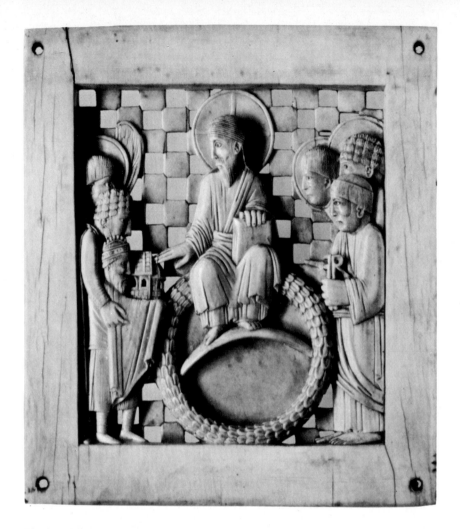

The Magdeburg Antependium. Christ receives the model of Magdeburg Cathedral from the Emperor Otto I, attended by his patron saint, Maurice, and an angel, probably Saint Michael; the other side shows Peter, another patron saint of the cathedral, with two other saints. c. 970–80. Ivory panel, $4^{1}/_{4} \times 3^{7}/_{8}''$. Probably northern Italian (Milanese?). Gift of George Blumenthal, The Metropolitan Museum of Art, New York City

In Magdeburg, which lay on the eastern border of the Ottonian Empire and in the "royal domain" of the Harz, the Emperor Otto the Great endowed an archbishopric in 986, and founded the cathedral of Saint Mauritius. The cathedral furnishings included an *antependium* or bishop's throne decorated with ivory panels of scenes from the Life of Christ. This early masterpiece of Ottonian ivory was partly destroyed by a fire in the cathedral. Twenty panels are now scattered among different collections and museums.

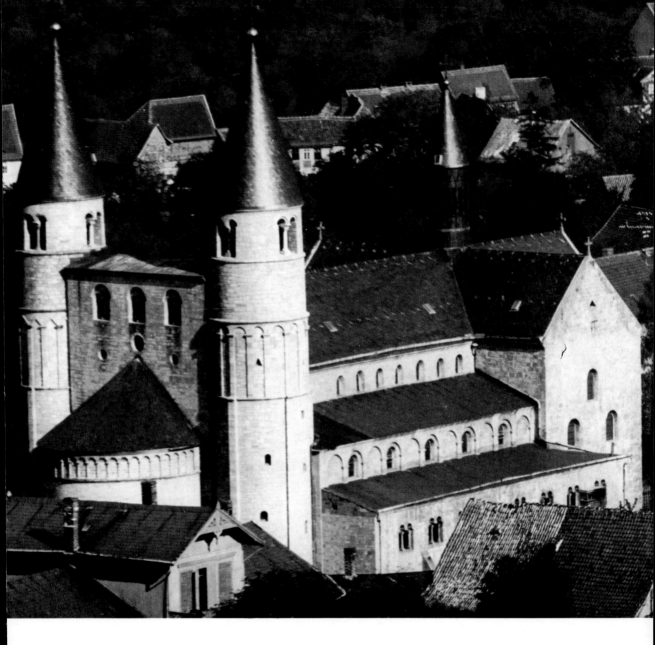

Former convent church of Saint Cyriakus in Gernrode. c. 961–65. The original westwork replaced by a western apse in the twelfth century

The Margrave Gero was a member of the close political entourage of Otto I and an important figure in the spread of Christianity in the region between the Elbe and the Oder. In 961 he founded the convent church of Saint Cyriakus, with his widowed daughter-in-law Hedwig as abbess. He himself was buried there in 965.

The building that survives from the time of foundation is an impressive example of early Ottonian architecture. The exterior is austere, stern, almost forbidding, only the apse being slightly ornamented.

153

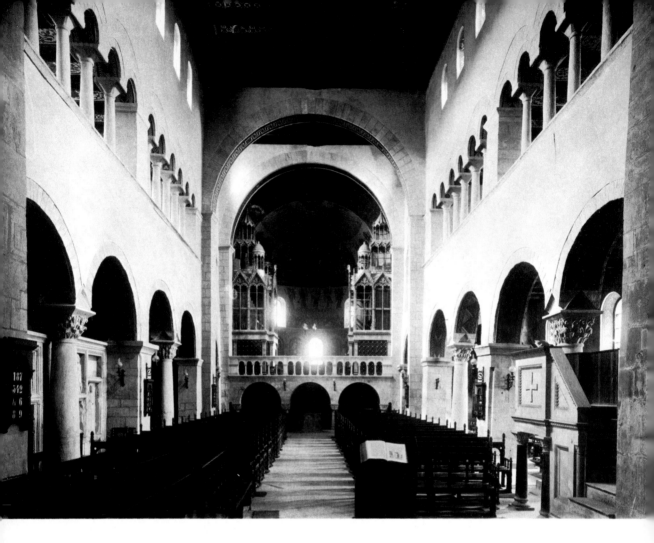

Former convent church of Saint Cyriakus, Gernrode. Interior, looking east. Built after 961

The animation of the nave walls of Saint Cyriakus through the alternating of piers and columns at the sides, through the open arches of the galleries with piers half way down the nave, and through the vertically non-aligned arrangement of the high clerestory windows, was an important new creative achievement. Galleries are found here in a distinct form for the first time, probably because of the church's origin as a convent, and as a consequence of the influence of Byzantine architecture (basilica of Demetrius in Salonica); but for the time being they were not repeated elsewhere in early Romanesque architecture.

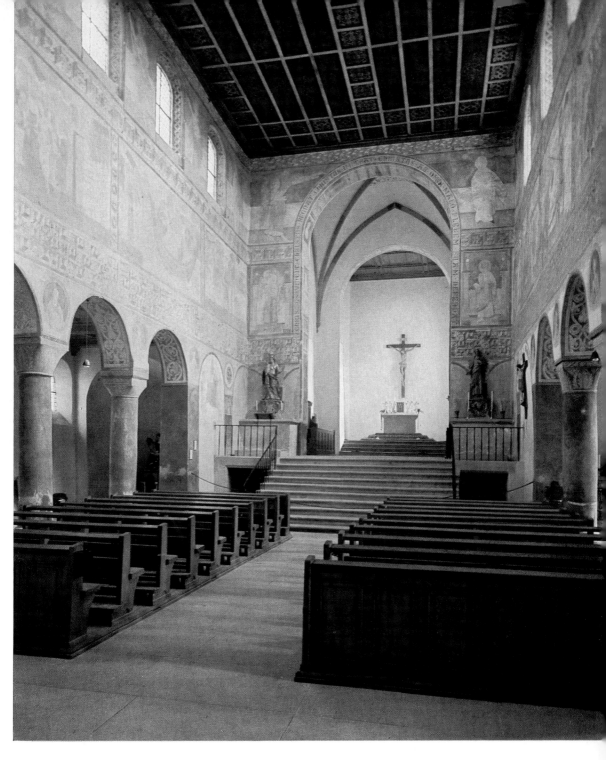

Former convent church of Saint George, Reichenau, Oberzell. Late ninth to fifteenth centuries. Wall paintings late tenth century, probably from the time of Abbot Witigowo (985–97)

The Calming of the Storm at Sea. Late tenth century. First painting on the northern nave wall, church of Saint George, Reichenau. Oberzell (see page 155)

The church of Saint George in Oberzell on the island of Reichenau in Lake Constance boasts the largest and most complete German cycle of wall paintings from Ottonian times (see page 155 and above).

A consistent polychrome scheme covers the nave walls of the church. Reddish-brown capitals with painted yellow palmettes rise from red columns, above which, between the arches of the arcades, are medallions with pictures of the abbots. Above these, separated by wide bands of a meandering pattern, are big rectangles with scenes from the saving acts of the life of Christ in warm tones of yellow, red, blue, and green. The expressive, animated figures contrast with the loving depiction of the surrounding details. Figures of prophets stand in the spaces between the windows of the clerestory. The three-tiered cycle originally culminated in a Christ in Majesty in the eastern choir. The paintings recall the traditions of Carolingian and urban Roman art and also reveal a strong Byzantine influence.

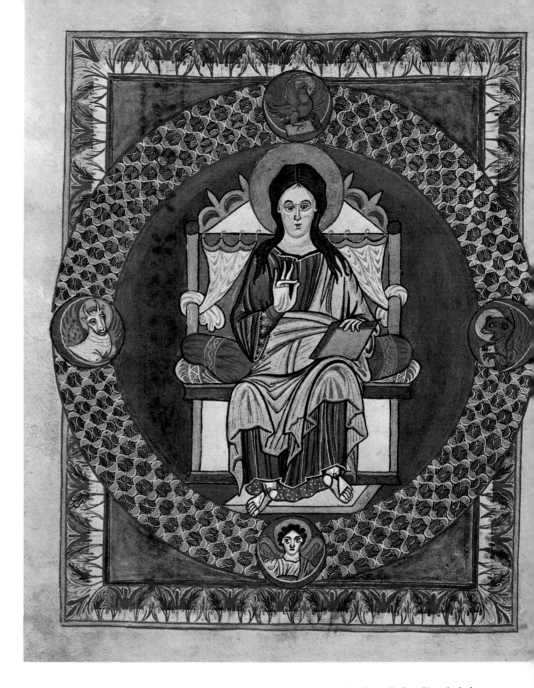

Christot in Majesty with the circle of the heavens and the symbols of the four Evangelists, from the *Gero Codex*. Shortly before 969; probably presented by the future archbishop of Cologne, Gero. Miniature on parchment. Hessische Landes- und Hochschulbibliothek, Darmstadt

The *Gero Codex,* with its exalted vision of Christ, stands at the beginning of Reichenau book illumination; it is close to the Carolingian *Lorsch Gospels.*

157

The Calming of the Storm at Sea from the *Second Gospel Book of Otto III*.
Late tenth century. School of Reichenau. Cathedral treasury, Aachen

The dedication miniature in this manuscript shows a monk named Liuthar offering the Emperor Otto III the Gospel Book. A whole series of miniatures all having close artistic and stylistic resemblances (see pages 164, 165, and 168) was executed by what is called, after this early master from the Reichenau monastic school, the Liuthar Group. The *Second Gospel Book of Otto III* contains, besides a glorification of the Emperor, the four Evangelists and twenty-one scenes from the Life of Christ. A comparison of the same theme in wall painting and illumination (see this page and page 156) clearly shows the sense of tension of the Reichenau School. The painting of the ship threatened by storm suggests that the two works were based on very similar iconographic models; but the drawing in the manuscript, particularly of the sea, is more calligraphic, more expressive. The architectural framework with dainty birds and flowers directly recalls Carolingian manuscript illumination.

Archbishop Egbert of Trier (see pages 174 ff.) commissioned two Reichenau monks, named Keraldus and Heribertus on the dedicatory leaf, to execute a manuscript for the Trier monastery of Saint Paulin. Perhaps the Codex was written and illuminated in Trier itself. The fifty-one scenes from the Life of Christ are the most comprehensive surviving pictorial program from Ottonian times. They were based on early Christian and Byzantine models, so that in the forms, movements, robes, and ornament, the world of Late Roman classical art of the fourth and fifth centuries shines through. But the strictness and symmetry of the composition, the intense eyes, and the animal-like foliage work express the new post-Carolingian style of the tenth century. The illuminations are the work of three or four masters, including the "Master of the *Registrum Gregorii*" (see pages 160–62).

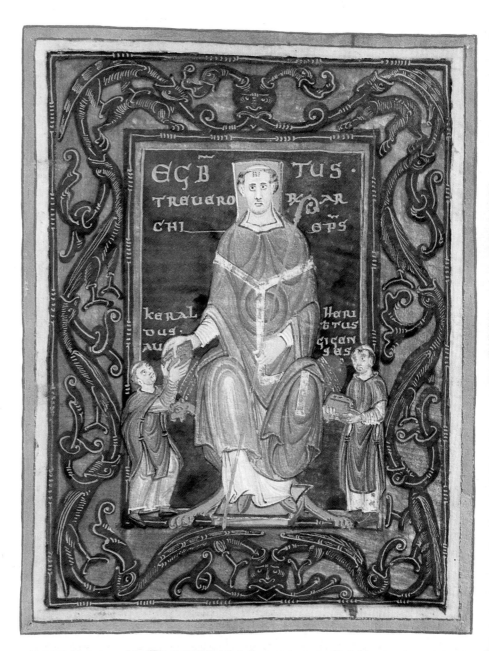

Bishop Egbert of Trier presented with the Codex Egberti by two Monks of Reichenau, Keraldus and Heribertus, from the *Codex Egberti.* c. 980. Dedicatory miniature on parchment, 9³/₈ × 7¹/₂". School of Reichenau. Stadtbibliothek, Trier

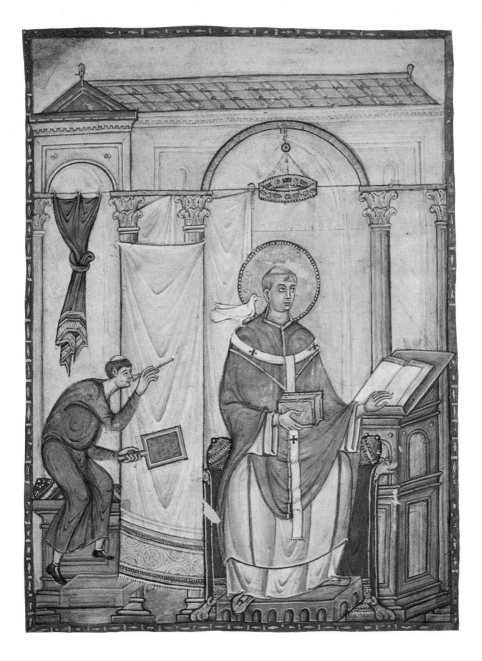

Fragment of the *Registrum Gregorii* (a collection of letters from Pope Gregory the Great), presented to the cathedral of Trier by Archbishop Egbert. After 983, before 996. School of Reichenau or Trier.
Left: *Pope Gregory the Great.* Stadtbibliothek, Trier
Right: *Homage to Emperor Otto II or Otto III.* Musée Condé, Chantilly

One of the ablest and most talented artists of the school of Reichenau, known, in the absence of his real name, as the "Master of the *Registrum Gregorii*," created these outstanding miniatures. Pope Gregory is seated at his desk under a canopied structure, by the bold perspective of which interior and exterior views are combined at one and the same time, listening, with thoughtful eyes, to the inspiration of the Holy Ghost through the dove; his deacon and scribe, recognizable by the board and quill, watches from behind a curtain.

The balanced color, the careful composition (the preliminary drawing is still visible and shows a correction to the arch above Gregory's head), and the relaxed lines are characteristic of the style of this master.

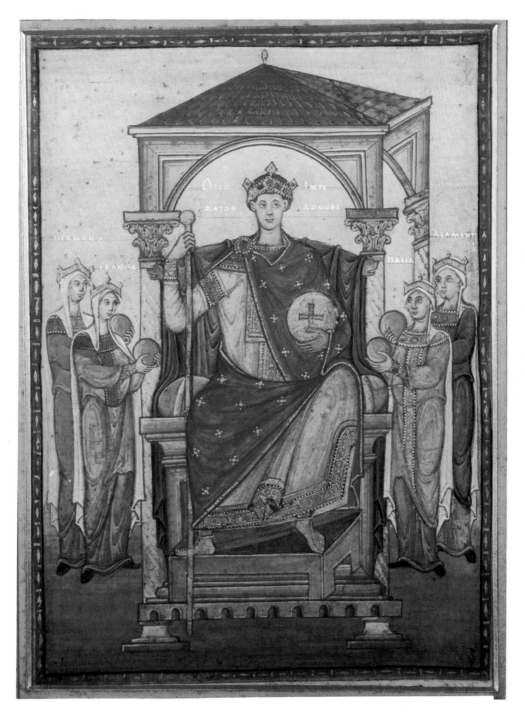

In this idealized picture of the Emperor enthroned under a baldachin—a still young, and yet lordly and dignified figure, receiving the homage of the four chief provinces of the Western Empire: Germania, Francia, Italia, and Alamannia—the artist achieved a remarkable apotheosis of the Ottonian Empire.

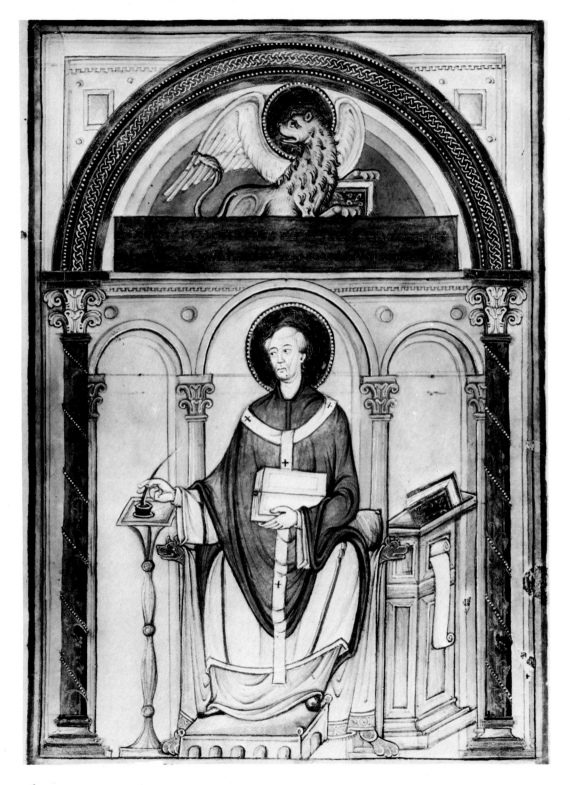

The Evangelist Mark, from the *Gospel Book of the Sainte-Chapelle,* Paris. c. 984. From Trier. Bibliothèque Nationale, Paris

This large and splendid manuscript, with text entirely in gold and with miniatures of Christ in Majesty and of the four Evangelists, was created at Trier. It counts as the masterpiece of the Master of the *Registrum Gregorii.* The superior, majestically remote figure of the Evangelist Mark, backed and surmounted by a remarkable piece of symmetrical architecture, proclaims the same artistic maturity as the Trier fragment (see page 160).

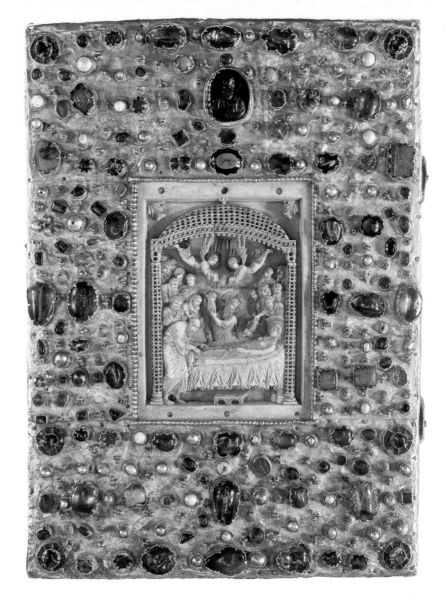

Cover of the *Gospel Book of Otto III,* showing the *Death of the Virgin.* Late tenth century. Gold, with precious stones, pearls, and filigree, with an ivory relief. From Reichenau. Bayerische Staatsbibliothek, Munich

The gold setting of the cover of this Imperial manuscript, encrusted with gems, pearls, and granulated filigree, has a delicate, tenth-century Byzantine ivory relief of the *Death of the Virgin* in the center. The manuscript is an important work by the Liuthar Group (see page 158). It contains the most comprehensive cycle of miniatures of the Life of Christ of any Ottonian manuscript except the *Codex Egberti.* The famous scene of homage to the Emperor extends over two facing pages—a novelty in illumination then (see over). The miniature of the same scene in the Chantilly fragment (see page 161) has acquired here an even more intense, monumental solemnity and remote dignity. The formal and spiritual resemblances in the depiction of the scene to the religious theme of the Majestas Christi are striking. The provinces paying homage recall iconographically the Adoration of the Three Kings; it is difficult to imagine a more intense expression of the priestly nature of the Emperor's sway.

163

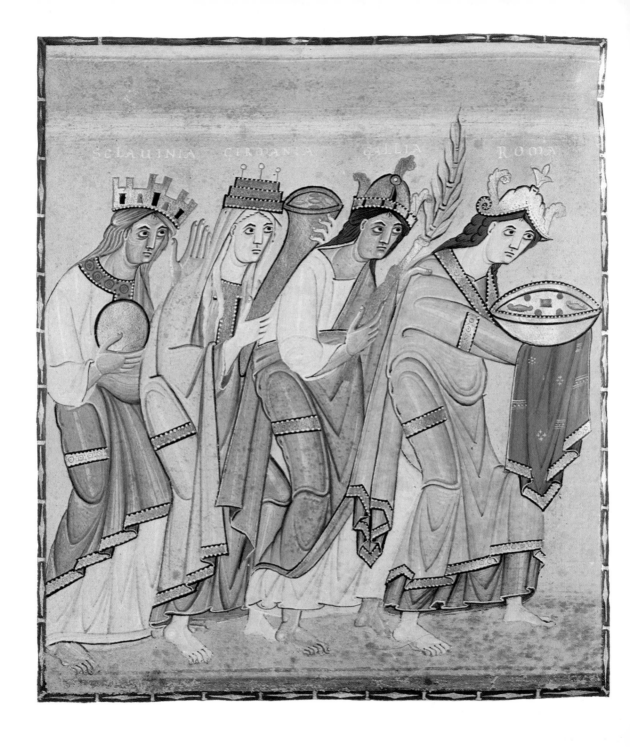

The Four Provinces Paying Homage to Emperor Otto III (above), and *The Emperor Enthroned between Two Ecclesiastics and Two Soldiers* (right). Miniatures from the *Gospel Book of Otto III*. Late tenth century. From Reichenau. Bayerische Staatsbibliothek, Munich

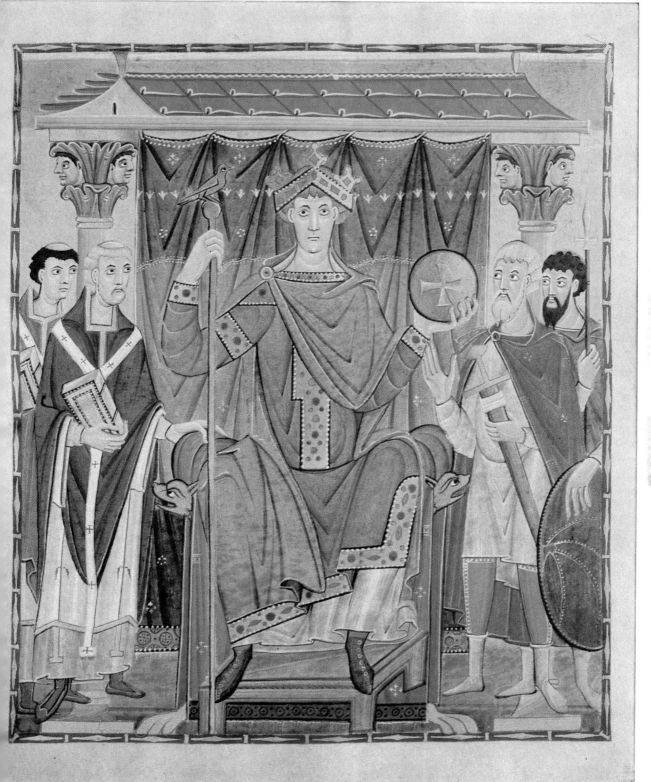

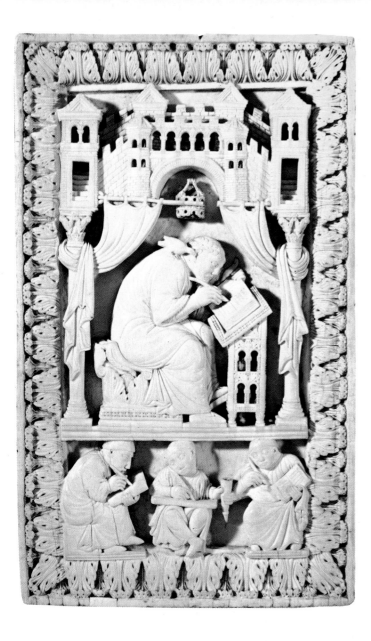

This is the same theme as in the miniature from the Trier *Registrum Gregorii* (see page 160): Pope Gregory the Great (590–604), the reformer of church music and the liturgy, receiving inspiration. Both works show the Saint at his desk in a study supported by columns. A semicircular vault surmounts him like an aureole. In each case the mysterious inspiration by the Holy Ghost is depicted in an entirely different fashion: in the painting an absorbed, almost transfigured hearkening to the Divine Voice, and in the ivory, an eager, almost breathless transcription of the inspiration in order to hold it fast. Three monks in the scriptorium below are copying and distributing the record of what has been beheld. The outstanding artistry of the carving, the joy in detail and narration, the balanced composition, and the marked Roman and Byzantine influences (e. g., in the architecture and the acanthus ornament) point to an artist from the circle of the workshop of the Master of the *Registrum Gregorii.*

King Henry, who became Emperor Henry II in 1014, and his wife Kunigunde presented this Codex on the foundation of the bishopric of Bamberg in 1007, or on the consecration of Bamberg Cathedral in 1012.

The splendid silver-gilt cover is decorated with four Ottonian gold cloisonné enamels with the symbols of the Evangelists, and twelve Byzantine gold enamels from the tenth century showing Christ and the Apostles. In the center of the cover is the delicately carved Carolingian ivory panel by the Liuthar Group (see page 158) illustrated on the right, dating from the second half of the ninth century. It shows the Crucifixion and Resurrection of Christ.

The artistically valuable miniatures in this manuscript (see overleaf) are fascinating for the sharply defined contours of the figures set against a plain ground, for the group's exaggeratedly expressive gestures, and for the penetrating intensity of their gaze. This late work by the Liuthar Group (see page 158) is the most mature and moving achievement of the Reichenau School.

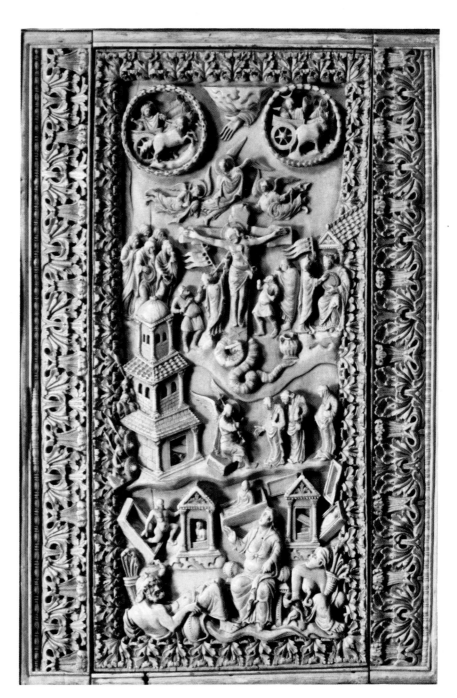

The Crucifixion, and The Holy Women at the Sepulcher, from the front cover of the *Book of Pericopes* of Henry II. Early eleventh century. Carolingian ivory relief. School of Reichenau. Bayerische Staatsbibliothek, Munich

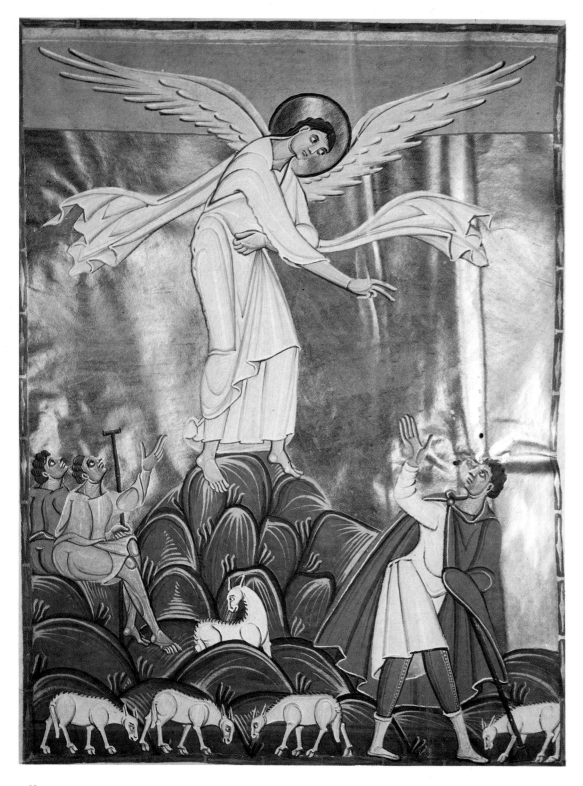

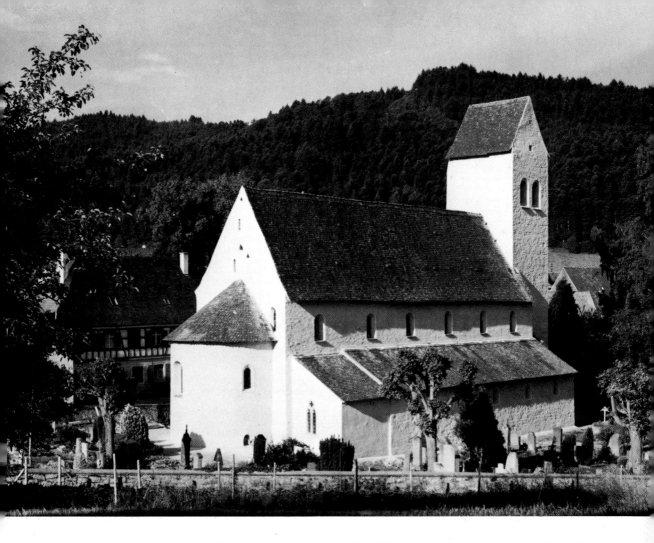

Former monastery church of Saint Cyriakus, Sulzburg. Exterior from the northeast

About 990–93, Birchtilo, Count of Breisgau, built the collegiate or conventual church of Saint Cyriakus in Sulzburg with the support of the Ottonian Imperial house. It was converted into a Benedictine convent on the transfer of Breisgau to the loyal bishopric of Basel in 1008. The monastery survived until 1555. Today only the church remains, and its complicated architectural history was not made clear until the restoration work and excavations of 1954–61. The original Ottonian building was a plain, three-aisled basilica without transepts; the western apse was the count's burial place, and the larger east choir—simple, austere, and clean in appearance—was for the monks. After its conversion into a convent, an eastern crypt was added, with a plain, single, middle column and a nuns' gallery which has now disappeared. Finally, toward 1280, the western apse was replaced by a contemporary belfry and the roof over the eastern apse was raised to its present height. The aisles, destroyed in 1510, were added again in 1963–64.

The Annunciation to the Shepherds from the *Book of Pericopes of Henry II*. Early eleventh century (before 1014). School of Reichenau. Bayerische Staatsbibliothek, Munich

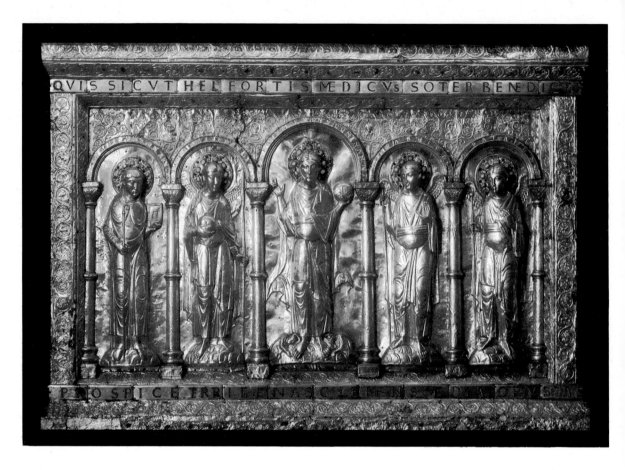

Christ Adored by the Emperor Henry II and the Empress Kunigunde between the Archangels Michael, Gabriel, and Raphael, and Saint Benedict on the so-called *Basel Antependium*. Total view. Detail of the head of Christ (right). c. 1015–20, 47¼ × 69⅝″. West German, perhaps from Reichenau or Fulda. Paris, Musée de Cluny

The Emperor Henry II and his wife Kunigunde originally donated these altar panels to the Benedictine monastery of Saint Michael in Bamberg, founded in 1015. The wooden core is covered with chased gold plate, the reverses of the images being filled with wax. Framed by ornamental foliage work, Christ, the three archangels, and Saint Benedict stand beneath a five-arched arcade. Their bodies glow delicately through the many folds of their draperies. Narrow lips, sharply cut noses, and a penetrating, almost piercing gaze characterize the faces of this row of dignified, reserved figures with their haloes of precious stones. Both the icon-like dignity of the individual figures (see the *Aachen Antependium*, page 190), and the delicate foliage work on the ground point to Byzantine inspiration. Christ is brought out by the higher arch, by his greater stature and richer draperies, and by the greater spiritualization of his features. At the feet of the heavenly Emperor, designated "rex regum et dominus dominatium" by the inscription, the Emperor and Empress kneel in homage and submission, *proskynese,* to indicate that they are the donors and as a sign that they hold their authority by the hand of Christ.

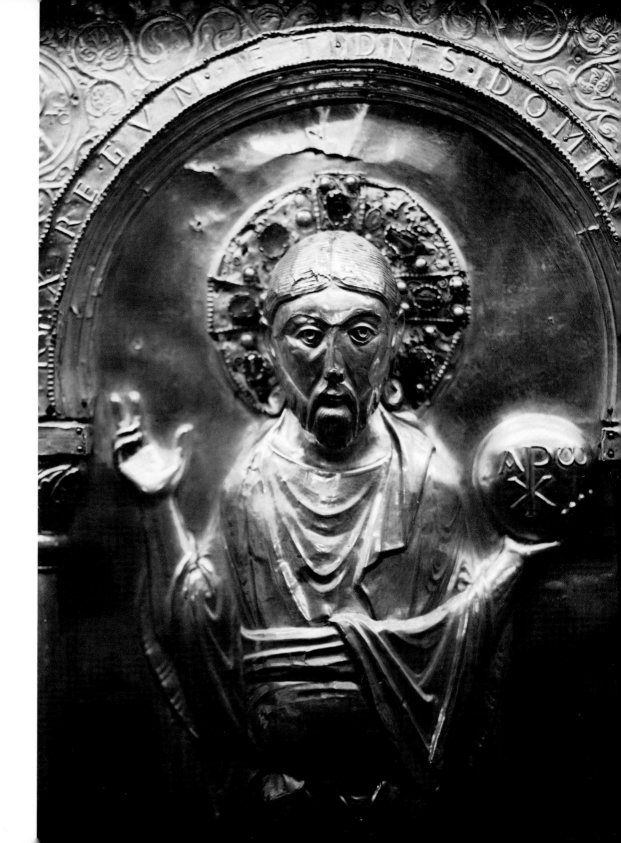

Saint Erhard Celebrating Mass, from the *Uta Codex.* 1002–25. Miniature on parchment, 15 × 10⁵/₈″. From Regensburg. Bayerische Staatsbibliothek, Munich. Clm. 13601, fol. 4 r

The highly varied cultural influences in the old duchy and bishopric of Regensburg resulted in a very curious and individual style of local illumination, quite distinct from the school of Reichenau in color and composition. The profoundly contemplative theological themes of the miniatures in the *Uta Codex* anticipate the twelfth century. The scenes are depicted in compositions built up from diverse geometric, ornamental, and figurative elements. The miniature reproduced here tells of the traveling bishop Erhard, who was buried and venerated in Niedermünster, but not canonized until 1052. In the dedicatory miniature, Uta presents the book to the Mother of God, described by the Greek name *"Theotokos."*

An artist of extreme individuality, known since 1899 as the "German Master of circa 1000," carved this ivory relief, which perhaps came from a book cover. It is a work of immense compositional boldness in the pressing together and mingling, almost, of the two figures. Christ is seen frontally, Thomas, by contrast, from behind, against a flat ground. The dramatic tension of the scene is concentrated in the direct encounter of the two figures' gaze. Here we can see the Reichenau School's creative power.

The powerful and realistic ivory panel on the cover of the *Codex Aureus* of Echternach (page 175) is by the same master. It shows Christ on the Cross between Longinus and Stephaton. Beneath His feet is the personification of the earth, above Him the sun and the moon—all symbols of the universal significance of the Crucifixion.

Saint Thomas and the Risen Christ. c. 1020–30. Ivory relief panel, height 9¹/₂″. From Trier. Former State Museums, Berlin

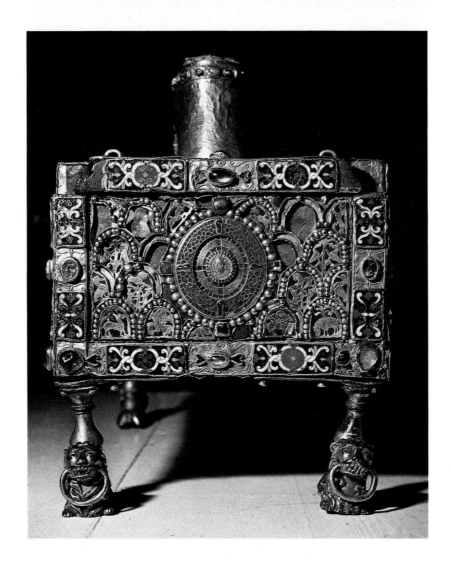

Reliquary of the Foot of Saint Andrew (narrow side). c. 980–90. Gold with precious stones, height 12¹/₄″. From Trier. Cathedral treasury, Trier

Under Archbishop Egbert of Trier (977–93), Chancellor to the Emperor Otto II, the old episcopal city on the Mosel experienced a golden age of artistic craftsmanship. While the Egbert miniatures were still painted by artists from Reichenau (see pages 159–61)—unless the Master of the *Registrum Gregorii* also worked in Trier—the three masterpieces of the Egbertian goldsmith's art were created in Trier itself.

The shrine above, donated by Egbert himself according to the inscription, is both a portable altar and a reliquary surmounted by an artistic reproduction of the relic it houses. Four lionlike legs support the reliquary, and it is crowned by the foot of Saint Andrew in gold, the sandal thongs being encrusted with precious stones.

Empress Theophano (d. 991) and her son the Emperor Otto III gave the "Golden Book Cover" (opposite) and the manuscript within, which no longer survives, to the abbey of Echternach, founded in 698 by Saint Willibrord, bishop of Utrecht. Precious stones, panels of cloisonné enamel, and rows of pearls frame eight chased figurative gold panels. In rich eschatological symbolism, they show the four rivers of Paradise and the symbols of the Evangelists (above and below), the Virgin, Peter, and four patron saints of Echternach, together with the two imperial donors (left and right). For a description of the ivory, see page 173.

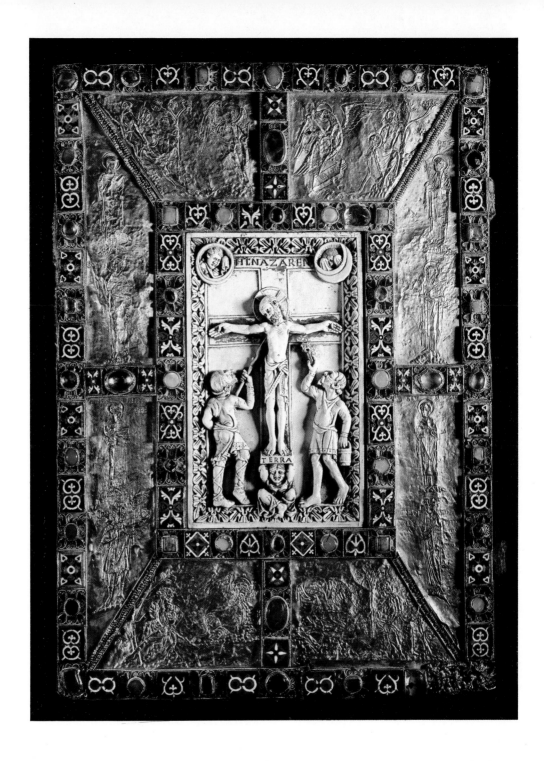

Cover of the *Codex Aureus* of Echternach. c. 985–91; the ivory relief of the *Crucifixion* somewhat later. Germanisches Nationalmuseum, Nuremberg (see text, pages 173 and 174)

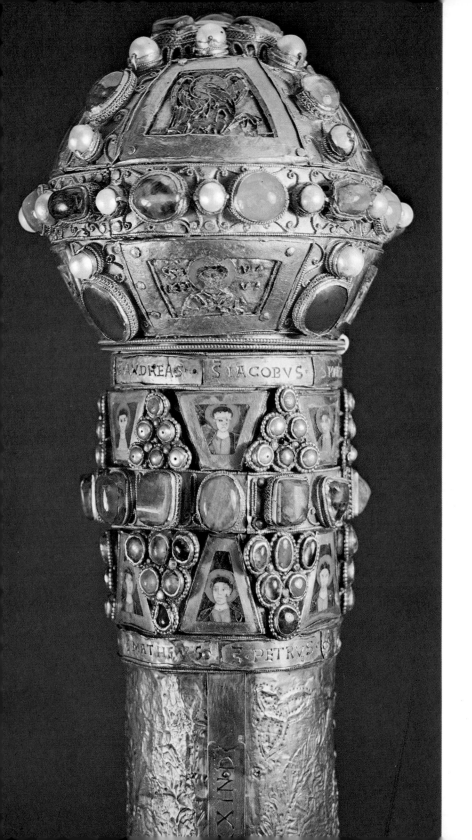

Gold casing of the *Staff of Saint Peter (Reliquary of the Staff of Saint Peter)*. c. 980. Gold, with precious stones and enamel, total height 6$\frac{1}{2}$". From Trier. Cathedral treasury, Limburg an der Lahn

Legend has it that the Apostle Peter gave his miraculous sacred staff to the bishops of Trier, Valerius and Eucharius, a symbol of the direct apostolic succession of the bishops of Trier. During the Norman invasions, the relic came to the archbishopric of Cologne which was engaged in a violent dispute with Trier. Proud of possessing such a religious and political trophy, Archbishop Warinus gave only the actual staff back to Bishop Egbert in 980: the pommel has remained till today in the Cologne treasury. Egbert had the staff covered in a wooden casing plated with gold and carved with reliefs of popes and the bishops of Trier; he also had a new neck and knob made with elaborate decoration in gold, precious stones, and enamel. The Emperor Charles IV, who stayed in Trier in 1354, gave a piece of the staff to the cathedral of Saint Vitus in Prague. In the nineteenth century the Trier gold piece passed to the bishopric of Limburg which was founded in 1821.

The reliquary made for Constantine Porphyrogenitus was originally in the Imperial Treasury of Byzantium (Constantinople), whence it was stolen by crusaders in 1204 and given to the monastery of Stuben on the Mosel by Knight Henry of Ulmen in 1208. In 1789, during the confusion of the French Revolution, it reached Coblenz; it arrived at Limburg in 1827.

The particles of the True Cross are concealed by a double cross set in gold and precious stones and created, according to the inscription, between 945 and 959—at the latest in 963. A silverplated casing made between 963 and 989 frames the double cross. The figurative enamel plaques set in the cross are of extreme delicacy in modeling, color, and technique; this work is impressive evidence of the outstanding ability of Byzantine artists in the tenth century.

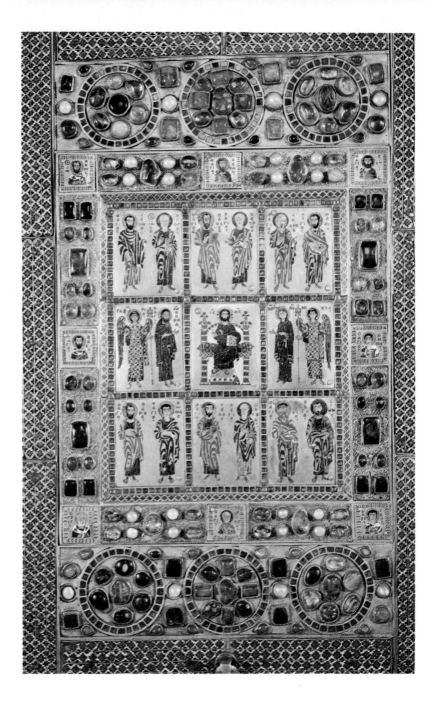

Reliquary cover of the True Cross, so-called *Staurotheca*. Second half of tenth century. Silverplated casing, enamel plaques, and jewels, height (length) 18⅞″. Byzantine, from Constantinople. Cathedral treasury, Limburg an der Lahn

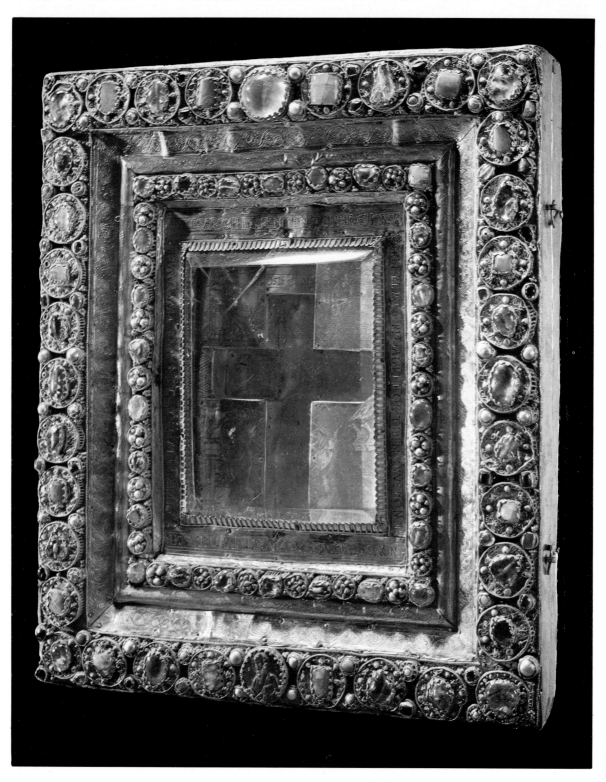

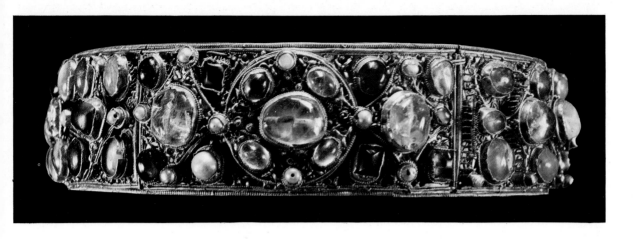

Crown of Empress Kunigunde. Early eleventh century. Gold, with precious stones and pearls, height 2″, diameter 7¹/₂″. West German, perhaps from Fulda. Treasury, Residenz, Munich

The Emperor Henry II gave this valuable late Ottonian work of gold (left) to Bamberg Cathedral, as we know from a Latin inscription on the front cover. Originally it was probably a reliquary for a particle of the True Cross consisting of two lids only, like the Limburg reliquary (page 177), and inspired by Byzantine works. Only later was it converted into a portable altar. In the middle of the front cover, a piece of rock crystal is worked in as an altar stone through which one can see the interior of the lower lid with its cruciform cavity for the relic and the glowing niello panels of the four Evangelists. The linear style of these figurative panels recalls the apostle pictures on the back of the Imperial Cross (see page 148). The outer wreath of precious stones set in gold also contains at the bottom a Byzantine cameo with a relief of the Apostle Paul.

The woman's crown (above) comes from a related, if not the same, workshop as the portable altar of Henry II. Since the late Middle Ages, it has crowned the Bamberg reliquary bust of Saint Kunigunde. No doubt it originally belonged to the Empress Kunigunde, wife of Henry II.

Reliquary of the True Cross and portable altar (so-called *Portable Altar of Henry II*) from Bamberg Cathedral. c. 1014–24. Height 16⁷/₈″. West German, perhaps from Fulda. Treasury, Residenz, Munich

Of the numerous architectural copies of the Aachen palatine chapel made in Ottonian and Salian times, Ottmarsheim is certainly the most complete, and it is almost the same size. The Habsburg, Rudolf von Altenburg, founded the abbey around 1040 and Pope Leo IX consecrated the church in 1049; so the building was not completed until the time of the Salian emperors. The differences between the model and the copy illustrate the transition to early Romanesque, e. g., the ambulatory is octagonal instead of sixteen-sided, so that the structure has clearer and more compact lines, and there are cubiform instead of Corinthian capitals. The style is therefore forward-looking, early Romanesque rather than a reuse of antique forms.

Chapel of Mary (exterior view) in the courtyard of the castle of Marienburg at Würzburg. Early Romanesque, tenth to eleventh century (?). Choir and stuccoed interior c. 1603; altars 1701

Church (interior) of the former Benedictine abbey of Ottmarsheim (Upper Alsace). Begun c. 1030–40, consecrated 1049

The Burgberg ("Castle Hill"), which dominated the Main, already had a stronghold on it in pre-Christian times. According to tradition, the Frankish Duke Hetan II had a Chapel of Mary erected inside the ramparts in 706 on top of the place of worship of a Germanic mother-goddess. The building that stands today, a round two-story structure with walls over ten feet thick, with semicircular niches hollowed out in the interior, formerly had a choir in the east and, under it, a three-aisled hall crypt: accordingly, the structure could only have arisen in early Romanesque times, not in 706, and is to be considered a small-scale copy of Aachen. The bishop of Würzburg, Julius Echter von Mespelbrunn (1573–1617), had the old chancel destroyed, the present choir added, the larger windows broken through the walls, and the interior stuccoed in 1603.

Former Benedictine monastery of Saint Andreas in Fulda-Neuenberg. Monastery church consecrated 1023; crypt with cycle of wall paintings on the vault from the time of construction. Below: crypt with view to the east. Right: festal row of angels bearing symbols of Christ as Ruler

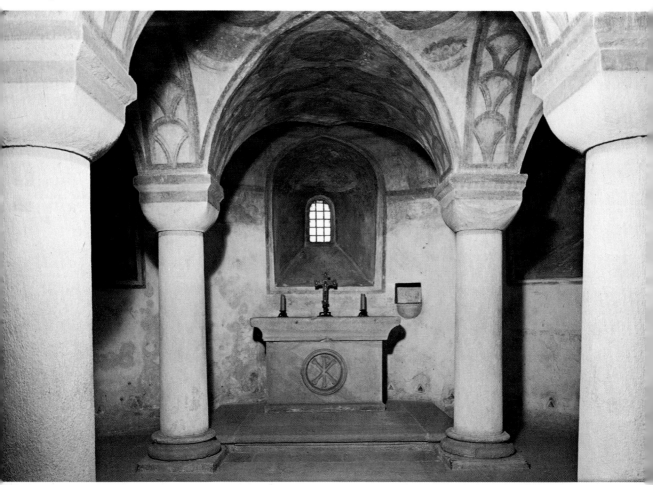

Four medieval hilltop monasteries still surround the old monastic town of Fulda—the Frauenberg, the Andreasberg, the Petersberg, and the Johannesberg. In the twelfth century, their locations were already seen as together being at the extremities of an imaginary cross. The Benedictine monastery of Saint Andreas was founded by the Fulda reforming abbot, Richard von Amorbach (1018–39), soon after his consecration. By 1025, the Emperor Conrad II had already stayed in the monastery. In spite of the encroachments of rebuilding and extensions in Baroque times, the eastern part of the church, with transepts, choir and apse, has survived. Four columns with simple block capitals subdivide the semicircular crypt and carry a semicircular barrel vault with an intersection in the center. The vault paintings discovered in 1930–32, dating from about 1020, are a rare and valuable example of late Ottonian German monumental painting (cf. pages 155 f.). The theme of the paintings points symbolically to the Canon of the Mass: each of the three window niches shows Christ in a *mandorla* and an Old Testament scene referring typologically to the Crucifixion in the New Testament. The surrounding barrel vaulting has a ceremonial row of twenty-two angels and Christ's symbols of empire. On the two central surfaces of the vault are medallions of kings and saints. The paintings are all carefully framed by wide ornamental bands stressing architectural features of the crypt (edges, ridges, and vault surfaces).

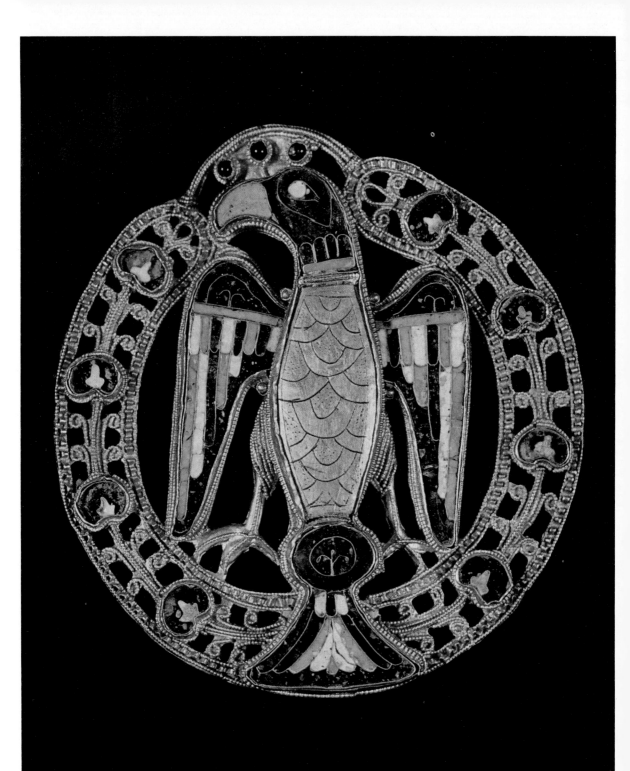

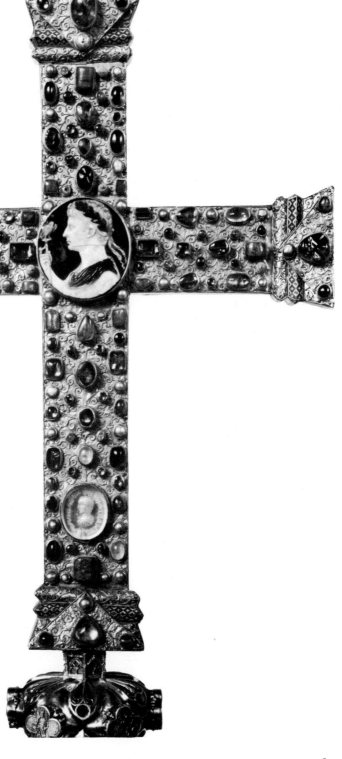

Eagle fibula, so-called *Gisela Jewel*. c. 1000. Gold with enamel, height 3⁷/₈". West German. Mittel-rheinisches Landesmuseum, Mainz

Cross of Lothair. c. 1000. Fourteenth-century base. Gold, silver, precious stones, and enamel. Height 19¹/₂". Cathedral treasury, Aachen (see overleaf)

In 1880, chance diggings in Mainz uncovered the ceremonial robes of an Ottonian Salian queen of the tenth or eleventh century. The finds included a gold collar, a brooch of precious stones and pearls, earrings, combs, eagle fibulas, tassels, and rings. Most of the jewelry went to Berlin, but the most beautiful and outstanding piece remained in Mainz: a large eagle fibula (left), with white, emerald, and turquoise enamel on gold, originally worn on the breast as a fastening for clothes. The eagle had been seen traditionally as a commanding, sovereign animal since Germanic and classical times. In the Middle Ages it became an imperial attribute and was used in art many times as a symbol of imperial sovereignty (e.g., on capitals). The usual ascription of the fibula to the Empress Gisela, wife of Conrad II, is only an assumption.

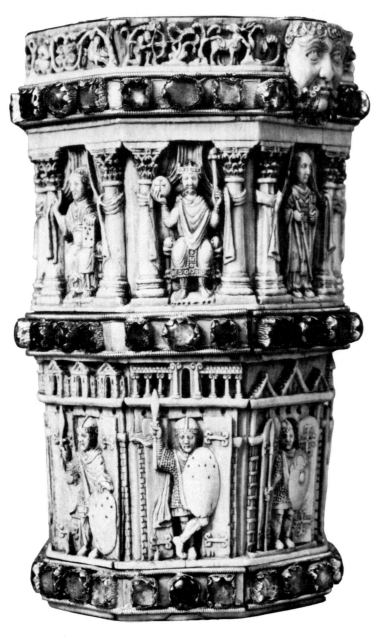

Saint Matthew, from the *ambo* of Emperor ▶
Henry II. 1002–14. Ivory, height 8¹/₄″. West
German. Aachen Cathedral

Situla. c. 1000 or early eleventh century. The
metal and precious stones renewed in the
nineteenth century. Height 7″. Cathedral trea-
sury, Aachen

The Ottonian emperors dedicated val-
uable works of church art to the pala-
tine chapel at Aachen. The *Cross of
Lothair* (page 185) excels not only in
material value through its gold, silver,
and precious stones, but also by its per-
fect craftsmanship; the masterly use of
filigree, enamel, and engraving; and the
well-proportioned order and harmoni-
ous distribution of the precious stones
according to a color scheme and to their
symbolic value. In Byzantine fashion,
the Roman sardonyx cameo in the
center of the cross, depicting the Em-
peror Augustus, points to Christ as the
true King and Emperor, and at the
same time to the earthly emperor, the
protector and servant of the cross, prob-
ably Otto III. The reverse of the cross,
perhaps made in a Cologne workshop,
is engraved with Christ on the Cross.
The maturity and greatness of this work recall *Gero's Cross* in Cologne.
The pictorial theme of the ivory relief on the situla above, probably presented by Henry II and used at his coro-
nation, emphatically stresses the secular, and yet priestly and apostolic nature of the Emperor's mission,
parallel to the Pope's spiritual one. The Apostle Peter, standing, is flanked by Pope Sylvester, enthroned on
his right, and by the Emperor on his left; in the lower register, earthly soldiers guard the gates of the heavenly
city, the *civitas dei.*

The pulpit of Henry II has hung in the Late Gothic choir of Aachen Cathedral, above the door to the sacristy, since 1414. It is in the form of three semicylindrical bays and, according to the inscription, the Emperor bestowed it on the Carolingian cathedral as an *ambo*. Five chased copper gilt reliefs of Christ and the four Evangelists once decorated its body, but only the relief of Saint Matthew has survived, one of the noblest figurative reliefs of the late Ottonian era. The almost classical clarity and elegance of the Evangelist recalls Carolingian models. The interlocking architectural features, an indication of the heavenly city of Jerusalem, are very distinct from the works of the school of Reichenau and suggest a Cologne master.

The pulpit is divided in all into fifteen coffered areas. The five central ones are arranged in the form of a cross and contain five ornamental pieces of very varied origins: a classical agate bowl, a Roman glass bowl, a contemporary agate bowl, a Fatimid Islamic cup (tenth century), and an accompanying saucer of rock crystal. Each of the two side areas contains three large Alexandrine reliefs of the sixth century B.C.: a warrior on horseback being crowned by the genies (opposite); nereids riding on tritons (left); the god Bacchus surrounded by foliage; a standing warrior; the Egyptian mother-goddess Isis with genies and animals; and another Bacchus. There is no visible connection between these subjects, and one cannot interpret them in a Christian way. It may be that they were never conceived as such. The inclusion of original Roman objects in an Ottonian work and within a Carolingian church was perhaps meant to serve simply as a striking and visible proof of the continuity of the Empire between Roman and medieval times.

Ambo of Emperor Henry II. Late Roman ivory reliefs. Left: nereids and tritons. Right: horseman with genies. Aachen Cathedral

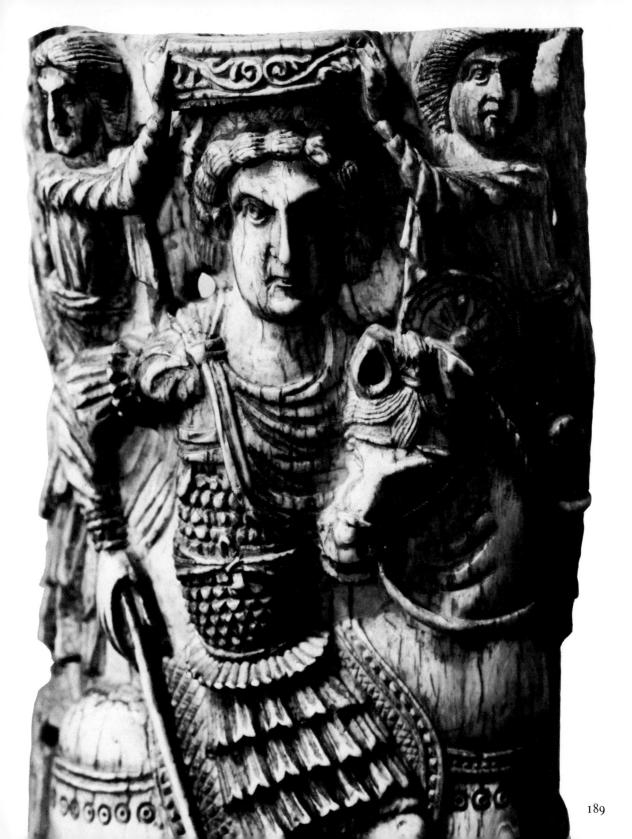

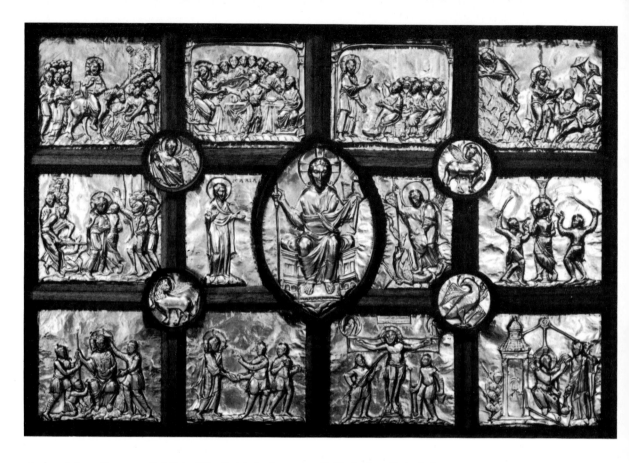

Aachen Antependium, so-called *Pala d'Oro* (total view). c. 1020. Gold. Aachen Cathedral

The famous *Aachen Antependium* is another gift from the Emperor Henry II to Aachen Cathedral. It is a gold altar frontal which still shimmers before the high altar. The wooden frame, renewed in 1950, holds seventeen chased gold reliefs. In the center is an almond-shaped relief of Christ as a ruler and judge, to whom the Virgin and Saint Michael on either side turn in intercession. Ten other reliefs tell of the Passion and Atonement of Our Lord, beginning with the Entry into Jerusalem and the Last Supper, and ending with the Crucifixion, and the Holy Women at the Sepulcher. The four circular symbols of the Evangelists were formerly at the corners of the frame. Presumably this frontal is only a part of what was once a complete paneling covering the whole altar. Details of the partly damaged or flattened reliefs were remade in the nineteenth century. As a whole this is an outstanding religious artistic masterpiece of late Ottonian goldwork, its precious metal aglow and its scenes and figures startling in their intensity.

The technique and style, the type of the figures, and, in particular, the iconography of the reliefs, are related to other contemporary works, such as the gold cover of the so-called *Treasury Gospels* in the cathedral treasury at Aachen (1020); to the manuscript itself of the early ninth century (see page 104); to the figurative niello reliefs on the *Portable Altar of Henry II* in Bamberg Cathedral (see page 178); and also, despite all the differences, to the *Basel Antependium* (see pages 170 f.). According to recent research, these stylistic connections suggest that all these works were created near the abbey of Fulda. This would point to the existence at Fulda of a late Ottonian artistic center, almost unknown hitherto, in the first quarter of the eleventh century.

In the scene of the Last Supper below, Christ is seated at the left-hand corner of the semicircular table, but is raised to the center of spiritual attention because of His stature, His halo, and the direction of His gaze upon the Apostles. Judas is linked to Christ by the gesture of his arm, yet stands apart before the table and the rest of the picture, already an outcast.

The Last Supper. c. 1020. Second relief panel on the *Aachen Antependium*. Gold. Aachen Cathedral

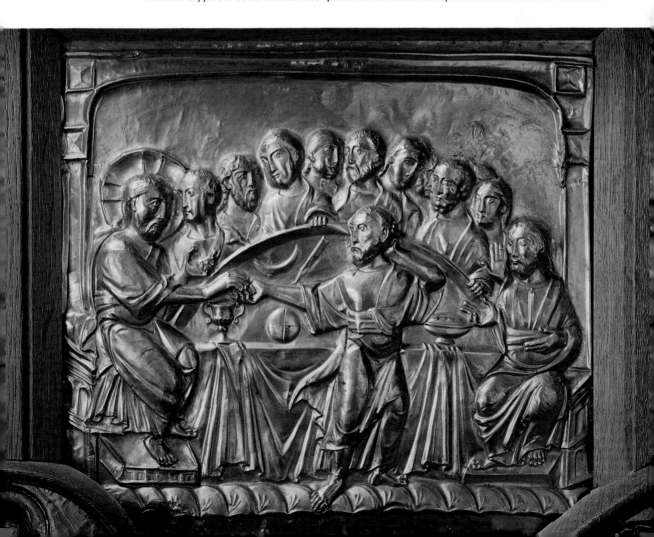

Archbishop Bruno of Cologne (953–65), brother of Emperor Otto I, founded the former Benedictine abbey of Saint Pantaleon on the hill of Pantaleon in Cologne in 957, which was already settled in Roman times. Thanks to endowments by the Empress Theophano, the widow of Otto II, the church was rebuilt after 984. The Empress was buried there in 991 and the building was probably completed on the lying in state of the Emperor Otto III in 1002. The monumental westwork of this building, so strongly stamped with the impress of the Ottonian Imperial house, still stands. It was well restored in 1890–92 (though the west porch originally projected farther).

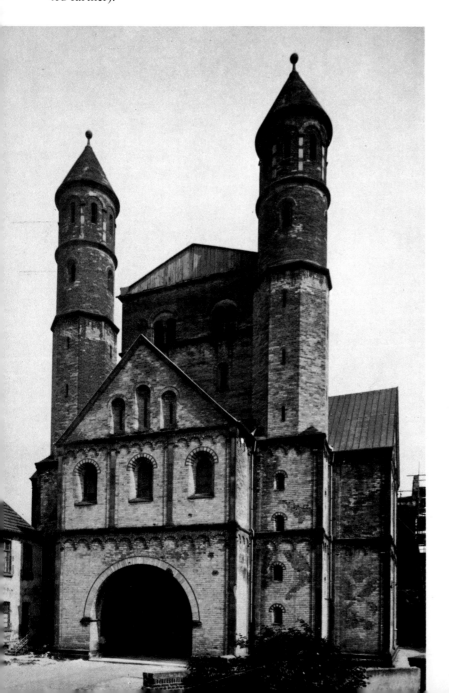

Former Benedictine abbey of Saint Pantaleon, Cologne. Westwork. 984–c. 1002, restored 1890–92

The three towers are a symbol of the heavenly Jerusalem. The appearance of the abbey church, majestic and commanding, expresses the power of the imperial earthly and divine ruler. The central, tower-height interior space of the westwork, surrounded by an open gallery, opens into the nave through a wide curving arch. All the arches are in stone of two alternating colors. The throne and the faldstools of the Emperor and his family probably stood in the gallery.

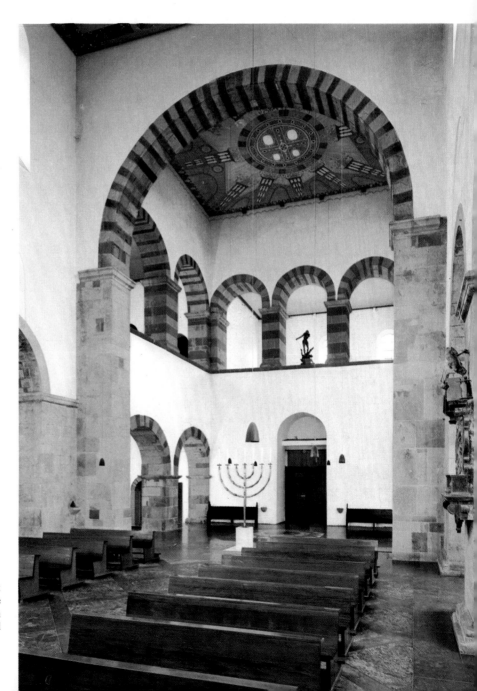

Former Benedictine abbey of Saint Pantaleon, Cologne. Interior to the west. Founded 957. Construction 984–c. 1002; painted flat roof and seven-armed candelabrum 1965

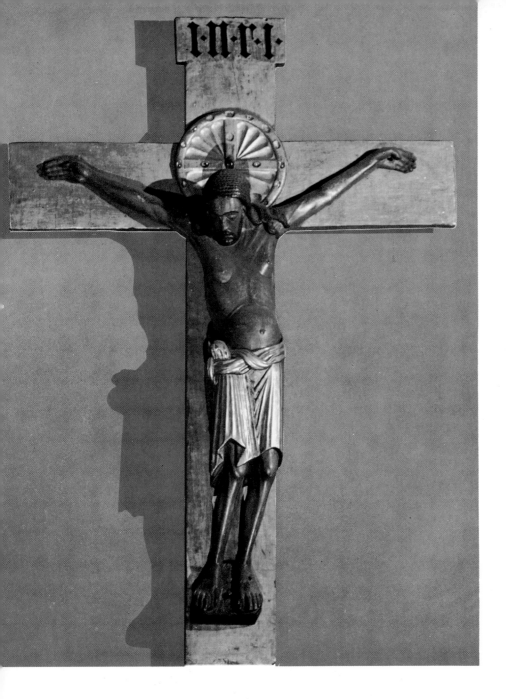

So-called *Gero Cross*. Given to Cologne Cathedral, c. 970–76, by Archbishop Gero of Cologne. Oak, height of *corpus* 73¹/₂″. Gothic setting, probably fourteenth century; stem of the cross and nimbus new

The *Gero Cross* is the oldest surviving large-scale crucifix, and, together with the Madonna of Essen (page 202), is also one of the oldest monumental sculptures in the West. The expressive force of the inclined head, the counterpoint and naturalism of the body inspired by Roman models, and the folds and tautness of the loincloth modeled on Byzantine precedents, give the work an intense artistic realism. The relic and the Host, originally set in a cavity in the head, would have imbued it with an immediate religious reality.

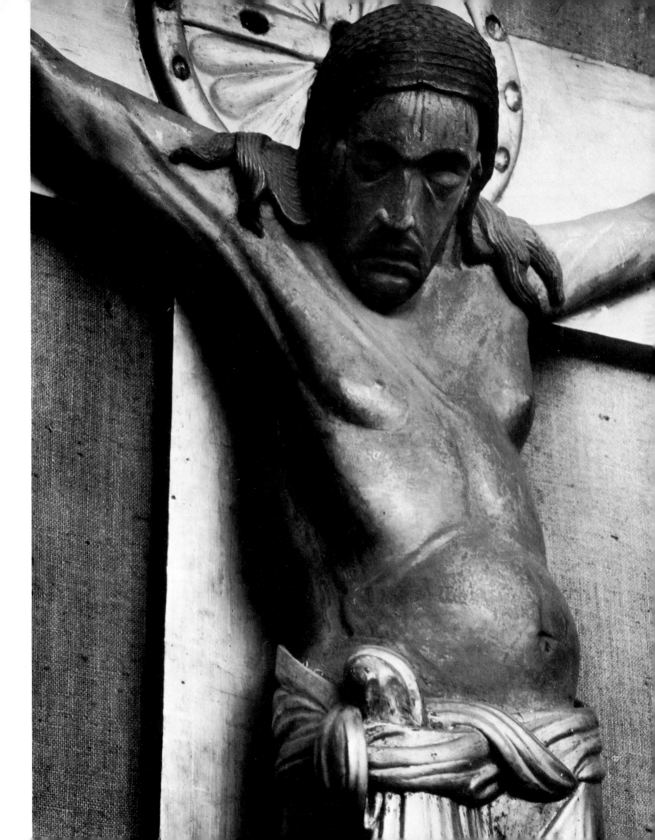

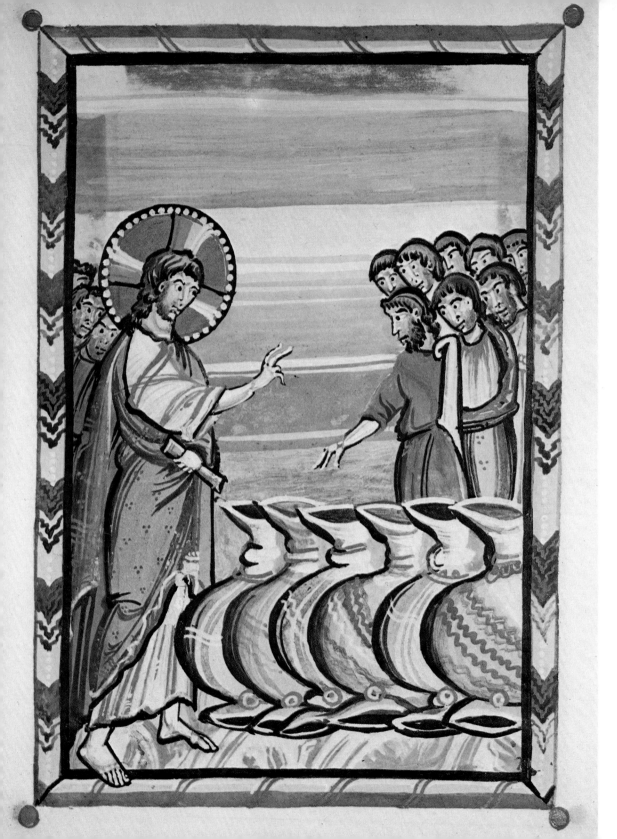

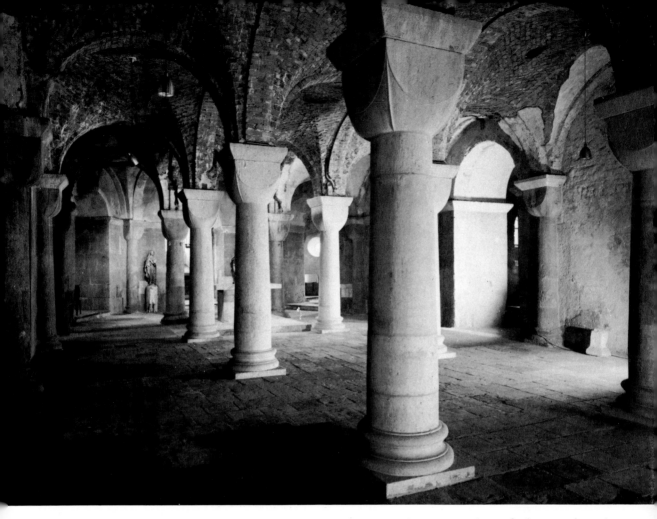

Crypt of the former abbey church of Saint Maria im Kapitol, Cologne. Begun 1015; altar consecrated 1049; final consecration 1065

The manuscript made at Cologne and given by Abbess Hitda to the monastery of Saint Walburga in Meschede, Westphalia, stands out by its wealth of miniatures: twenty-two scenes from the New Testament (see left), full-page miniatures of Christ in Glory, of the four Evangelists, of Saint Jerome, and a presentation miniature of the abbess and Saint Walburga. The pronounced interlocutory gestures of the figures bring it near to the Reichenau School, while the generous artistic quality of the work recalls Late Roman illusionist painting, and the iconography Byzantine works: thus three cultural traditions, part historical, part contemporary, appear at Cologne, in this masterpiece of Ottonian illumination.

Abbess Ida, daughter of the count palatine Ezzo and granddaughter of the Emperor Otto II, began the new building of the church above in 1015. The three-aisled hall crypt with its massive, powerful columns surmounted by block capitals, and the grave solemnity of its interior, have survived from a series of rebuildings. This plan became the starting point for all later Romanesque crypts (see the almost contemporary crypt of Speyer Cathedral).

◀ *Marriage at Cana of Galilee,* from the so-called *Hitda Codex.* First quarter of eleventh century. Miniature on parchment, $11^3/_8 \times 8^5/_8''$. Hessische Landesbibliothek, Darmstadt, Hs. 1640. fol. 169

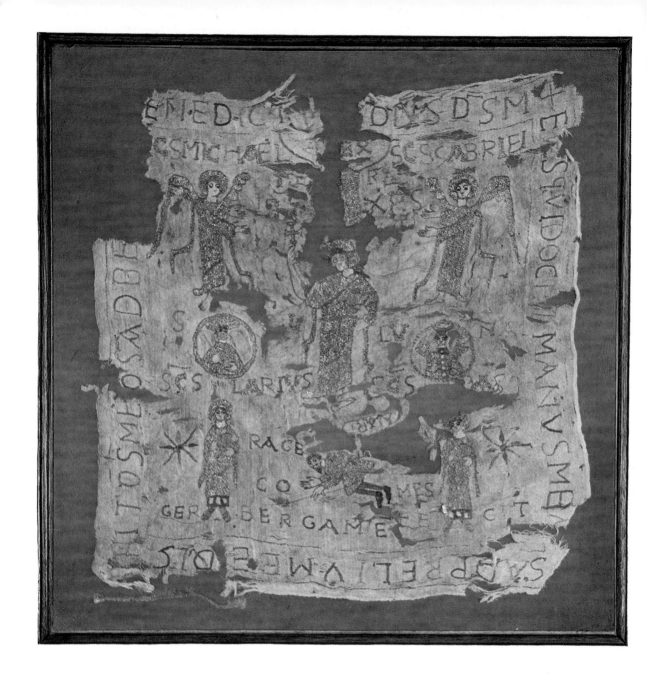

The center of this fabric shows the victorious Son of God holding a cross, flanked by Sol and Luna, symbols of the divine order. Sol is the symbol of the supreme Godhead or Christ; Luna is the sign of all Creation dependent on God and radiant in the light of Him or of the Virgin. In the two upper corners are the archangels Michael and Gabriel, and below, two saints, so that together the figures form the usual symbolic fivefold composition. Count Ragenard, named in the inscription, kneels at the feet of Christ in an attitude of worship. The lady who made it is also named: "Gerberga me fecit."

Abbess Theophano of Essen (1039–58; see page 201), whose name in Salian times still echoed the idealized relationship with Byzantium, built a church of which the crypt, parts of the transept, the nave, and the westwork still stand together with the slightly later atrium. The westwork with three towers outside is a reduced-scale reproduction of one half of the octagon of the Aachen palatine chapel, a strikingly faithful copy in detail. This was a deliberate reversion to the artistic, political, and religious concepts of the Carolingians. Like the westwork of Saint Pantaleon in Cologne, the building had several functions: as a porch, a western sanctuary with the altar of Saint Peter, a choristers' tribune, a stage for Easter Passion plays (in the Late Middle Ages), and probably also an imperial gallery.

The seven-armed bronze candelabrum now standing in the center, donated by the Abbess Matilda (973–1011; see page 201), is a copy of the lost candelabrum from the Temple of Solomon in Jerusalem. It was a symbol of the Tree of Jesse.

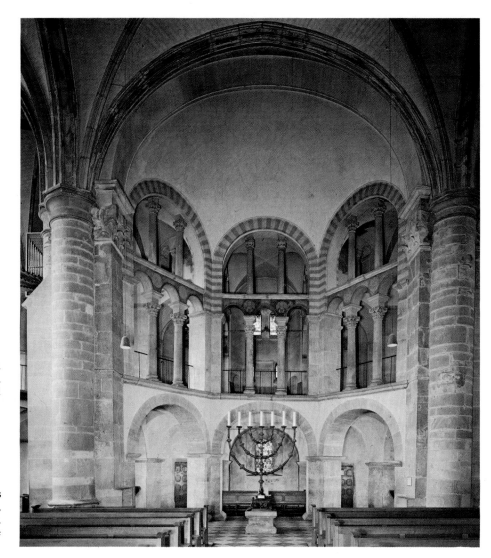

So-called *Flag of War*. c. 962. Embroidery on silk, height 13″. Cathedral treasury, Cologne

Former church of Saints Cosmas and Damian, of the Imperial convent, Essen. Interior of the westwork. c. 1040–50

So-called *Essen Enamel Cross,* a processional cross. c. 1000, back renewed in the twelfth century. Gold with enamel and a cameo, height 18¹/₈". Rhenish. Cathedral treasury, Essen

Five enamel plaques with the symbols of the Evangelists at the ends, and the Crucifixion in the middle, decorate this Rhenish gold cross (left), probably made in Cologne around 1000. The lower arm of the cross is inlaid with a classical two-colored cameo of the head of Medusa—perhaps an allusion to vanquished heathendom.

The large rock crystal in the center of this cross (right), which probably once contained a relic from the True Cross, and the little enamel plaques set in the arms presumably taken from an uncompleted reliquary cross in or about 1000, were assembled to form a processional cross in the mid-eleventh century, and eight Eastern enamels were added at the ends of the arms. A Cologne goldsmith thoroughly reworked the cross in the twelfth century and, as on the cross above, added a new back engraved with the Crucifixion.

So-called *Cross of Theophano,* a reliquary cross. Mid-eleventh century, reworked in the twelfth century with a new back. Gold, enamel, and rock crystal, height 17¹/₂". Minster treasury, Essen

Front cover of the *Gospel Book of the Abbess Theophano*. Second quarter of eleventh century. Chased gold and ivory relief. West German

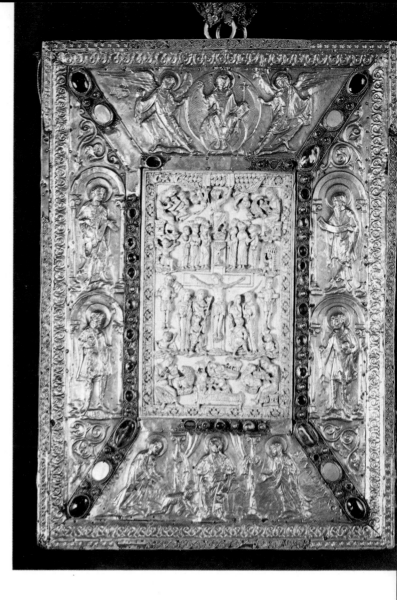

The former Imperial convent of Essen owes its period of artistic greatness, and the church treasury its greatest ornament, to three abbesses from the Imperial house: Abbess Matilda (973–1011), granddaughter of Otto the Great; Abbess Sophia (1011–39), daughter of Otto II and his wife Theophano from Byzantium; and Abbess Theophano (1039–58; see page 199), granddaughter of Otto II.

The *Gospel Book of the Abbess Theophano,* an illuminated manuscript with a decorated gold and ivory binding, is entirely intact. The front cover is now separate. The beautiful, delicate narrative scenes on the great ivory relief on the cover tell of the Nativity, the Crucifixion, and the Resurrection, with the Evangelists in the four corners. They are framed by chased gold reliefs of Christ in Majesty between two angels above, the patrons of the convent on the sides, and below, the Virgin between Saints Pinosa and Walburga, with Theophano worshiping at the feet of the Virgin.

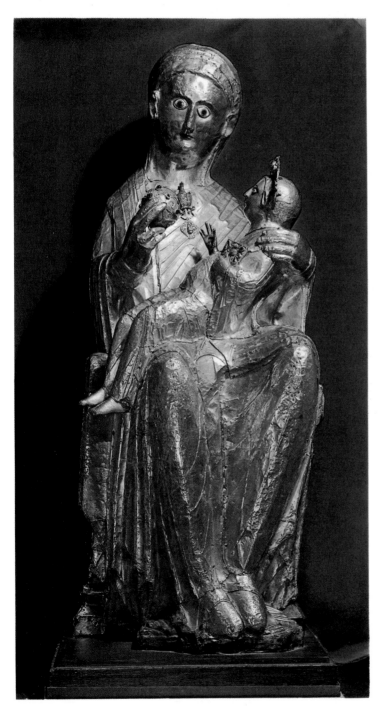

Golden Madonna of Essen. Late tenth century. Gold leaf, formerly on a wooden core replaced in 1902 by cast metal; ornaments of gold, filigree, enamel, and precious stones. The right hand of the Child completed in silver. The eagle fibula on the breast of the Virgin dates from Hohenstaufen times (thirteenth century); the quatrefoil jewel below was added in the fourteenth century. Height 29$^1/_8$″. Rhenish, perhaps from Cologne. Essen Minster

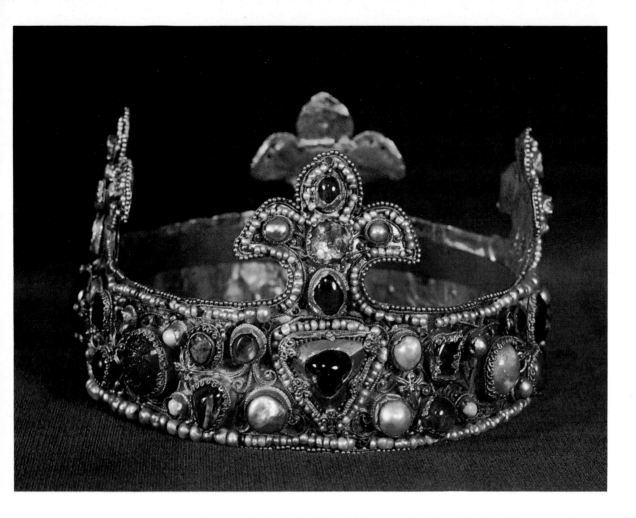

Crown of the Golden Madonna. Late tenth century. Gold, the four lilies richly encrusted with pearls and precious stones, diameter 5″. West German. Minster treasury, Essen

The Essen Madonna (left) is the first free-standing sculptural representation of the Virgin in the West before the early eleventh-century gold Madonna in the Hildesheim cathedral treasury and the gold Madonna of Bishop Imad of Paderborn of the third quarter of the eleventh century. Unlike the two later works, the gold sheet covering is still complete. In the flicker of candlelight, this cult image would return a warm, mysterious, unreal glow, an almost transfiguring, supernatural radiance, the external sign of an indwelling reality, i. e., the relic which the interior of the Madonna held. Mary holds an apple which designates her theologically as the "new Eve," the mother of all those who have been baptized. The Child holds the Book of Wisdom adorned with the usual five precious stones—a reference to the Sacrifice on the Cross and the Lordship of Christ. The crown (above) was probably not created for the Essen Madonna: it served formerly as the royal crown of the Ottonians and may have been made for the coronation of Otto III in 983.

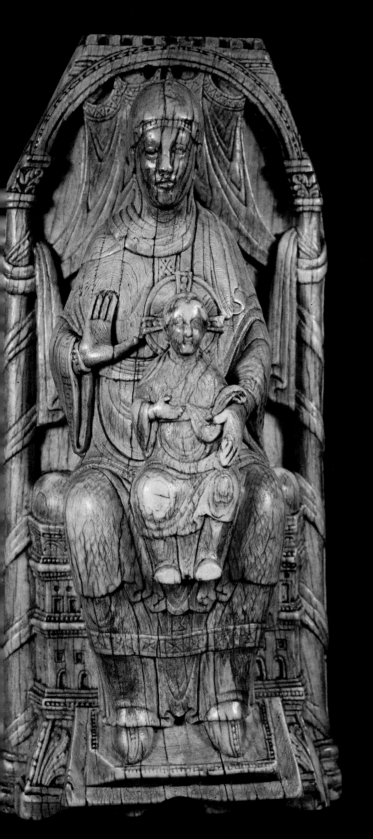

In spite of its small form, this is a work of monumental effect and great quality. The Virgin and Child are carved in strict, unapproachable confrontation and dignity, the Virgin being represented as the "Throne of Christ," as medieval theology taught. She is related in type to the great Hildesheim and Paderborn Madonnas of the eleventh century; but she is of a different kind from the Essen Madonna where the Child is seated across her lap and leans back (see page 202). The quality of the carving and the various motifs and formal details have led scholars to suggest the Master of the *Registrum Gregorii* as the artist (see page 160).

Enthroned Virgin. c. 1000. Ivory relief, the upper corners of the panel cut diagonally at a later date, height 8⁵/₈". West German, perhaps from Trier. Rheinisches Landesmuseum, Mainz

The golden reliquary of Saint Foy, from the former abbey of Conques in Limousin, is equally unapproachable and remote to the eye of the beholder. It is the oldest surviving large-scale Christian sculpture in Europe. The strangeness and quality of the work is heightened by the glitter of the precious stones. The wealth of ornament and the rigid forms distinguish the Saint Foy from the somewhat later Essen Madonna and perhaps have hints of a preceding style. We know of similar French works, particulary seated Madonnas, only through written records or from copies like the Madonna of Clermont-Ferrand.

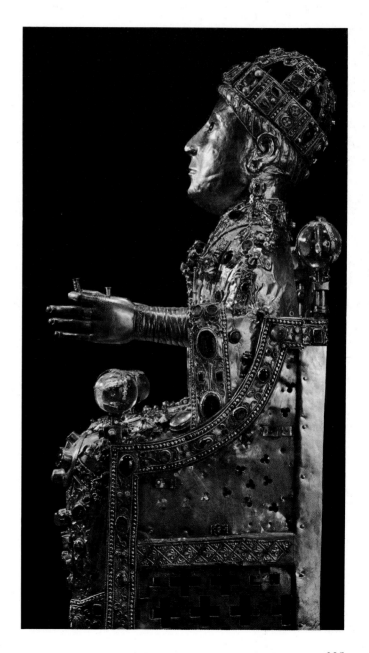

Reliquary of Saint Foy (Saint Fides). c. 980. Wooden core, covered in gold leaf, and encrusted with precious stones, height c. 27″. French. Treasury of the former abbey of Conques

Chapel of Saint Bartholomew, Paderborn (Westphalia). Exterior from the southeast, and interior to the east (right). Built in 1017 under Bishop Meinwerk of Paderborn by Greek workmen ("per operarios graecos")

Emperor Henry II was a great patron of the city and bishopric of Paderborn. Nine imperial visits are recorded. In 1002, the archbishop of Mainz crowned the wife of the Emperor, Kunigunde, in Paderborn Cathedral. In 1009, the Emperor appointed his relative, the court chaplain Meinwerk, bishop of Paderborn (d. 1036). Meinwerk gave the city a new cathedral as well as the monastery church of Abdinghof, the convent church of Busdorf, and the chapel of Saint Bartholomew, shown above and right. The simple chapel, with its plain exterior, has, surprisingly, a three-aisled, hall-shaped interior, the oldest surviving example north of the Alps. Three slender columns on either side, with partly Byzantine capitals, subdivide the space into a nave and two aisles with vaults of an equal height throughout. The records refer to Greek workmen, which again shows the characteristic links between the Ottonians and Byzantium.

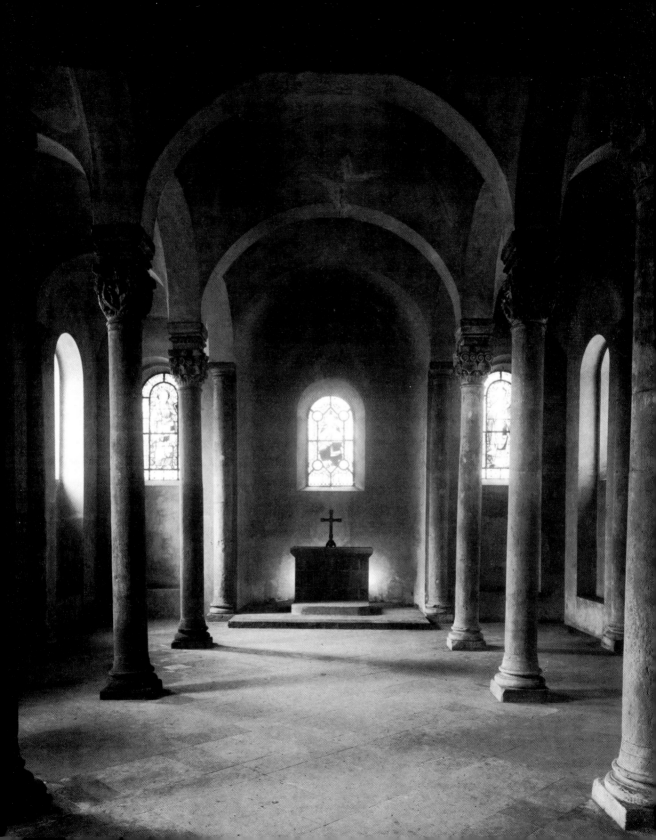

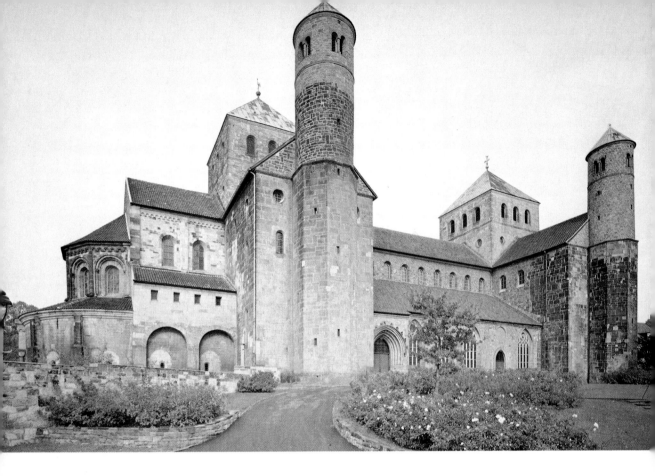

Former Benedictine monastery of Saint Michael, Hildesheim, Above: exterior from the north. Opposite: interior to the east (see below for the history of the building)

This church was founded on a hill about 1000 as a Benedictine monastery by Bishop Bernward of Hildesheim. The foundation stone was laid in 1010. Bernward had a strong influence on the planning of it. The crypt was consecrated in 1015, and Bernward was buried in it in 1022. The whole building was consecrated in 1033, but fires occurred in 1034 and 1162 so that it was largely under renovation, under Bishop Adelog (1171–90) and Abbot Theodoric II, until 1186. The enrichment of the detail and the vaulting of the west choir date from this period, as do most of the columns and the stuccoed arcades of the nave, the richly ornamented choir screens of the western crossing (only the northern part is original; see pages 209 f.), and the flat painted wooden ceiling of the nave. In 1650 the eastern apses were destroyed and the eastern crossing tower collapsed. In 1662 the western crossing tower was taken down. The building was largely destroyed in 1945, and rebuilt by 1958 when the east end and crossing towers were restored to their eleventh-century form.

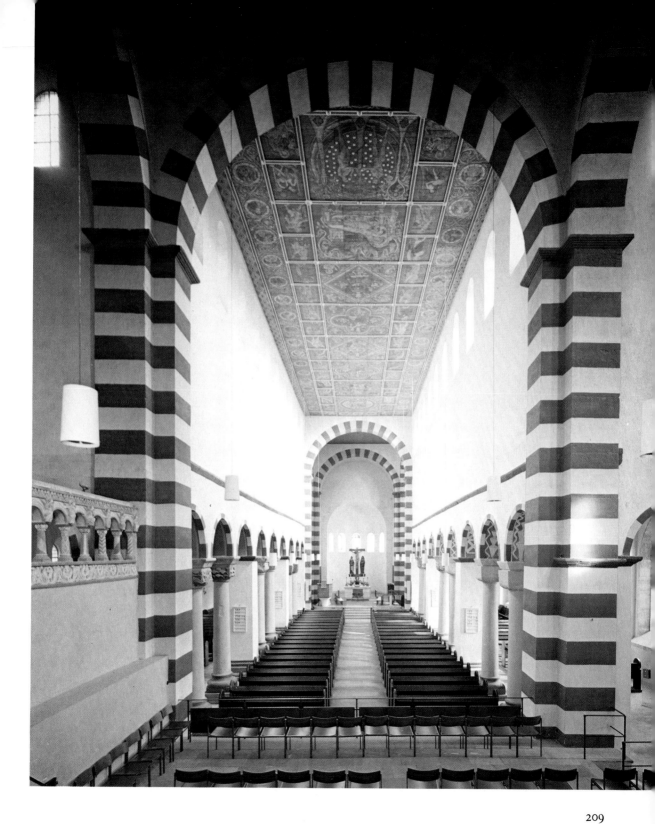

Bishop Bernward of Hildesheim (993–1022) was one of the most remarkable religious figures of the Ottonian era. He trained at the cathedral school of Hildesheim, worked under Archbishop Willigis in Mainz, was tutor to the young Otto III at the court of the Empress Theophano, and was court chaplain. He made many journeys in the West, including one to Rome in 1001, and finally he became a bishop and a leading figure in the religious, political, and artistic life of his time. Hildesheim owes to him its great early eleventh-century masterpiece of architecture and the cast bronze doors.

Saint Michael's counts as a source building for German Romanesque. It summarizes and re-creates all that had appeared in isolated forms or been hinted at elsewhere in Western architecture: i. e., a double choir with two powerful, counterbalanced pairs of towers; a clearly linked and carried through system of harmonious spatial and architectural cubes, starting from the ground plan of the square crossings; separate crossings with equal-sized round arches on all sides; transept galleries ("angels' choirs") that rise up and open out in three stories; the so-called Saxon alternation of supports in the nave in the rhythm of two columns to one square pier; strongly marked block capitals (see below left, background), a western choir ambulatory, and a three-aisled, vaulted, hall crypt with its own barrel-vaulted ambulatory.

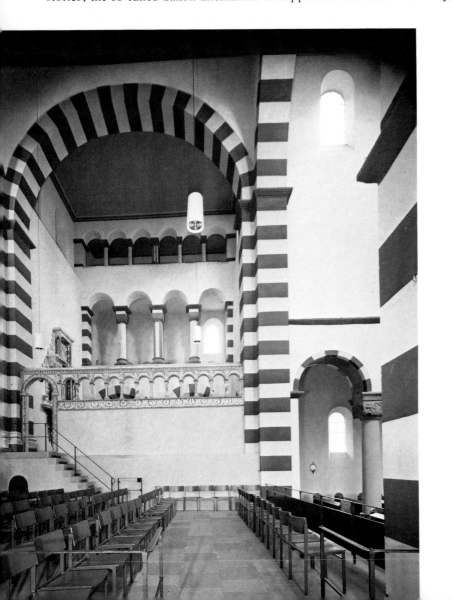

Former Benedictine monastery of Saint Michael in Hildesheim. View across the western transept to the north. Eleventh-century transept galleries in the background; in front, late twelfth-century choir screens

Bronze doors with sixteen Old and New Testament scenes. Cast at the behest of Bishop Bernward of Hildesheim for Saint Michael, Hildesheim; finished in 1015. Height 15' 6". Now on the inside of the west porch of Hildesheim Cathedral

The two wings of this door, now reunited, were each originally intended as single doors for the two southern portals at Saint Michael's which were to be reconstructed. Bishop Godehard, successor to Bernward, transferred the doors to the cathedral. It was probably he who had the Latin inscription carved with the details of the date of completion in 1015 (see page 212).

Encouraged by the wooden doors of Santa Sabina in Rome, the doors of Saint Ambrose in Milan, and the doors of Archbishop Willigis in the cathedral at Mainz (about 1000)— but at the same time intending to surpass these models by far through pictorial and sculptural realism— Bishop Bernward personally laid down the form and the scheme the doors of Saint Michael at Hildesheim would take and thus created an example of German Ottonian art of ever new and changing fascination. In strict thesis and antithesis, the left-hand door portrays the Fall of Man in eight scenes from the Old Testament, while the right-hand door shows New Testament scenes of Man's Deliverance from the Fall.

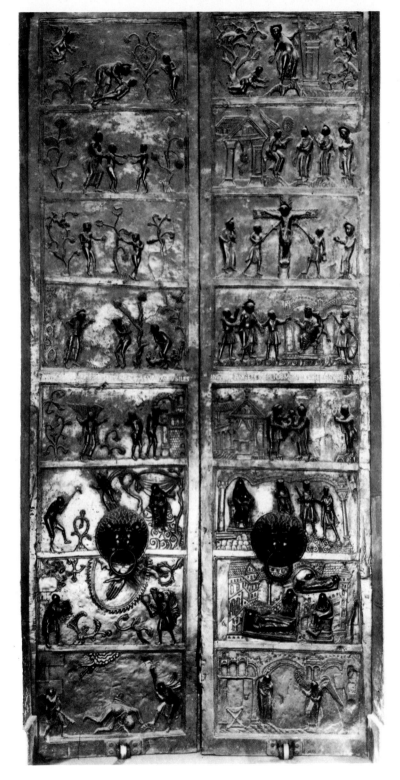

With dramatic gestures which recall the rich tension of the Reichenau School (see page 168), the artist has depicted the vicious circle of the Fall: God points to Adam angrily and accusingly who, with a guilty and lowered gaze, indicates Eve backward; she in turn points reproachfully in self-excuse at the serpent. A classical stylized tree on the left edge marks Paradise while two more realistic plants, one rather jagged, the other softer, distinguish the human couple. The empty surfaces between the figures cry out with tension. The sculptured heads spring forcefully and clearly out of the background while the bodies remain flatter and more bound to it.

Research has indicated three different hands for the individual reliefs and ascribes this scene to the "Master of the Paradise Scenes." Iconographical models have been found in the picture bibles from Tours and in Roman fresco cycles. Yet the composition and sculptural power of this great bronze work remain amazing and inexplicable.

Adam and Eve Face God after the Fall. 1015 (?). Bronze panel from the Hildesheim door

Inspired by Trajan's Column (A.D. 137) and the Marcus Aurelius Column in Rome (A.D. 187)—the pagan cycles of pictures which the Middle Ages constantly repeated, using Christian themes—Bishop Bernward had this column cast and set up behind the main altar of Saint Michael. The crowning capital and crucifix, which completes the scheme of the work, was lost in the seventeenth century. Just as the Roman triumphal columns glorify the deeds of the Roman emperors, so, in the long-drawn-out spiral of twenty-four New Testament reliefs, the crucifix column glorified the redeeming power of the True Emperor. They are a monument to the triumph of Christ and complete the theological scheme of the bronze doors. This work has no model and no successor in Northern art. The style of the reliefs, distinct from that of the doors, gives an idea of the artistic versatility of the Hildesheim bronze casters.

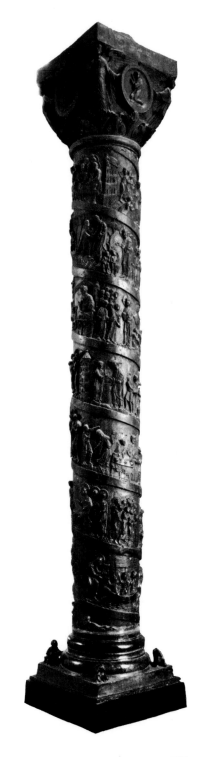

Bernward's Column. Cast c. 1020 in Hildesheim; capital 1871. Bronze, total height c. 12′ 3″. Presented by Bishop Bernward to Saint Michael in Hildesheim. In the cathedral transept since 1895

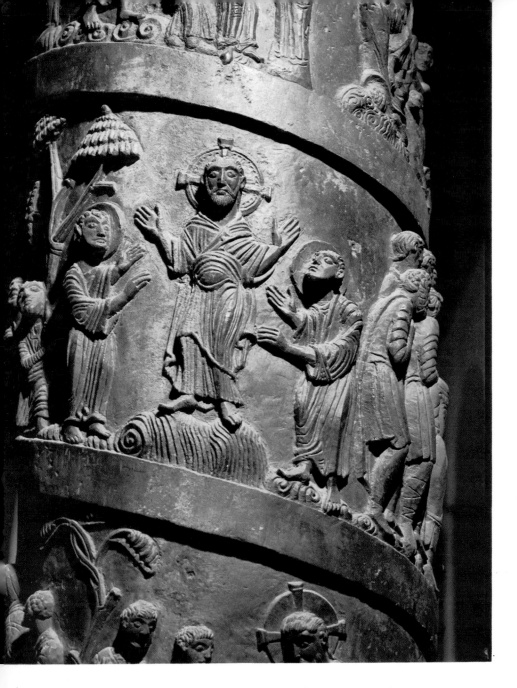

Detail of the *Ascension of Christ*, from *Bernward's Column* (see page 213). c. 1020

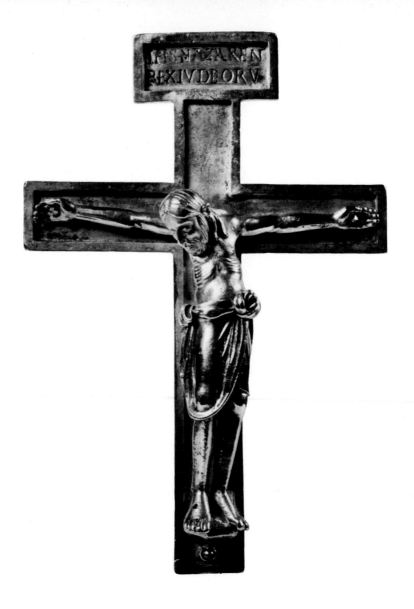

Bernward's Crucifix. c. 1007–8. Silver, partly gilt, total height 5″. Cathedral treasury, Hildesheim

The inscription on the back of the *Crucifix* names Bishop Bernward as donor. The cross and the body are both cast in silver. The hair of Christ, the loincloth, the footrest, and the projecting rim of the cross, were formerly gilt. In spite of the small scale of the work, the figure of the Crucified Christ has a powerful, internal monumentality which recalls the similar, though somewhat older *Gero Cross* (see page 194). *Bernward's Crucifix* marks the beginning of an important series of Romanesque cast altar crucifixes, as indeed did so many Ottonian works standing at the point of departure for Romanesque art. At the same time, the silver *Crucifix* takes over from the magnificent jeweled crosses of Carolingian and Ottonian art.

In place of an imperial palace, which Henry II built between 1008 and 1011 and had scarcely completed, his wife Kunigunde endowed a Benedictine foundation about 1015. In 1025, a year after the Emperor's death, Kunigunde herself entered the convent, where she died in 1033.

The eleventh-century building was a flat-roofed, cruciform basilica with a clearly defined crossing, a short, rectangular choir bay, a semicircular apse, and side apses on the arms of the transepts. From within, the central tower of the mighty westwork, formerly with three towers, opens onto the central aisle of the nave through a typical three-arched arcade of unusually tall slender columns with spreading block capitals. Originally the imperial gallery must have lain behind it. The arches and galleries inspired several copies in Westphalia and Hessen in the eleventh and twelfth centuries. In the fourteenth century, the foundation building was extended into a hall church. The choir was rebuilt in 1469, and the present wooden ceiling was put up in 1564. The Ottonian west gallery, walled up in the thirteenth century, was uncovered in 1938.

◀ Former Benedictine Imperial convent of Oberkaufungen, Hessen. Monastery church of the Holy Cross, view westward to former Imperial gallery

The original building at Bad Hersfeld, over 110 yards long, was one of the largest early Romanesque churches. Although it was begun later than Saint Michael in Hildesheim, the three-aisled, columned basilica, once with a flat roof, seems older because of its surprisingly long transept and its ill-defined crossing with high narrow eastern apses. This can be explained by the special links connecting Hersfeld with Fulda (a Carolingian church) and Mainz (Saint Alban), but it is also typical of the many variations of form to be found in eleventh-century architecture. (The early dating of Hersfeld to Carolingian times has been excluded by the diggings undertaken by Dr. Feldtkeller in 1955 and 1963.) The crypt, completed in 1040, belongs, like Hildesheim, Saint Maria im Kapitol (Cologne; see page 197), Limburg an der Hardt, and Speyer, to a famous series of early Romanesque monumental hall crypts. The new church building, begun around or shortly before 1037 and completed under Abbot Ruthard (1059–72), was not consecrated until 1144. The building was burnt in 1761 during the Seven Years' War and has been in ruins since then.

Former Benedictine abbey and collegiate church at Bad Hersfeld. Founded c. 770

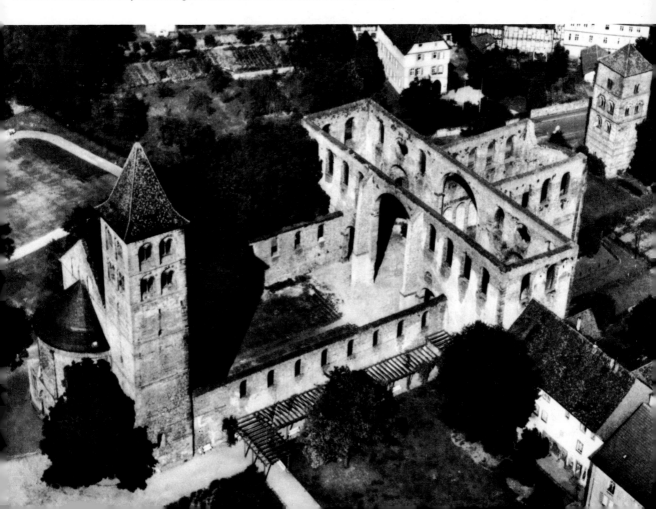

In the Middle Ages, *oliphants* (hunting horns) served as horns for hunting, warfare, or for use in castles. They were up to twenty-seven inches in length. Of the forty odd examples surviving in Germany, some were probably direct imports from the Egyptian Fatimid Empire. Others, including our example with its characteristic frieze of interlacing and animals (see below), were copied from African or Islamic models. The hunting horn of Charlemagne in Aachen Cathedral treasury is equally famous.

A number of Byzantine works of art came to the West through trade and exchange, often as gifts from emperor to emperor, or as plunder; they include ivories (see page 163), enamels and gold (see page 177), and valuable worked textiles, carpets, and embroideries (see opposite, below). Indigenous workshops used these works as technical and pictorial models for their own products (see opposite, above).

Hunting horn, so-called *oliphant*. First half of eleventh century. Ivory. Presumably German, after a Fatimid model. Herzog-Anton-Ulrich-Museum, Brunswick

Fragment of a woven carpet from the former convent church of Saint Gereon in Cologne. Early eleventh century. West German. Germanisches Nationalmuseum, Nuremberg

Embroidered hanging of the *Eagle Flight of Alexander the Great*. Tenth century. Byzantine. Mainfränkisches Museum, Würzburg

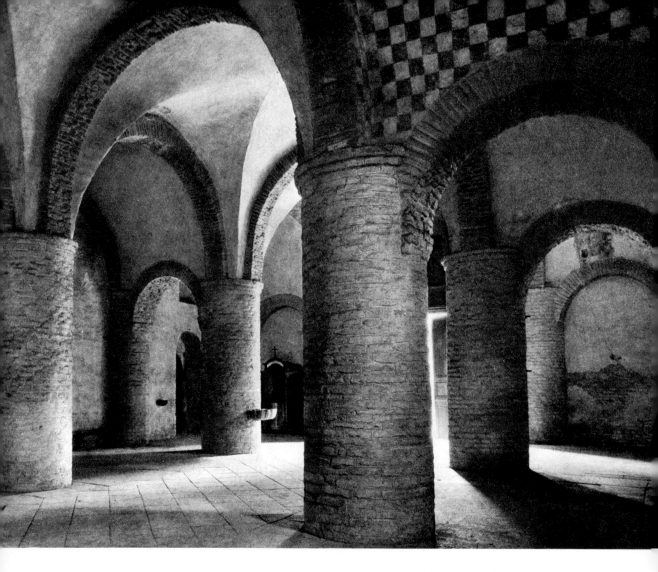

Ground floor of the narthex of the former Benedictine abbey of Saint-Philibert in Tournus on the Saône (Burgundy). Consecrated 1019

Like the large Ottonian churches in Germany, the abbey church of Tournus in Burgundy is a synthesis of earlier, backward-looking elements with basic features of Romanesque architecture. This characterizes it both as a transitional building and as a fresh point of departure. The ante-church follows the traditional form of Carolingian westworks (see pages 80ff.): it is on two levels and has a three-aisled, low, cryptlike ground floor. But the basilican shape of the main church and the two towers of the facade point to the future (see Cluny). Its spacious hall nave with its brick columns, surmounted by small half-columns, formerly higher and reaching up to the eleventh-century flat roof, opens the long series of hall churches of the eleventh and twelfth centuries in southwest Europe.

In the ninth century, monks from Noirmoutier, who had fled from the Normans with the relics of Saint Philibert, founded the former Benedictine abbey of Saint-Philibert in Tournus. The church, with the westwork and then the nave, was rebuilt after a fire at the beginning of the eleventh century. Only the narthex was probably finished at the time of consecration in 1019. The nave was not completed until the second quarter of the century. About 1100 and in the first quarter of the twelfth century, the choir and the transepts were rebuilt and the nave was vaulted. The church was consecrated in 1120.

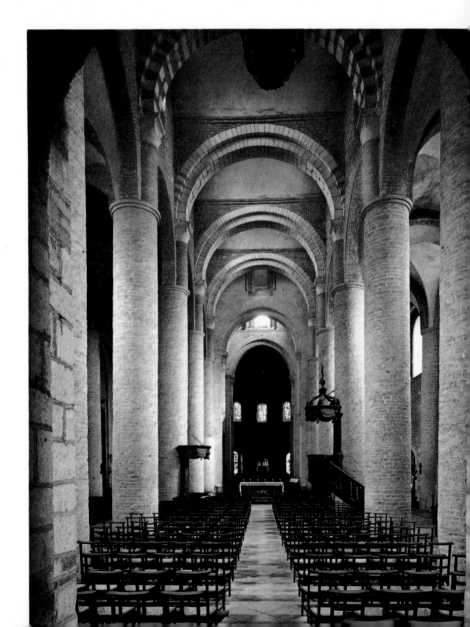

View to the east of the nave of the abbey church of Saint-Philibert in Tournus

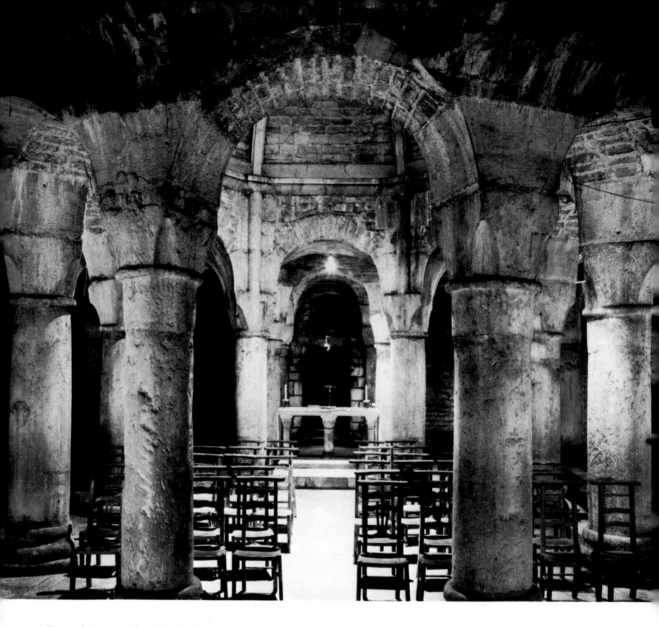

Crypt of the rotunda with view from the outer gallery eastward to the center. Former Benedictine abbey of Saint-Bénigne in Dijon, Burgundy. Founded 529. New building of the church begun in 1001. Total consecration 1106. Early eleventh century

Quite apart from the copies of the Aachen palatine chapel (see pages 180, 181, 199), the Early Middle Ages favored the form of the round church as a re-creation of the Church of the Holy Sepulcher in Jerusalem, and also as a burial and martyrs' church. A particularly valuable architectural example was Saint-Bénigne in Dijon. The flat-roofed, galleried, basilican nave led in the east to a three-storied rotunda with a crypt on the ground floor and concentric, partially double, ambulatories. Only the crypt survives, impressive in the contrast between its simple unadorned forms and the variegated perspectives of the building.

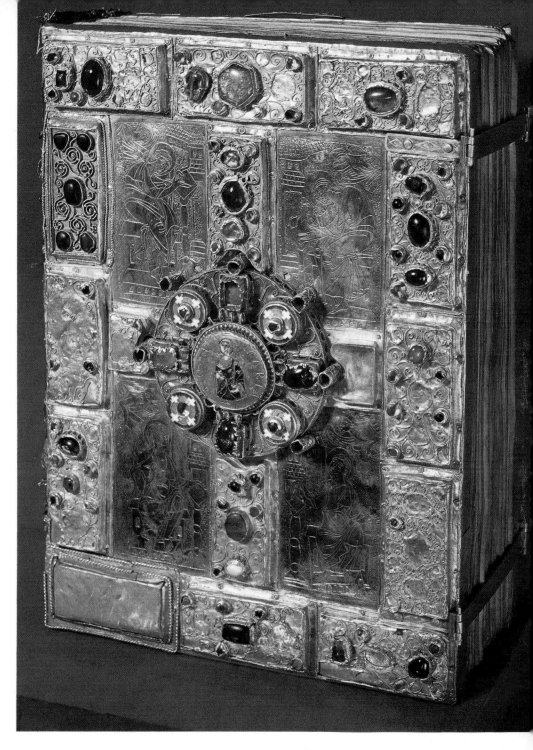

Book cover of the *Gospel Book of Saint Gauzelin*. Mid-tenth century. Oak panel covered in gold cloisonné, pearls, precious stones, and silver plaques. A small gold plaque from the border is lost, another was remade in the twelfth century. Lorraine workshop. Cathedral treasury, Nancy

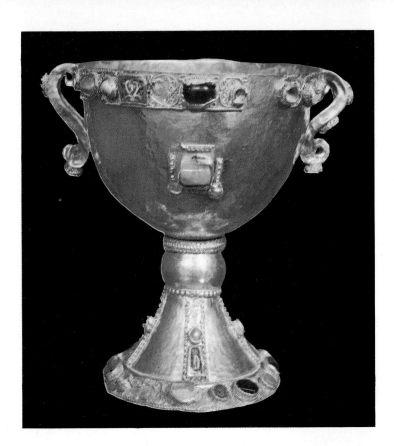

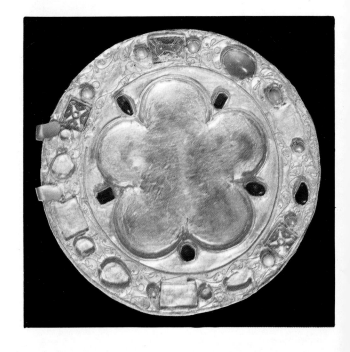

Chalice, and Paten (below), *of Saint Gauzelin*, Bishop of Toul. Late tenth century. Gold, pearls, and precious stones on a silver base. Lorraine. Cathedral treasury, Nancy

Saint Gauzelin, Bishop of Toul (922–62), who lies buried in the abbey of Bouxières-aux-Dames (diocese of Toul) which he founded, owned several works of gold and ivory, which have been in the cathedral treasury at Nancy since 1801. They came from Lorraine workshops whose individual sites are not known; they may have been at Tours or Reims. To some extent, customary Carolingian forms are carried on these works, e. g., the large dominant cross on the book cover with an enamel figure of the Virgin in the center, which became one of the inspirations of Trier goldwork under Bishop Egbert (see pages 174ff.).

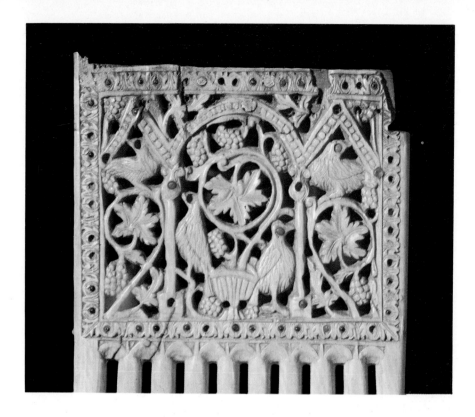

Ivory comb of Saint Gauzelin. Mid-tenth century. Ivory, height $4^1/_2''$. Lorraine workmanship, perhaps from Metz. Cathedral treasury, Nancy

This comb, a piece of delicately interwoven carving, comes from Toul. Tradition has it that it belonged to Saint Gauzelin (see page 223). The motif of vine leaves, rising from a vessel decorated with birds, probably doves, recalls Carolingian and early Christian symbolism: the human soul (birds) feeds on the sacrificial gifts of Christ (wine and chalice). The well-balanced architectural division of the ornamental surface, with a triple arcade of two pointed arches and one round arch in the center, also recalls earlier formal traditions. It has been assumed that the comb was exported from Fatimid Egypt or copied from a Fatimid work.

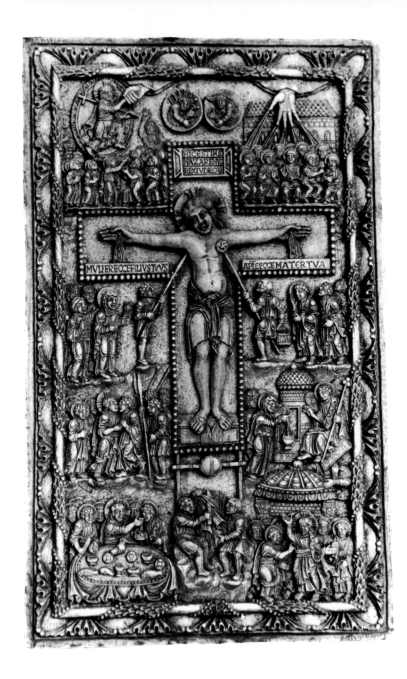

The Crucifixion, from the cover of a gospel book. First half of tenth century. Ivory relief. French (southwest). Cathedral treasury, Saint-Just, Narbonne

The relief with scenes from the Life of Christ, dominated by the Crucifixion, was probably made in the ecclesiastical province of Narbonne, perhaps by a west German carver. The decorative and sculptural scenes show the varied influences at work in this border land; there are backward-looking Carolingian elements and Spanish Mozarabic motifs (see page 243). The influence of the Rhenish centers of Ottonian art is particularly strong.

In England in pre-Norman times, especially in the second half of the tenth century under King Edgar, numerous large churches were built, such as Ely, Canterbury, and Durham; but later reconstructions have left very little of the original work of these above ground. The greater number of surviving small churches must make up for this loss. The tower of Earls Barton is famous for its rich decoration: indigenous insular forms mingle with Carolingian and Ottonian influences, but the local, perhaps Scandinavian, tradition of half-timbered work is particularly strong in the stone pilaster-strips fixed in imitation of wood to the walls.

West tower of the church from the southwest. Earls Barton, Northamptonshire. Second half of tenth century; battlements and nave Gothic

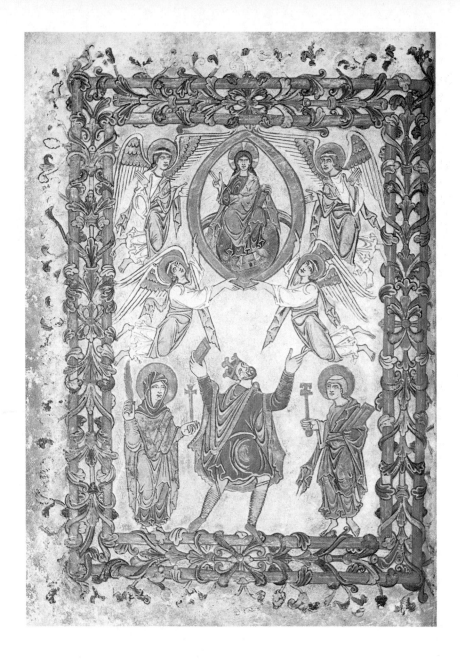

This is the oldest manuscript made for Winchester, and it contains just the one presentation miniature. It shows King Edgar standing between the Virgin and Saint Peter, the patrons of the New Minster, holding the Charter in his right hand and offering it to Christ who hovers above in a *mandorla* carried by four angels. There is a marked linear quality in the drawing; the figures, in gold and translucent colors, stand against an open, light purple ground. This manuscript marks the beginning of the flowering of the famous school of Winchester, inspired by Carolingian and northern French works.

Page of text from the *Benedictional of Ethelwold.*
c. 975–80. School of Winchester. British Museum,
London. Add. MS. 49598 (see overleaf)

Bishop Ethelwold (963–84) promoted the religious and artistic flowering of the royal and cathedral city of Winchester. He abolished the hitherto secular orders of the Old and the New Minster in Winchester and replaced them with Benedictine monks from the monastery of Abingdon, where he had previously been abbot himself. He was an artist too, and his relations with the northern French abbeys of Fleury and Corbie had a great effect on the artistic development of the school of Winchester.

The fundamental and most significant collection of miniatures by this important center, which influenced continental works too, especially in France, is a *benedictional* (bishop's liturgical prayer book) with over twenty pages of pictures and decorations, executed for Bishop Ethelwold himself. The monk Godeman (c. 984–1012), later Abbot of Thorney, Lincolnshire, was the scribe and presumably also the illuminator. The script of this text has an effect of balanced clarity and order.

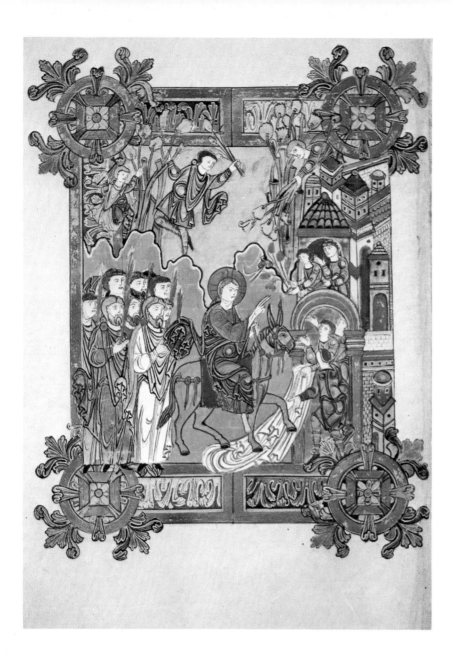

The Entry into Jerusalem, from the *Benedictional of Ethelwold.* c. 975–80. School of Winchester British Museum, London (see page 229)

A wide pictorial border frames the crowded figurative scene. The acanthus leaves and foliage work are characteristic decorative motifs of the school of Winchester. The dynamic of the scene compels the images and the architecture to spill over the borders freely and without any plan—part of the charm of the picture.

Missal (properly *Sacramentary*) of the abbot and bishop Robert of Jumièges. Early eleventh century, probably between 1013 and 1017. School of Winchester. Bibliothèque Municipale, Rouen

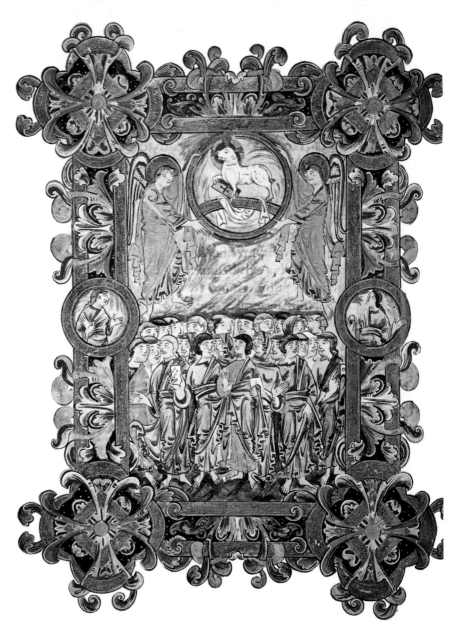

This manuscript was probably made at the New Minster of Winchester. Robert of Jumièges, Bishop of London from 1044 to 1050, gave the miniature to the abbey of Jumièges, where he had been abbot. The pictures follow Ethelwold's *Benedictional* in layout, borders, ornamentation, and iconography (see page 229); the forms and style are freer and looser, but more animated and expressive.

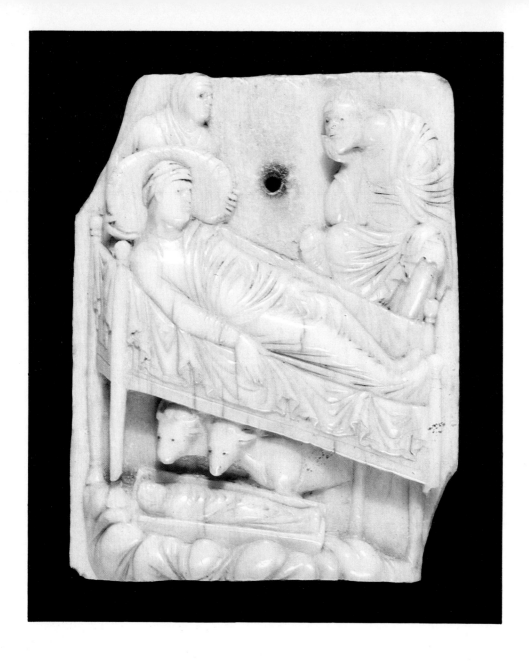

The Nativity. Late tenth or eleventh century. Ivory relief panel, height 3″. English, from the circle around the Winchester School. City Museum, Liverpool

The striking composition of this small, charming relief presents the Virgin on a diagonally placed bed, with the crib of the Christ Child, over which the animals are leaning, beneath it. Joseph is seen crouching above on the right, resting his head on his hand. The scene coincides almost exactly with that of a miniature from the *Benedictional of Ethelwold*. Both works were probably inspired by continental Ottonian or Carolingian models. The forms and lines of the ivory, however, are much softer and more rounded than those in the manuscript.

The very delicate carving below, with the Crucifixion on one side and Christ in Majesty on the other, decorated with foliage work and animal and birds' heads, was found in 1903 in the rectory garden at Alcester in Warwickshire.

Crook of a bishop's staff, so-called *Alcester Tau*. First half of eleventh century. Walrus ivory, length 5³/₄″. English, Winchester School circle. British Museum, London

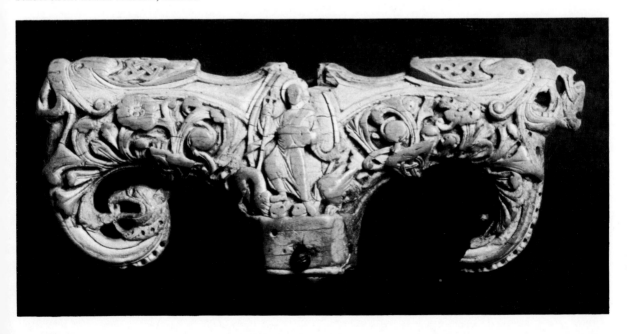

Sant' Eufemia in Spoleto (Umbria). Interior to the east. Tenth century. Originally a flat-roofed, galleried basilican church; vaulting twelfth century

From the sixth century on, Spoleto was the center of a Lombard duchy; from the ninth century it was the center of a province. The former ducal palatine church reflects the golden age of the city in the tenth century. It is simple, almost modest in detail, of strict and rigid proportions, particularly if one imagines the original flat roof. The nave walls, divided by the two-storied double arcades, have a rich rhythmic order. The intermediate pillar in front on the right, the "colonna santa," was part of an earlier architrave, perhaps a Late Roman spoil.

Crypt of San Stefano in Verona. Interior to the east. Tenth century (see text page 236) ▶

San Stefano in Verona (see page 235) was originally a single-nave, Late Roman building which was extended into a three aisled, flat-roofed hall with galleries in the course of the tenth century. The crypt is a clear example of the early, vaulted form of hall church—a form which superseded the earlier galleried round crypts and prefigured the large Romanesque crypts. The proportions, especially of the columns, are lighter, more slender, and more classical than we find in Germany.

Cathedral of Santa Maria Assunta in Torcello, Venice. New building 1008. Late eleventh century (see opposite)

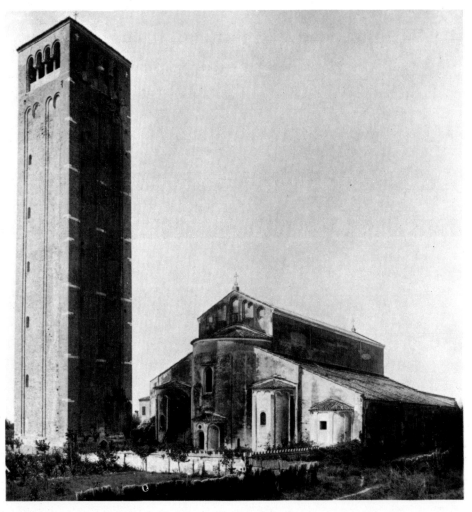

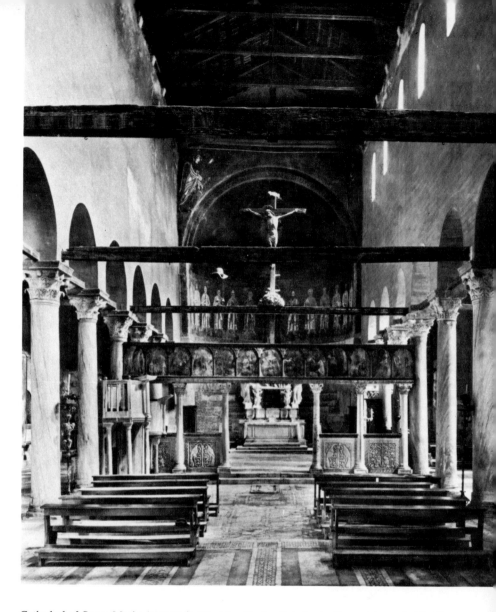

Cathedral of Santa Maria Assunta in Torcello, Venice. Interior to the east. c. 1008. Marble floor and choir screens (with classical columns) c. 1008. Byzantine apse mosaic renewed in early thirteenth century

In contrast to the systems of varied compositional areas and clearly graded spatial cubes found in Northern churches, Italy at this time adhered mainly to the tradition of Roman and early Christian basilicas. The exterior of Torcello is almost wholly untreated and undemanding—a mere outer shell. The interior is very narrow and steep, creating a tension between the large number of light columns and the massive, compact wall surfaces above them, the austerity of which was originally relieved by paintings or mosaics.

The Virgin on the Donkey, from ▶ the *Flight into Egypt.* Second quarter of tenth century. Wall painting from Santa Maria in Castelseprio, north of Milan

Several important examples of Ottonian wall painting have survived in northern Italy. The New Testament cycle recently discovered at Castelseprio (opposite) has a surprising freshness, lively classical forms, and a wholly Byzantine iconography. It is indeed "a portion of the Macedonian renaissance on Lombard soil" (André Chastel).

The intense colors of the paintings in Galliano, with their animated, gesticulating figures and sharp lines of light on the folds of the draperies, are closely related to early Reichenau painting—a sign of the close artistic connections between northern Italy and southwest Germany. The paintings were a gift from Aribert of Intimiano (d. 1045) who felt himself very closely bound politically to the Ottonian Imperial house. In 1015 Henry II made him archbishop of Milan. It is to this archbishop that Milan Cathedral treasury owes the valuable book cover illustrated on pages 240 f.

Jeremiah at the Feet of Christ. c. 1007. Fresco in the apse of San Vicenzo in Galliano, near Como

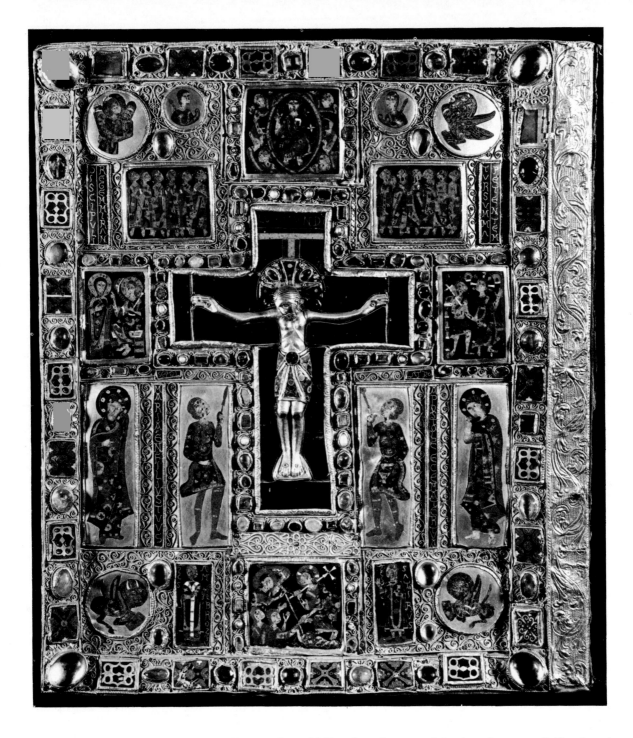

Front of a book cover belonging to Archbishop Aribert of Milan. Second quarter of the eleventh century. Gold and precious stones, with figurative enamel plaques of scenes from the Life of Christ; gold filigree ornament, and cast gold crucifix, height 16³/₄″. Cathedral treasury, Milan

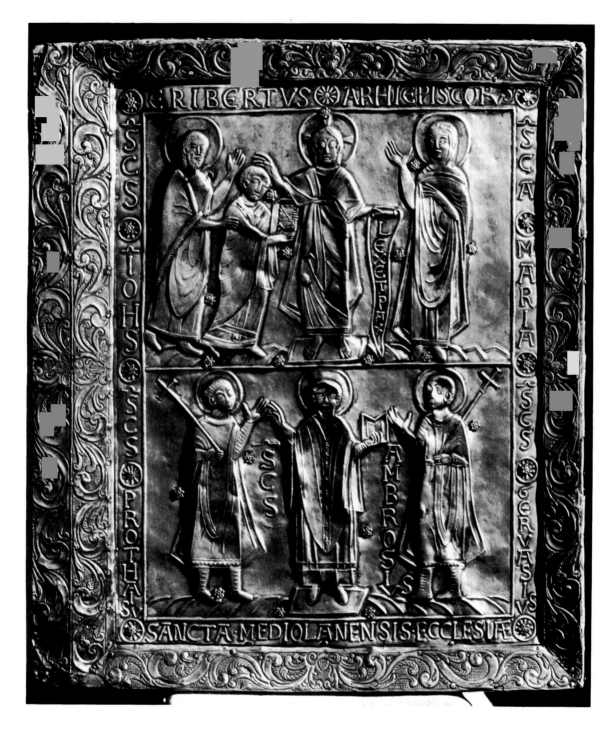

Back of the book cover of Archbishop Aribert of Milan. Upper register: Archbishop Aribert offering the Codex to Christ, and John and the Virgin. Lower: the patron saints of Milan, Prothasis, Ambrose, and Gervase. Second quarter of eleventh century. Chased reliefs in silver gilt, height (without frame) 15³/₄″. Cathedral treasury, Milan

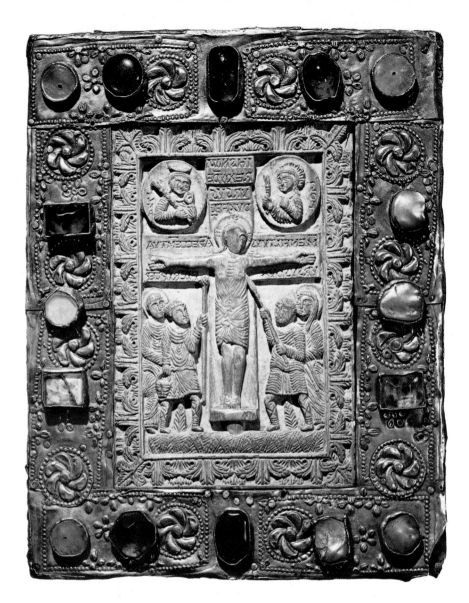

Pax of Duke Ursus (Orso). c. 900. Chased gold with ivory relief. Lombard workshop. Museo Archeologico, Cividale

From the sixth to the eighth centuries, Friuli was under the rule of the Lombards who came from the region between the Elbe and the Danube. Cividale was the seat of a Lombard duke. In Charlemagne's time, this area came under a Frankish margrave, but the traditions of Lombard art remained alive until post-Carolingian and early Romanesque times. An example is this goldwork surrounding an ivory relief of the Crucifixion. The figurative images recall works by Master Tutilo in Saint Gall.

The religious and political state of Spain led to an artistic development that was closely connected to the rest of Europe yet remained original. What is called Mozarabic art flourished in the border area of conflict between Islam and Christianity, especially in the province of León, during the tenth and eleventh centuries. The Mozarabs were Christians who were partly tolerated and partly persecuted by the Moors, and who eventually migrated to the north. Mozarabic churches such as San Miguel de la Escalada are based on the ground plans of Roman columned basilicas with an open roof truss; but they also made use of Visigothic, Arab, and North African motifs, together with late Carolingian and Byzantine formal elements. Thus highly individual buildings came into being. It is not always possible to distinguish the different influences clearly. For instance, it is not certain whether the horseshoe arch (i.e., consisting of three-quarters of a circle in shape) was of Visigothic or Moslem origin. The more or less unadorned exterior of San Miguel de la Escalada nevertheless pleases by its noble columned porch. Inside, fairly large arches over the aisles and a triple, parclose screen-like arcade of three arches define transepts and a crossing in visual rather than spatial terms.

Former Benedictine monastery of San Miguel de la Escalada, Spain (Province of León). External view from the southwest. Newly established under King Alfonso III, the Great, of Asturias (866–910) by monks who had been driven out from Córdoba by the Arabs. Church built in the early tenth century and consecrated in 913

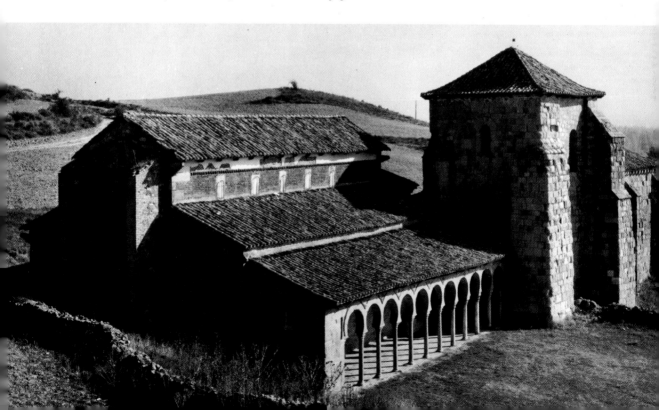

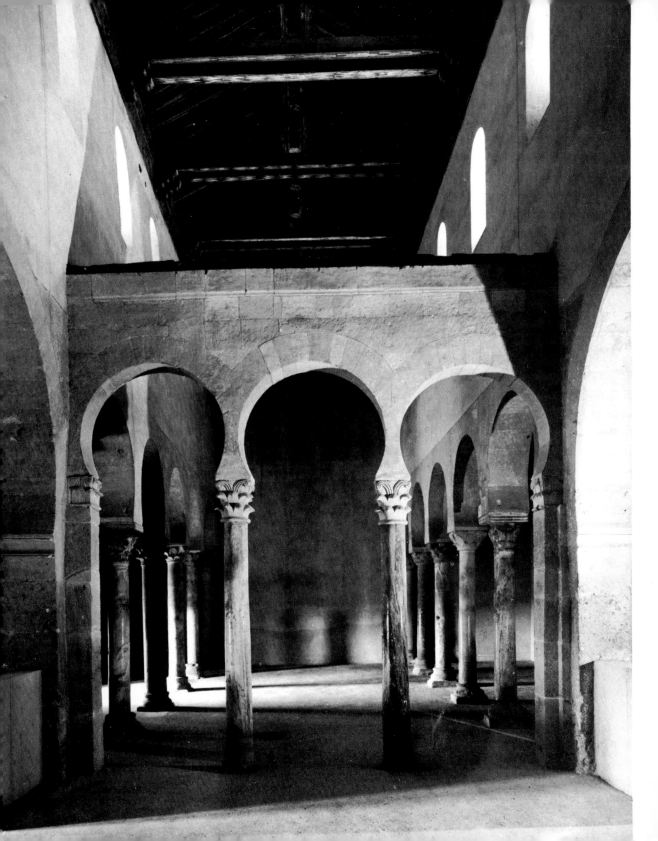

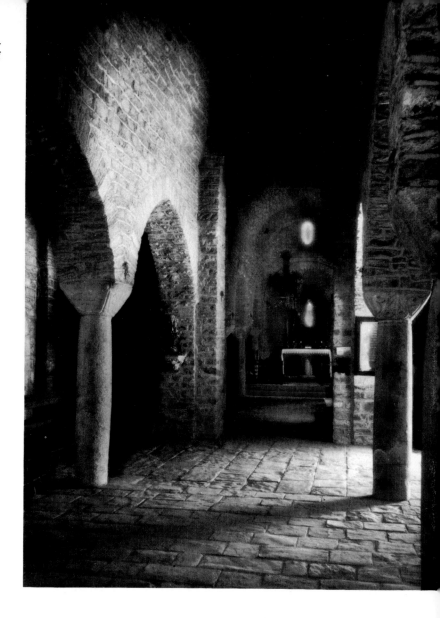

◀ Former Benedictine monastery of San Miguel de la Escalada, Spain (province of León). c. 912–13

Nave of the main church of Saint-Martin de Canigou. Interior to the east. 1009 and 1026

A number of rustic, almost "homely" churches in the early Romanesque style were built on both sides of the Pyrenees in Catalonia about the turn of the tenth and eleventh centuries. As yet they are relatively unknown. Saint-Martin de Canigou is distinguished by its particularly generous, impressive proportions. It has a three-aisled, crypt-like undercroft, a bell tower built to one side, and a trapezoid cloister. The main church is a three-aisled hall with an exaggeratedly high nave and a rhythmic alternation of columns and piers in the ratio of two to one (Saxon alternation of supports, see page 210).

From the Revelation of St. John the Divine, chapter 12:

1. And there appeared a great wonder in heaven; a woman clothed with the sun, and the moon under her feet, and upon her head a crown of twelve stars....

3. And there appeared another wonder in heaven; and behold a great red dragon, having seven heads and ten horns, and seven crowns upon his head.

4. And his tail drew the third part of the stars of heaven, and did cast them to the earth; and the dragon stood before the woman which was ready to be delivered, for to devour her child as soon as it was born.

5. And she brought forth a man-child, who was to rule all nations with a rod of iron: and her child was caught up unto God, and to his throne....

7. And there was war in heaven: Michael and his angels fought against the dragon; and the dragon fought and his angels.

Commentary on the Revelation of Saint John the Divine after Beatus of Liébana. c. 975. Double page, $15^3/_4 \times 20^1/_2$". Cathedral treasury, Gerona

8. And prevailed not, neither was their place found any more in heaven.

9. And the great dragon was cast out, that old serpent called the Devil, and Satan, which deceiveth the whole world: he was cast out into the earth, and his angels were cast out with him....

13. And when the dragon saw that he was cast unto the earth, he persecuted the woman which brought forth the man-child.

14. And to the woman were given two wings of a great eagle, that she might fly into the wilderness, into her place, where she is nourished for a time, and times, and half a time, from the face of the serpent.

15. And the serpent cast out of his mouth water as a flood after the woman, that he might cause her to be carried away of the flood.

16. And the earth helped the woman, and the earth opened her mouth, and swallowed up the flood which the dragon cast out of his mouth.

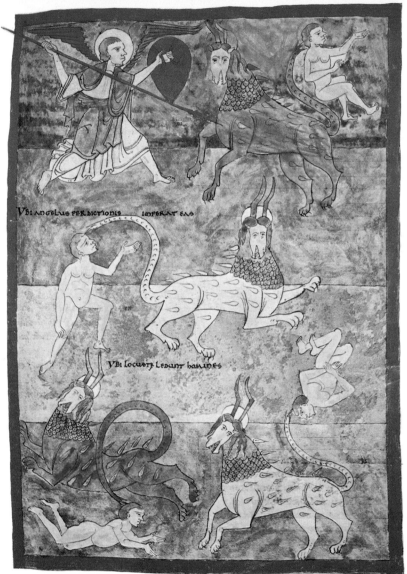

The Angel of Destruction and the Tormenting Animals (Rev. 9:7-14) from *Commentary on the Revelation of Saint John the Divine* after Beatus of Liébana (d. 798). Eleventh century. Mozarabic manuscript, perhaps originating in Catalonia. Biblioteca Nazionale, Turin

In 780, Beatus of Liébana wrote a commentary on the Revelation of St. John the Divine, which is handed down in a number of northern Spanish, Mozarabic, and French manuscripts of the ninth to thirteenth centuries with iconographically very varied miniatures. The monk Maius who fled from Córdoba to León in 926 wrote a commentary for Abbot Alfonso of the monastery of San Miguel de la Escalada (see pages 243 f.). The priest Emeterius, a pupil of Maius, was the scribe and the illuminator, together with a female painter *(pintrix)*, and a female assistant *(adjutrix)*, of what is now the best-known manuscript of the Beatus commentary at the order about 975 of a certain Dominicus, abbot of an unknown double foundation. The manuscript, consisting of 284 pages, is preserved almost entire in the cathedral treasury at Gerona. The mystical vision of the illuminations (page size $15^3/_4 \times 10^1/_4''$), their deeply glowing colors, and the sharp intensity of the drawing, are as much expressions of all the Visigothic, Moorish-Córdoban, Byzantine and Oriental, even Syrian and Mesopotamian influences and sources that went into it as of individual and original artistic creativity (see the preceding pages and above).

248

The Evangelist Mark, from a bible from the monastery of Albeares. Dated 920. 14 × 9³/₈″. Cathedral library, León

In medieval Spanish manuscripts it was usual to give on the colophon (introduction or conclusion of text) the names of the scribe and the illuminator as well as the date and place of origin (see also page 252). So we learn that the two deacons Juan and Vimara illuminated this Bible for Abbot Maurus' monastery of Albeares in 920. The text of the Gospel of Saint Mark begins with a fantastic, visionary miniature of the winged figure of the Evangelist. The very flat, linear quality of the painting with narrow bands of color is based on Visigothic and Mozarabic models; but it also recalls Irish and Anglo-Saxon illuminations of the seventh and eighth centuries— so varied were the artistic currents that came together in the land of the *Reconquista.*

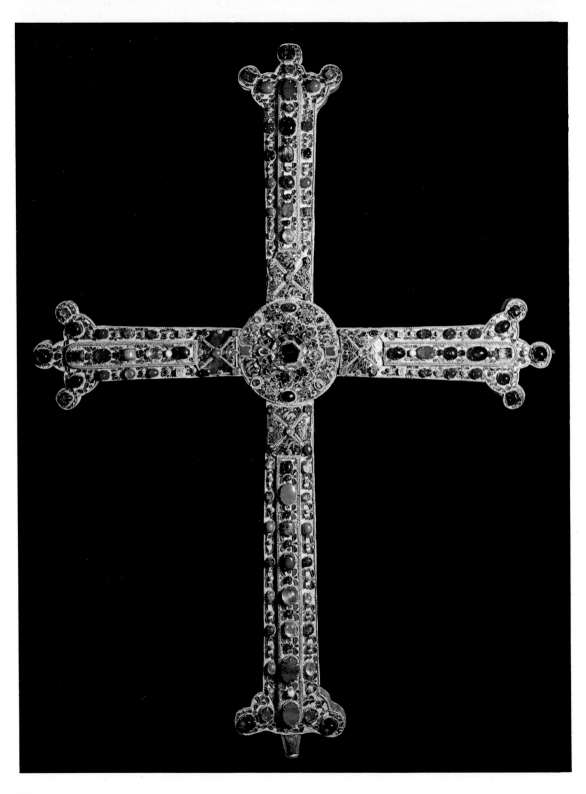

So-called "Cross of Victory" *(Cruz de la Victoria)*. Front view. Presented by King Alfonso III, the Great, of Asturias (866–910) in 908. Gold and precious stones on a wooden core, height 34¼″. Cámara Santa, Oviedo Cathedral

Spain owes to the kings of Asturias (eighth to tenth centuries) the beginning of the successful *Reconquista* (Christian reconquest and freeing of the country from Islam), while art history owes to them important works of architecture and precious works of gold. The Visigothic King Pelayo is said to have carried the wooden core of the Cross of Victory with him in his successful battle against the Arabs. Of the rich series of valuable crosses of gold and precious stones from the Early Middle Ages, the one, illustrated on the left, elevated to a religious symbol of the *Reconquista*, is particularly attractive with its elegant form and stylistic wealth.

The small gold shrine below glows with a number of large deep-blue agates, which contrast strangely with the red enamel of the inset plaque added later (ninth century?).

Reliquary shrine (cover). Dedicated by King Fruela II of Asturias (910–25) and his wife Nunilo in 910. Gold with agates; the central plaque is later, perhaps Carolingian, total width 16⅛″. Cámara Santa, Oviedo Cathedral

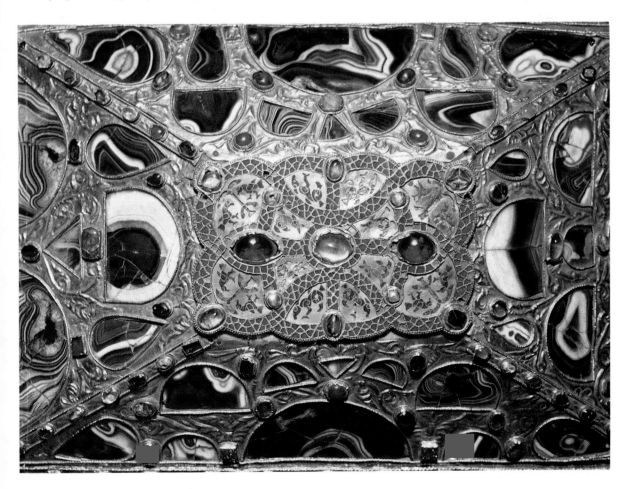

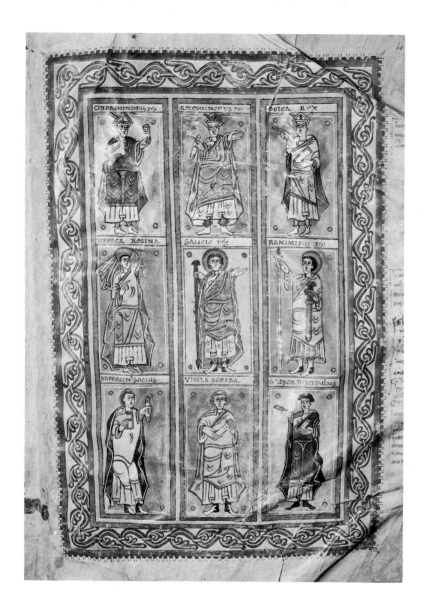

Codex Vigilano. Made in 916 under King Ramiro III of León. Upper row: the Visigothic kings Chindaswinth 642–53), Recceswinth (653–72), and Egica (687–701). Center: the kings of León, Sancho I (955–67), his son, Ramiro III (967–84), and the latter's wife Urraca (far left). Lower: the scribe Vigila (center), Sarracin his assistant *(socius)*, and his pupil Garsca. Escorial Library

The famous series of six kings at the end of this Codex was intended to show the direct continuity of the Christian kingdoms of northern Spain since Visigothic times, justifying politically, at the same time, the Christian struggle for liberation from the Moors, since the Visigoths had been driven with unlawful violence out of their lands by the Arabs in 711–13. So the three Visigothic kings in the upper register, dating from the time before the victory of the Arabs, correspond to the three contemporary Asturian kings of León from the time of the *Reconquista* in the middle register. That the three scribes and illuminators appear together with these majestic figures gives an idea of their high artistic and social standing.

Thus may the "self-portraits" of individual artists be allowed to conclude the otherwise largely anonymous early history of European art.

APPENDIX

Western art from the sixth to the eleventh century
(the numbers in parentheses refer to page numbers)

PERIOD	ARCHITECTURE	SCULPTURE/IVORIES	WALL PAINTINGS/MOSAICS
PRE-CAROLINGIAN 500 / 600 / 700 / 800	Tomb of Theodoric the Great (13) Baptistery, Venasque (37) Gallerus oratory, western Ireland (38) Temple of Clitumnus, near Perugia (21) Brixworth Church, Northampton (39) Baptistery, Poitiers (35) "Tempietto," Cividale (68) Gatehouse, Lorsch (72) San Giorgio in Velabro, Rome (58)	Funerary stele of horseman from Hornhausen (34) *Ciborium,* Cividale (66) *Dagulf's Psalter* (98) *Sigwald Relief,* Cividale (67) *Ciborium* of Eleucadius (64)	Santa Maria Antiqua, Rome (59) Santa Prassede, Rome (60–61)
CAROLINGIAN c. 850	Aachen palatine chapel (73–76) Saint Johann, Müstair (92) Saint Justinus, Höchst (78) Saint Vitus, Corvey (80–81) Basilica, Steinbach (82–83) Chapel of Saint Michael, Fulda (84) Saint-Germain, Auxerre (86) Santa Cristina de Lena (89) Santa Maria de Naranco (90–91)	Equestrian statuette of Charlemagne (?) (71) *Lorsch Gospels* (96) Book cover from the Bodleian Library, Oxford (97) Runic stones (141–43)	Apse, Germigny-des-Prés (88) Müstair (93) Mistail (95) San Clemente, Rome (62–63) *Saint Stephen,* crypt of Saint-Germain, Auxerre (87) Crypt of Saint Maximin, Trier (85)
OTTONIAN 900 / 950 / 1000 / 1050	Saint George, Reichenau (155) San Miguel de la Escalada (243–44) Saint Cyriakus, Gernrode (153) Saint Pantaleon, Cologne (192–93) Sant'Eufemia, Spoleto (234) San Stefano, Verona (235) Chapel of Mary, Würzburg (181) Torcello Cathedral (236–37) Saint-Philibert, Tournus (221) Saint Maria im Kapitol, Cologne (197) Saint Michael, Hildesheim (208–10) Chapel of Saint Bartholomew, Paderborn (206–7) Saint Andreas, Fulda-Neuenberg (182–83) Ottmarsheim (180) Saints Cosmas and Damian, Essen (199) Bad Hersfeld Abbey (217)	*Magdeburg Antependium* (152) Gero's Cross (194–95) *Reliquary of Saint Foy* (205) Essen Madonna (202–3) *Codex Aureus* of Echternach (175) *Book of Pericopes of Henry II* (167) *Basel Antependium* (170–71) Bronze doors from Hildesheim (211–12) *Bernward's Column* (213–14) *Gospel Book of Abbess Theophano* (201)	Castelseprio (239) Saint George, Reichenau/Oberzell (155–56) Fulda-Neuenberg (183)

MINIATURES	LITURGICAL OBJECTS	INSIGNIA OF RULE	PERIOD
	Gourdon Paten and *Chalice* (30–31) *Gospel Book of Queen Theodolinda* (18–19)	Eagle fibula from Cesena (16) Medallion and gem of Theodoric the Great (14, 15)	500
			600
Book of Durrow (50)	Reliquary casket from Veluwe (32)	*Votive Crown* and *Cross of King Recceswinth* (22–23)	
Book of Kells (51) *Lindisfarne Gospels* (52) *Codex Amiatinus* (48–49)	*Reliquary of Warnebertus* (33)	Gold fibula from Mölsheim (25)	
			700
Dagulf's Psalter (99)	*Ardagh Chalice* (41) *Tassilo Chalice* (121) *First Lindau Book Cover* (119–20)		800
"Ada" Gospels (101) Gospel book from Saint-Médard (103) *Vienna Coronation Gospels* (104) Gospel book from Fulda (102) *Ebbo Gospels* (104–5) *Utrecht Psalter* (107) *Bamberg Bible* (108) *Count Vivian's Bible* (110–11) *Gospels of Emperor Lothair* (111) *Bible* and *Coronation Sacramentary* of Charles the Bald (112–13)	*Adelhaus portable altar* (122) *Purse of Saint Stephen* (124–25) *Chalice* of Lebuinus (129) *Purse of Pepin of Aquitaine* (125) *Altar of Wolvinus* (130) *Comb of Heribert* (134–35) *Codex Aureus* (114) *Portable Altar of Arnulf* (131)	*Talisman of Charlemagne* (70) Oseberg ship burial (139) *Lothair Crystal* (129)	} c. 850
	"Cross of Victory" (250–51)		900
Bible from Albeares (249)	Gold-and-agate reliquary shrine (251)		
Gero Codex (157) *Commentary on the Revelation of Saint John the Divine* (Beatus' Apocalypse) (246–48) *Codex Vigilano* (252) *Benedictional of Ethelwold* (229–30)	Reliquary cover of the True Cross (177)	Crown of the Holy Roman Empire (148–49)	950
Codex Egberti (159) *Registrum Gregorii* (160) *Second Gospel Book of Otto III* (158) *Gospel Book of the Sainte Chapelle* (162–63) *Gospel Book of Otto III* (164–65)	Reliquary of the Staff of Saint Peter (176) Reliquary of the Foot of Saint Andrew (174) Chalice and Paten of Saint Gauzelin (224)		
Book of Pericopes of Henry II (168–69) *Hitda Codex* (196) *Missal of Robert of Jumièges* (231)	*Portable Altar of Henry II* (178) *Crown of Kunigunde* (179) *Ambo of Henry II* (187–89) *Aachen Antependium* (190–91)	*Star Mantle of Henry II* (150) Eagle fibula (184) *Cross of Lothair* (185) Imperial Cross (148) *Ceremonial Mantle of Kunigunde* (151) Hunting horn *(oliphant)* (218)	1000
	Cross of Theophano (200)		1050

Bibliography

GENERAL LITERATURE

ABERG, N., *The Occident and the Orient in the Art of the Seventh Century,* Stockholm, 1943–47, 3 vols.

Arte del primo millennio (1950), Turin, 1952

BECKWITH, J., *Early Medieval Art, 800–1200,* New York, 1964

BEHN, F., *Römertum und Völkerwanderung,* Stuttgart, 1963

BRAUNFELS, W., ed., *Karl der Grosse,* Düsseldorf, 1965–68, 5 vols.

BULLOUGH, D. A., *The Age of Charlemagne,* New York, 1966

EGGERS, H. J., et al., *Kelten und Germanen in heidnischer Zeit,* Baden-Baden, 1964 (bibliog.)

ELBERN, V. H., et al., *Das erste Jahrtausend,* Düsseldorf, 1962

FOCILLON, H., *Art d'occident,* Paris, 1938 (Eng. trans., D. King, New York, 1963, 2 vols.)

HAUTTMANN, M., *Die Kunst des frühen Mittelalters,* Munich, 1929

HENRY, F., *Irish Art in the Early Christian Period to* A.D. *800,* 3d ed., London, 1965

HINKS, R., *Carolingian Art,* London, 1935 (reprinted Ann Arbor, 1962)

Karl der Grosse: Werk und Wirkung, exhibition catalogue, Düsseldorf, 1965

Karolingische und Ottonische Kunst, Wiesbaden, 1957

KUBACH, E., and ELBERN, V. H., *Das frühmittelalterliche Imperium,* Baden-Baden, 1968 (bibliog.)

Neue Beiträge zur Kunstgeschichte des ersten Jahrtausends, Baden-Baden, 1954

SCHRAMM, P. E., and MÜTHERICH, F., *Denkmale der deutschen Könige und Kaiser,* Munich, 1962

Sveagold und Wikingerschmuck, exhibition catalogue, Mainz, 1968

TALBOT RICE, D., ed., *The Dawn of European Civilization,* New York, 1965

Wandlungen christlicher Kunst im Mittelalter, Baden-Baden, 1953

Werdendes Abendland an Rhein und Ruhr, exhibition catalogue, Essen, 1956

GERMANIC ART

ABERG, N., *Die Goten und Langobarden in Italien,* Uppsala, 1923

ARBMAN, H., *Schweden und das karolingische Reich,* Stockholm, 1937

BRØNDSTED, J., *The Vikings,* London, 1965

HASELOFF, G., "Die langobardischen Goldblattkreuze," in *Jahrbuch des Römisch-Germanischen Zentralmuseums Mainz,* III, 1956, pp. 143–63

HOLMQVIST, W., *Germanic Art,* Lund, 1955

KENDRICK, T. D., *Anglo-Saxon Art,* London, 1938

KENDRICK, T. D., *Late Saxon and Viking Art,* London, 1949

LINDQUIST, S., *Gotlands Bildsteine,* Uppsala, 1941–42, 2 vols.

RADEMACHER, F., *Fränkische Goldscheibenfibeln,* Munich, 1940

SCHAFFRAN, E., *Die Kunst der Langobarden in Italien,* Jena, 1941

WILSON, D. M., and KLINDT-JENSEN, O., *Viking Art,* London, 1966

ARCHITECTURE

BUSCH, H., *Germania Romanica,* Vienna and Munich, 1963

CLAPHAM, A. W., *English Romanesque Architecture before the Conquest,* Oxford, 1930 (reprinted 1964)

CONANT, K. J., *Carolingian and Romanesque Architecture: 800–1200,* Baltimore, 1959

DE ANGELIS D'OSSAT, G., *Studi Ravennati,* Ravenna, 1962

DURIAT, M., and DIEUZAIDE, J., *Hispania Romanica,* Vienna and Munich, 1962

FRANKL, P., *Die frühmittelalterliche und romanische Baukunst,* Potsdam, 1926

GANTNER, J., and POBÉ, M., *Gallia Romanica,* Vienna and Munich, 1955

GOMEZ-MORENO, M., "Arte mozárabe," in *Ars Hispaniae,* III, Madrid, 1951, pp. 355–409

HEITZ, C., *Recherches sur les rapports entre architecture et liturgie à l'époque carolingienne,* Paris, 1963

HUBERT, J., *L'architecture religieuse du haut moyen âge en France,* Paris, 1952

JANTZEN, H., *Ottonische Kunst,* 2d ed., Hamburg, 1959

LEASK, H. G., *Irish Churches and Monastic Buildings,* Dundalk, 1955–60, 3 vols.

LEHMANN, E., *Der frühe deutsche Kirchenbau,* 2d ed., Berlin, 1949

OSWALD, F., SCHAEFER, L., and SENNHAUSER, H. R., *Vorromanischer Kirchenbau,* Munich, 1966 ff.

PALOL, P. DE, and HIRMER, M., *Early Medieval Art in Spain,* New York, 1966

TAYLOR, H. M. and J., *Anglo-Saxon Architecture,* Cambridge, 1965

VERZONE, P., *L'architettura religiosa dell'alto medioevo nell' Italia settentrionale,* Milan, 1942

WEBB, G., *Architecture in Britain: The Middle Ages,* Baltimore, 1956

SCULPTURE

BAUM, J., "Karolingische geschnittene Bergkristalle," in *Frühmittelalterliche Kunst: Akten zum III. Internationalen Kongress für Frühmittelaltersforschung* (1951), Olten, 1954, pp. 111–17

BEUTLER, C., *Bildwerke zwischen Antike und Mittelalter,* Düsseldorf, 1964

BOECKLER, A., "Elfenbeinreliefs der ottonischen Renaissance," in *Phoebus,* II, 1948–49, pp. 145–55

GOLDSCHMIDT, A., *Die Elfenbeinskulpturen,* Berlin, 1914–26, 4 vols.

WESENBERG, R., *Bernwardinische Plastik,* Berlin, 1955

PAINTING

BIRCHLER, L., "Zur karolingischen Architektur und Malerei in Münster/Mustair," in *Frühmittelalterliche Kunst: Akten zum III. Internationalen Kongress für Frühmittelaltersforschung* (1951), Olten, 1954, pp. 167–258

DAVIS-WEYER, C., "Die Mosaiken Leos III. und die Anfänge der karolingischen Renaissance in Rom," in *Zeitschrift für Kunstgeschichte,* XXIX, 1966, pp. 111–32.

DESCHAMPS, P., and THIBOUT, M., *La peinture murale en France,* Paris, 1951

GRABAR, A., and NORDENFALK, C., *Early Medieval Painting,* Geneva, 1957

SCHRADE, H., *Vor- und frühromanische Malerei,* Cologne, 1958

ILLUMINATION

BOECKLER, A., *Abendländische Miniaturen bis zum Ausgang der romanischen Zeit,* Berlin and Leipzig, 1930.

BOECKLER, A., and SCHMID, A. A., "Die Buchmalerei, II: Das Mittelalter," in *Handbuch der Bibliothekswissenschaft,* 2d ed., I, Wiesbaden, 1952, pp. 264–308

BOECKLER, A., "Die Reichenauer Buchmalerei," in *Die Kultur der Reichenau,* II, Munich, 1925, pp. 956–98

BOINET, A., *La miniature carolingienne,* Paris, 1913

DIRINGER, D., *The Illuminated Book: Its History and Production,* London and New York, 1958

DOMINGUEZ BORDONA, J., *Spanish Illumination,* Munich and Florence, 1930, 2 vols.

GOLDSCHMIDT, A., *German Illumination,* Florence, 1928

KÖHLER, W., *Die Karolingischen Miniaturen,* Berlin, 1930–60, 3 vols. in 7

MESSERER, W., "Ottonische Buchmalerei um 970 bis 1070 im Gebiet deutscher Sprache," *Zeitschrift für Kunstgeschichte,* XXVI, 1963, pp. 62–76

SCHNITZLER, H., *Die ottonische Kölner Malerschule,* Düsseldorf, 1967

TSELOS, D., "The Influence of the Utrecht-Psalter in Carolingian Art," in *Art Bulletin,* XXXIX, 1957, pp. 87–96

WORMALD, F., *The Utrecht Psalter,* Utrecht, 1953

GOLD- AND SILVERWORK

BRAUN, J., *Meisterwerke der deutschen Goldschmiedekunst der vorgotischen Zeit,* I, Munich, 1922

BUDDENSIEG, T., "Die Basler Altartafel Heinrichs II.," in *Wallraf-Richartz-Jahrbuch,* XIX, 1957, pp. 133–92

BURGER, W., *Abendländische Schmelzarbeiten,* Berlin, 1930

ELBERN, V. H., *Der karolingische Goldaltar von Mailand,* Bonn, 1952

GRIMME, H. G., *Aachener Goldschmiedekunst im Mittelalter,* Cologne, 1957

HASELOFF, G., *Der Tassilokelch,* Munich, 1951

MEDDING-ALP, E., *Rheinische Goldschmiedekunst in ottonischer Zeit,* Coblenz, 1952

ROSENBERG, M., *Geschichte der Goldschmiedekunst auf technischer Grundlage,* Frankfurt, 1909–22, 6 vols.

ROSS, M. C., *Catalogue of the Byzantine and Early Medieval Antiquities in the Dumbarton Oaks Collection, II: Jewelry, Enamels and Art of the Migration Period,* Washington, 1965

Index